HOLLYWOOD
FRAME BY FRAME

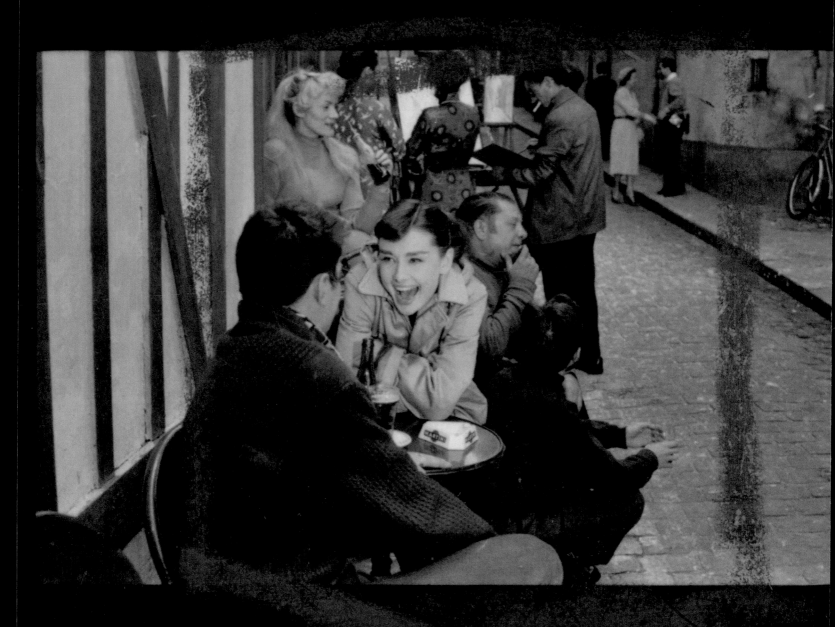

HOLLYWOOD FRAME BY FRAME

The Unseen Silver Screen in Contact Sheets, 1951–1997

Karina Longworth

PRINCETON ARCHITECTURAL PRESS · NEW YORK

Princeton Architectural Press
37 East Seventh Street
New York, New York 10003

Visit our website at www.papress.com

Printed and bound in China
17 16 15 14 4 3 2 1 First edition

For Ilex Press:
Publisher: Alastair Campbell
Executive Publisher: Roly Allen
Creative Director: James Hollywell
Managing Editors: Natalia Price-Cabrera and Nick Jones
Commissioning Editor: Zara Larcombe
Specialist Editor: Frank Gallaugher
Assistant Editor: Rachel Silverlight
Art Director: Julie Weir
Concept and Picture Research: Katie Greenwood
Design: Made Noise
Color Origination: Ivy Press Reprographics

For Princeton Architectural Press:
Project Editor: Nicola Brower

Library of Congress Cataloging-in-Publication Data:
Longworth, Karina, 1980–
 Hollywood Frame by frame : the Unseen Silver Screen in
contact sheets, 1951–1997 / Karina Longworth.
 pages cm
 ISBN 978-1-61689-259-3 (hardback)
1. Stills (Motion pictures)—United States. 2. Contact
printing—United States. 3. Motion pictures—United States—
Pictorial works.
I. Title.
 PN1995.9.S696L66 2014
 791.430973—dc23
 2013051020

Cover image: *Giant* (1956) © Sid Avery/mptvimages.com
Back cover image: *Cleopatra* (1963) photos by Ernst Haas/
Getty Images
Front flap image: *Some Like it Hot* (1959) United Artists/
The Kobal Collection

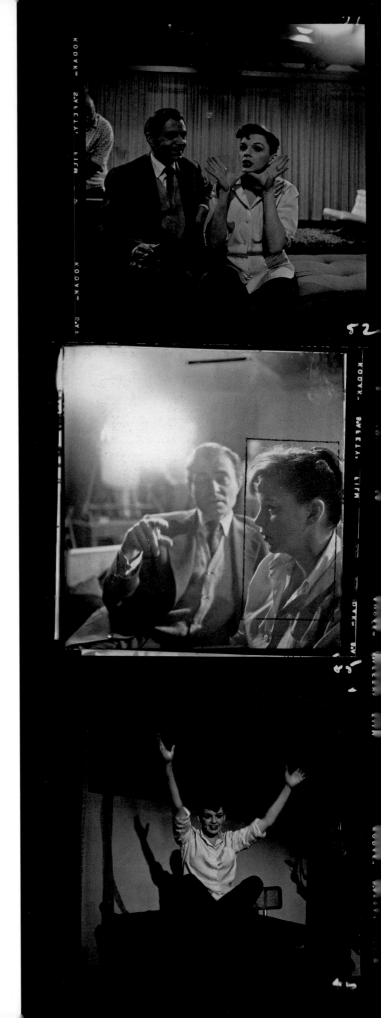

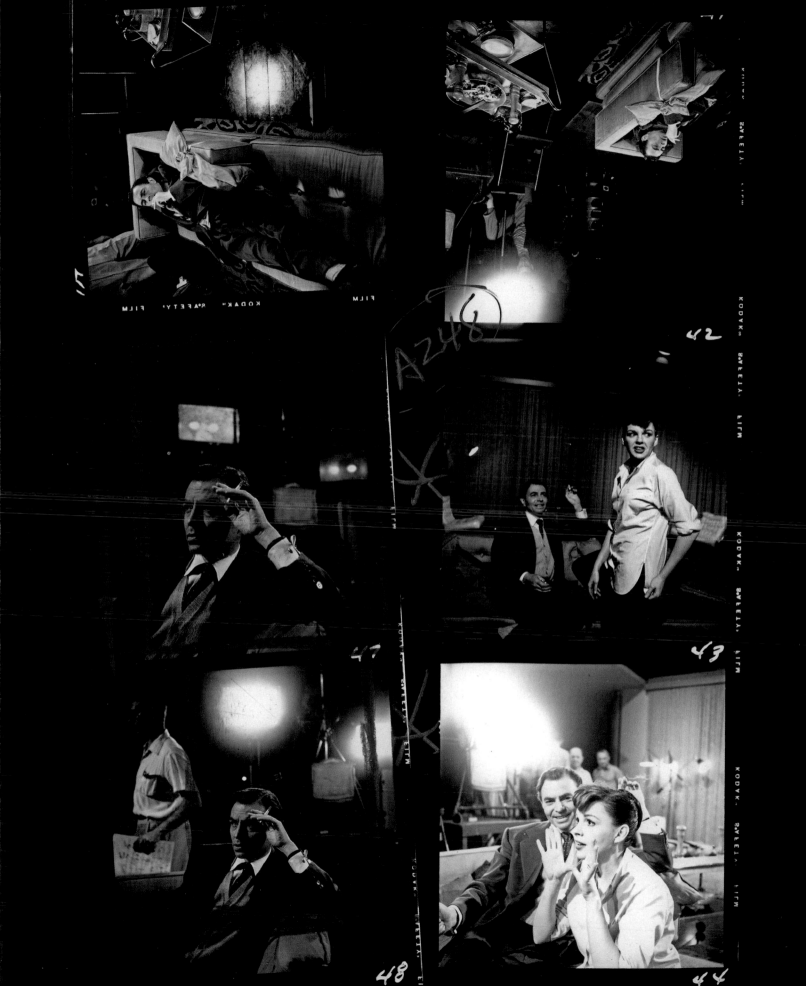

CONTENTS

THE LAST DAYS
OF CELLULOID 162
1981–1997
—

CODA: CONTACT
SHEETS IN THE
DIGITAL ERA 200
—

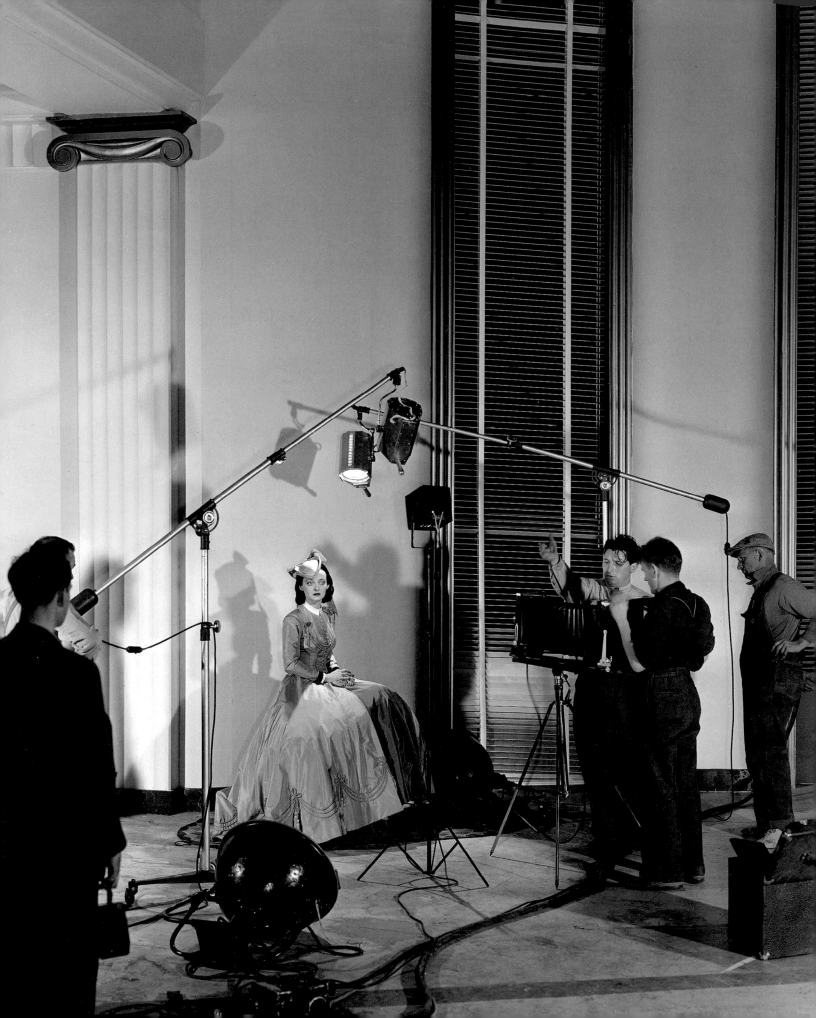

"FILM STILLS ARE NOT DOCUMENTS OF THE FILM MEDIUM, BUT OF ITS MONUMENTAL FACADE."

Alois M. Müller[1]

INTRODUCTION

This book compiles contact sheets produced by still photographers on movie sets, allowing a fragmented, but illuminating, highly narrative glimpse into both the art of filmmaking, and the construction of imagery used to promote movies. A contact sheet—also known as a proof sheet or contact print—is a printed reproduction of one or more strips of developed film, exposed at a one-to-one ratio in order to produce positive images in the same size as the frames on the negatives. In the pre-digital era, these sheets were used to preview the contents of an exposed roll of film at a glance, in order to select specific images to be printed at a larger size. Because of their ability to condense many different shots onto one printed sheet, contact sheets are useful to the historian in that they offer a quick, chronological visual summary of a photo shoot and the person, place, or event documented.

Their inherent narrative value is one reason why Hollywood contact sheets hold so much interest. Another is their ability to document both the creation of, as Alois M. Müller put it, the "monumental facade," and the slippage of that facade. Given the great artificiality of moviemaking and the role still photography plays in, essentially, selling lies, it's all the more remarkable to see the moments of spontaneity or misstep that are often visible in the outtakes, right alongside images deemed supportive of the facade, and thus commercially useful. Contact sheets show aspects of moviemaking that someone—a star, a producer, a publicity department, a photographer, a photo editor—didn't want us to see.

As an art form, a trade, and a functional aspect of the filmmaking process, the act of still photography on the sets of motion pictures has evolved enormously over the past 100 years. It has been part of the filmmaking process at least as far back as 1910, when the rise of the fan press and glossy magazines such as *Vanity Fair* increased demand for photos of stars. The earliest stills were usually distributed with no photographer attributed; back then, motion picture cinematographers were often asked to also take stills, which in addition to advertising and marketing, were used for production reference and occasionally special effects. In the early days of cinema, stills were shot on the largest film formats available, usually 8x10 negatives. These very high-detail,

very large cameras were mounted on tripods, limiting a photographer's movement and ability to capture spontaneous imagery; thus, most early set stills were group shots of cast and crew, or documentation of sets and costumes. Few were taken, and because strips of film were not used, there are few if any existent contact sheets.

Given the widespread destruction and deterioration of early films (90 percent of American films made before 1929 are considered lost), there are stars whose legends have survived solely or primarily based on their publicity stills. In 1915, Jack Freulich's shots of actress Theda Bara posed as a female vampire made Bara a notorious siren before her first major film, *A Fool There Was*, had even been seen. Soon thereafter, Bara became the star of Hollywood's first *Cleopatra*; though no complete prints of that 1917 silent survive, still photographs do, and they give a sense of Bara's approach to the role and the essential elements of her star persona. Freulich's images of Bara made him one of the most in-demand still photographers in Hollywood, and in 1919 he was hired by Universal to serve as the studio's director of portrait galleries, making him the first still photographer on a studio payroll. In the 1920s, most studios followed suit, setting up their own still departments. Unlike the cameramen who took stills when they were finished with their motion shots, the professional still photographers understood that their job was not merely to document the stars or their actions on the set, but instead to manufacture the image that would sell them to the public, and subsequently lure customers into theaters. Given that goal, and also the size and slowness of the silver plate cameras used at the time, still photographers could not simply take their shots while a scene was being filmed, but would often recreate the action of the scene after it had been shot. Soon photo galleries were built on studio lots for the shooting of all-important portraits of stars.

An early proponent and benefactor of the art of the film still was director/producer Cecil B. DeMille, who hired well-known photographers to shoot stills on the sets of films such as *The Ten Commandments*. William Mortensen's stills on the set of DeMille's *The King of Kings* (1927) are thought to be the first motion picture

LOOK MAGAZINE PHOTOGRAPHER
EARL THEISEN SHOWS CLARK
GABLE THE VIEW THROUGH HIS
ROLLEIFLEX, ON LOCATION OF
ACROSS THE WIDE MISSOURI
1951

stills to be captured with a hand-held camera, documenting the scenes while the motion picture camera rolled, rather than recreating the action after the fact. From the 1920s through the 1930s, the style and craft of still photographs evolved and deepened in sophistication; as photographers developed new lighting techniques and stylistic tropes, the Hollywood glamour portrait, in all its staged decadence, was born. These photographs were generally shot with large, mounted cameras using very high-detail individual negatives, on fixed sets that could be (and were) cosmetically redressed, but necessitated fixed poses from the actors. The process lent itself to beautiful but homogenized images; for instance, the same background screen can be seen in publicity photographs of Norma Shearer, Marlene Dietrich, and Ramon Novarro, all of them taken by George Hurrell. And, because the top stars had approval over their publicity photos, the outtakes of their portrait sections were contractually hidden from the public, ensuring that only the most polished and controlled images would be widely seen.

The practice of having a photographer dedicated to documenting a production in stills, often called a unit photographer, became standard after David O. Selznick hired Fred Parrish to shadow him on the set of *Gone with the Wind* (1939). Hollywood and the media that covered the film industry were becoming increasingly interdependent. A photographer on set was now both documentarian, and the artisan of precious materials that could bridge the divide between advertising and editorial. Smaller, portable cameras, utilizing 2 ¼ negatives, slowly came into circulation. The lightweight Leica portable camera, first introduced in 1925, took rolls of 35mm film, the same size as the celluloid that was now standard for capturing motion pictures, but it took decades for 35mm to fully usurp larger formats as the standard medium for stills. Roman Freulich (brother of Jack), a staff photographer at Universal, was one of the first to experiment with still 35mm, beginning in 1930, but his employers had little faith in the small negatives, and insisted he continue to take photos with the large Speed-Graphic camera as well. In 1937, in a how-to document on the shooting of "candid-camera images" circulated by the studio, Fox staff photographer Gene Kornman advocated for the use of 35mm, writing that "satisfactory" results could be had, "if you take the same care in exposing a double frame of 35mm film as you would take in exposing an expensive 11x14 negative." His wording suggests that in 1937, over a decade after the introduction of the Leica, the use of small-format film in the context of Hollywood still photography was considered controversial. In 1939, on the set of a Deanna Durbin feature called *One Hundred Men and a Girl*, Roman Freulich finally decided not to bother with the large-format camera, and instead took pictures only with his portable 35mm Leica. But Freulich was still the exception to the rule; the Leica was considered by many professionals to be something of a lark, or a toy. 35mm did not become a standard capture medium for still photography until after World War II, when it was literally tested in battle.

By the late 1940s, a studio still photographer would have been using a mix of cameras and formats: a Speed-Graphic for moving shots; 8x10 cameras for portraits; Leicas and other small cameras for shooting on-the-fly with available light. The introduction of the Nikon reflex camera made 35mm a more stable, versatile format for shooting stills, although some studios continued to require still photographers to shoot on larger formats into the 1970s, in the belief that only bigger negatives would suffice for large-scale reproductions.

The studio concern for image quality is, in some sense, ironic, given the industry's endemic laxity toward still image preservation. Before the days of home video, publicity materials were generally thought to be worthless once a film had finished theatrical release. Stills, negatives, and contact sheets were routinely lost or destroyed. When photo and fan magazines shuttered, pushed out of the marketplace by television, their archives went straight to the trash. Studios routinely treated photographic materials as the disposable detritus of the publicity process rather than historic artifacts or artworks in their own right. And most photographers, particularly those who were active in the heyday of magazines such as *LIFE*, which required them to burn through enormous amounts of film, lacked the space, time, funds, or even the inclination to keep archives of their own work. The contact sheets collected in this book are thus doubly unique, for the sheer fact that someone saw fit to save them—or rescue them. As photographer Bruce McBroom, who shot stills on the sets of films such as *What's Up Doc?*, *The Godfather Part II*, and *48 Hours* puts it, "Most of Hollywood history has survived because someone dug it out of the trash."[2]

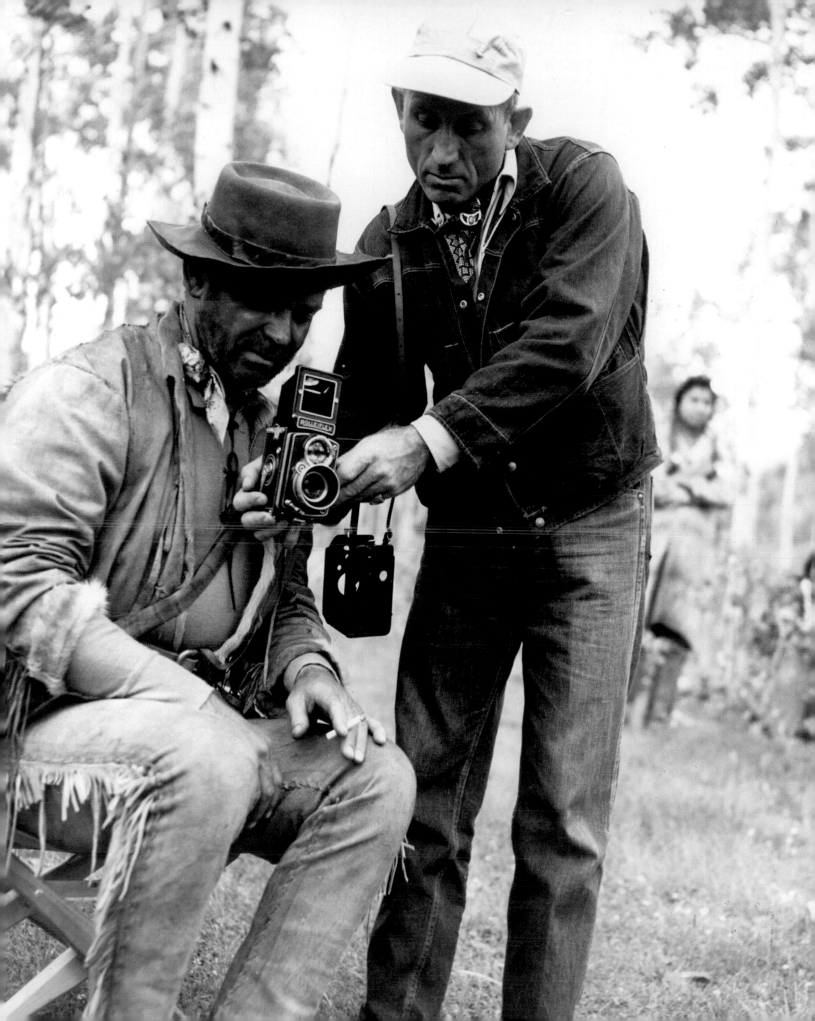

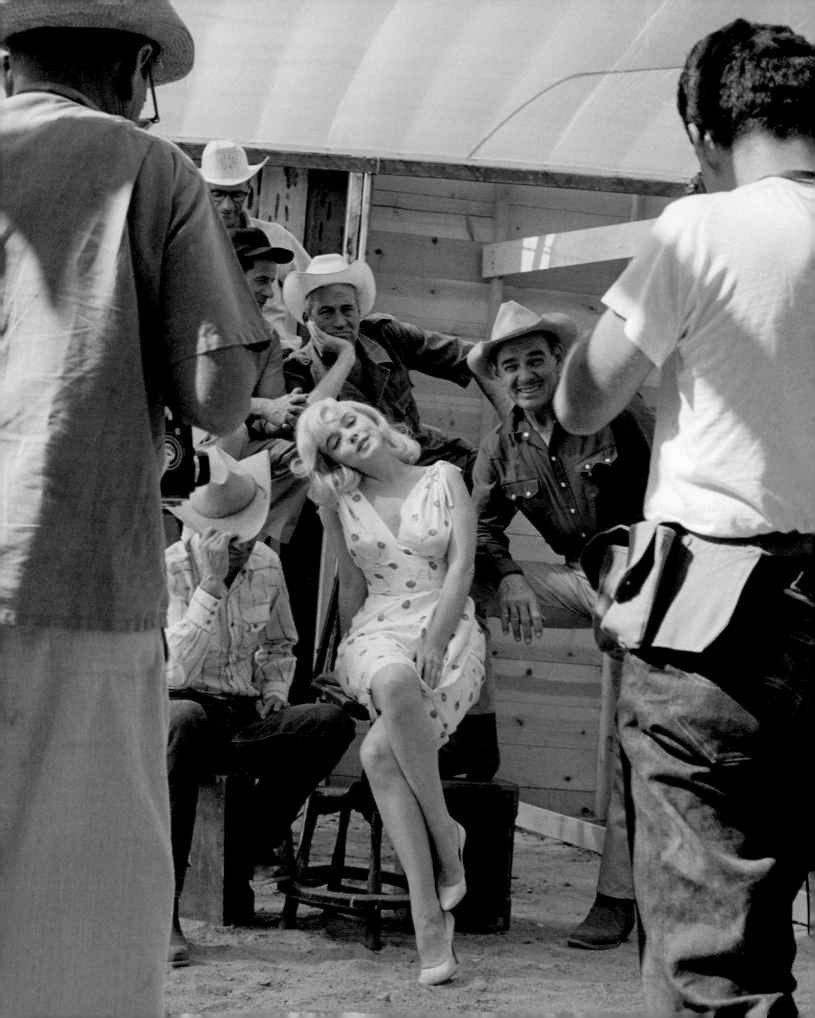

**PHOTOGRAPHERS ON
THE SET OF *THE MISFITS***
1961
Director: John Huston
Photographer: Ernst Haas

THE GOLDEN AGE
OF THE CONTACT SHEET
1951–1966

The 1950s to the 1970s could be considered a kind of golden age for the movie set contact sheet. As we'll see, the photographs from this time sometimes function as stand-alone documentaries on the sets and stars they depict. More often, they offer insight into how photography played a role in the creation, shaping, and promotion of stars.

LIFE magazine photographer Peter Stackpole, who covered the Hollywood beat from 1938–1951, was one of the first photographers on film sets to favor 35mm film. Due to the format's speed and portability, Stackpole was able to capture stars in a casual, unguarded way, producing photos that stood out amidst the heavily staged shots of the official studio photographers. "I wanted to photograph the stars as real people," the photographer said.[3] As initially the only major magazine to publish such images rather than rely on portraits supplied by the studios, *LIFE* helped to create a demand for images of stars like Stackpole's—images which, at that time, could only be captured via portable cameras using small- or medium-format roll film.

It's no accident that the heyday of *LIFE* and of picture magazines such as *Photoplay* and *Look* coincides with the unofficial golden era of on-set photography—and of the 35mm contact sheet. As publicity photos became more crucial to movie marketing, a greater number of photos were taken on sets, and the need for and usefulness of contact sheets increased, too. At newspapers and magazines contact sheets would be used by photo editors to decide which images to print and to plan layouts. Within the studio system, contact sheets had a very different purpose. As all major stars had contractual approval over which photos of themselves were published, they would use printed contact sheets to review and mark photos in order to give the go-ahead to the shots they liked—or, more often, to nix the images they didn't want anyone to see.

In this chapter, we'll see images of the greatest stars of the era—Marilyn Monroe, Elizabeth Taylor, Grace Kelly, James Dean, Paul Newman—both in and out of character, epitomizing Hollywood's highest standards of glamour and beauty in some frames and letting the facade slip in others. We'll also see studies of how the studio system's massive publicity machine approached selling a product that was increasingly, in the 1960s, reflective of a changing culture, and yet at odds with the Production Code: Hollywood's 30-year-old censorship standard that gradually fell apart over the course of the decade.

A PLACE IN THE SUN
1951

Director: George Stevens
Photographer: Peter Stackpole

—

LIFE magazine photographer Stackpole's shots of Montgomery Clift and Elizabeth Taylor—in the words of novelist Steve Erickson, "the two most beautiful people in the history of the movies, she the female version of him, and he the male version of her"[4]—are evidence of Stackpole's unique gift and its role in the evolution of Hollywood still photography. Though these images are evidently posed in something like the tradition of studio backlot glamour photography, and are captured on the larger 2 ¼-inch square format rather than 35mm, there is a refreshing spontaneity to them. The lighting is far more naturalistic than it likely would have been just a few years earlier, the staging more comfortable and organic. Most of all, the real friendship and affection shared off-screen by Clift and Taylor is abundantly evident. In fact, the actors almost seem to be having too much fun: these images hardly match the deeply romantic, dreamlike nature of the film they were taken to promote. But in capturing the inherent bond between the stars, the images reflected the magnetic connection the pair were able to project on-screen. The *LIFE* article that accompanied the photos noted that the finished film gave Clift and Taylor "the chance to give the most natural performances of their careers…While they may not make old-timers forget the Greta Garbo–John Gilbert embraces of the 1920s, Miss Taylor and Mr Clift lose no chance to show why they are considered two of the hottest juveniles in Hollywood."[5]

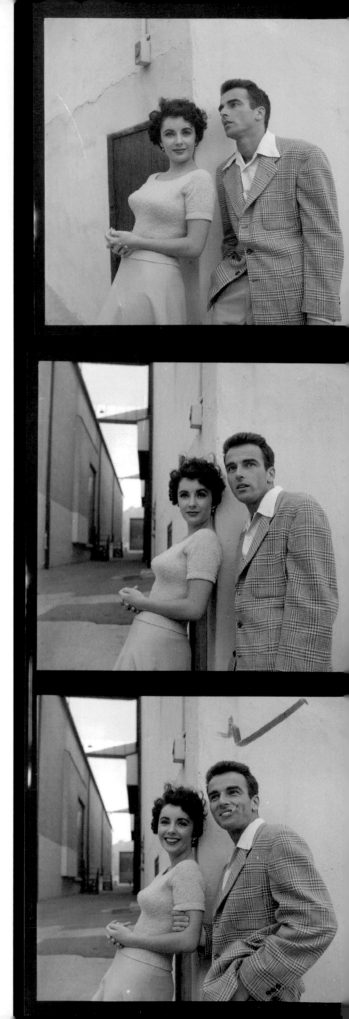

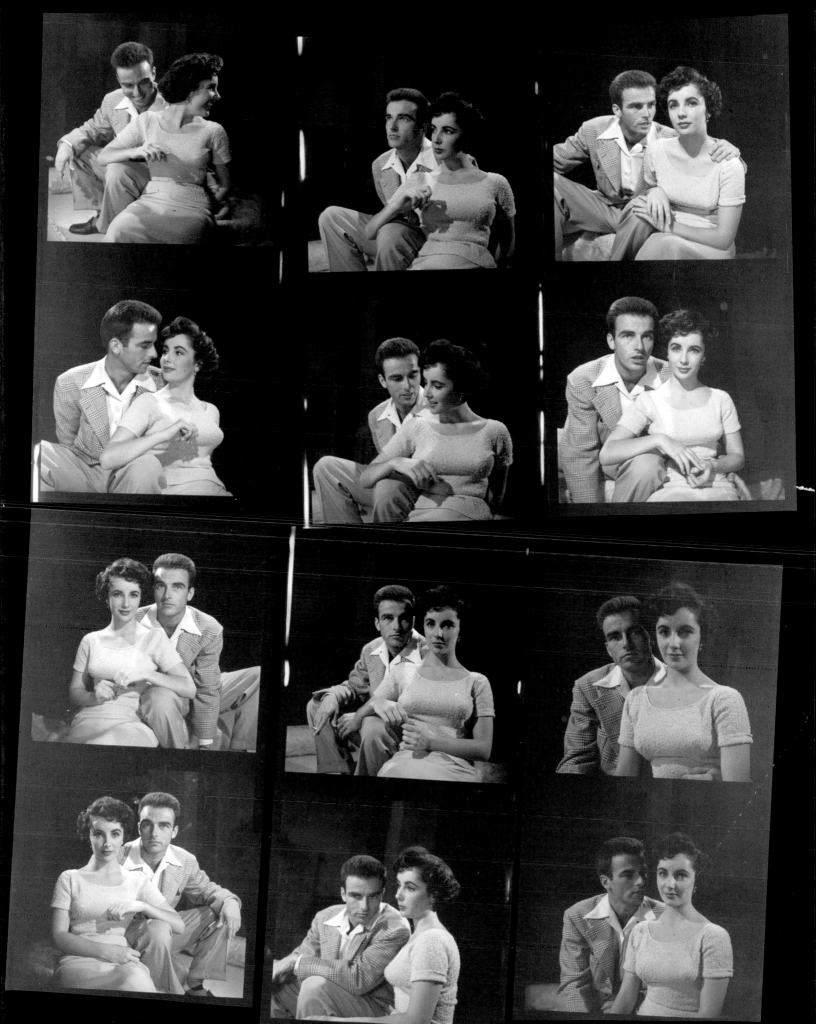

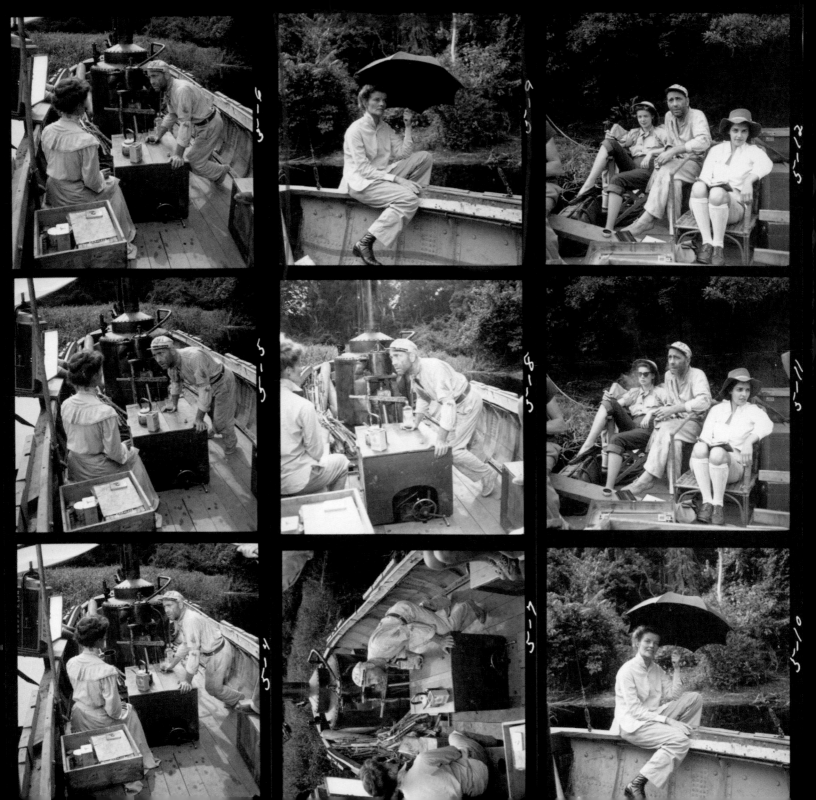

THE AFRICAN QUEEN
1951

Director: John Huston
Photographer: Eliot Elisofon

———

For his role as Charlie Allnut, a gruff boat captain hired to ferry missionaries down the Belgian Congo at the outbreak of World War I, Humphrey Bogart won the first and only Academy Award of his three-decade-spanning career. Bogart himself considered the film his highest achievement as an actor, although perhaps the result seemed all that much sweeter because the production was so grueling. While on location in Africa for four months, the cast and crew shot seven-day weeks without a break and slept in tents that eventually became infested with ants. Most of them became ill with dysentery, including Bogart's co-star Katharine Hepburn (seen here shielding her fair skin from the sun with an umbrella), who lost 20 pounds. Bogart managed to stay healthy throughout, a miracle he credited to his diet. ("All I ate was baked beans, canned asparagus, and Scotch Whiskey," Bogart claimed. "Whenever a fly bit Huston or me, it dropped dead."[6]) Both Hepburn and Bogart benefitted from the presence on set of Bogart's wife, Lauren Bacall (seen opposite sitting to Bogart's right), who made herself useful by volunteering to oversee lunch service, accompanying the lonely Hepburn on day trips, and helping to nurse the sick with smuggled contraband. "I'd brought every drug for every possible emergency from California," Bacall remembered in her memoirs, "and we used most of them!"[7]

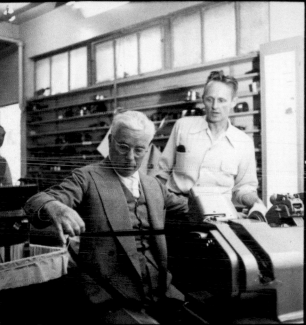

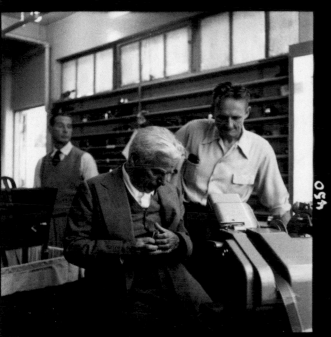

LIMELIGHT
1952

Director: Charlie Chaplin
Photographer: Francis O'Neill

———

An intensely autobiographical nostalgia piece, *Limelight* was both the first film Charlie Chaplin would make in five years (after the reviled-in-its-time dark comedy *Monsieur Verdoux*), and the last he'd ever make in Hollywood. The story of a stage comedian struggling to retrieve a lost bond with his audience in turn-of-the-century London, *Limelight* reflected Chaplin's feeling that his own film career was fading away. The shoot was by all accounts pleasant—Chaplin surrounded himself with family, finding small parts for his wife, Oona, and their three children—but the release was another matter. With the Red Scare haunting Hollywood, Chaplin was cited as a supposed communist, and refused a Visa to enter the United States from London in order to attend *Limelight's* premiere. Rather than fight the order, Chaplin decided to relocate with his family to Switzerland, saying of America, "the sooner I was rid of that hate-beleaguered atmosphere the better…"[8] As a result of the controversy surrounding Chaplin's politics, *Limelight* didn't have a theatrical run in Los Angeles until 1972, at which point it, and Chaplin, were embraced by the Hollywood community. In fact, Chaplin would win his only Oscar for this film, for his contribution to its musical score—quite the ironic achievement for perhaps the greatest artist of the silent cinema era.

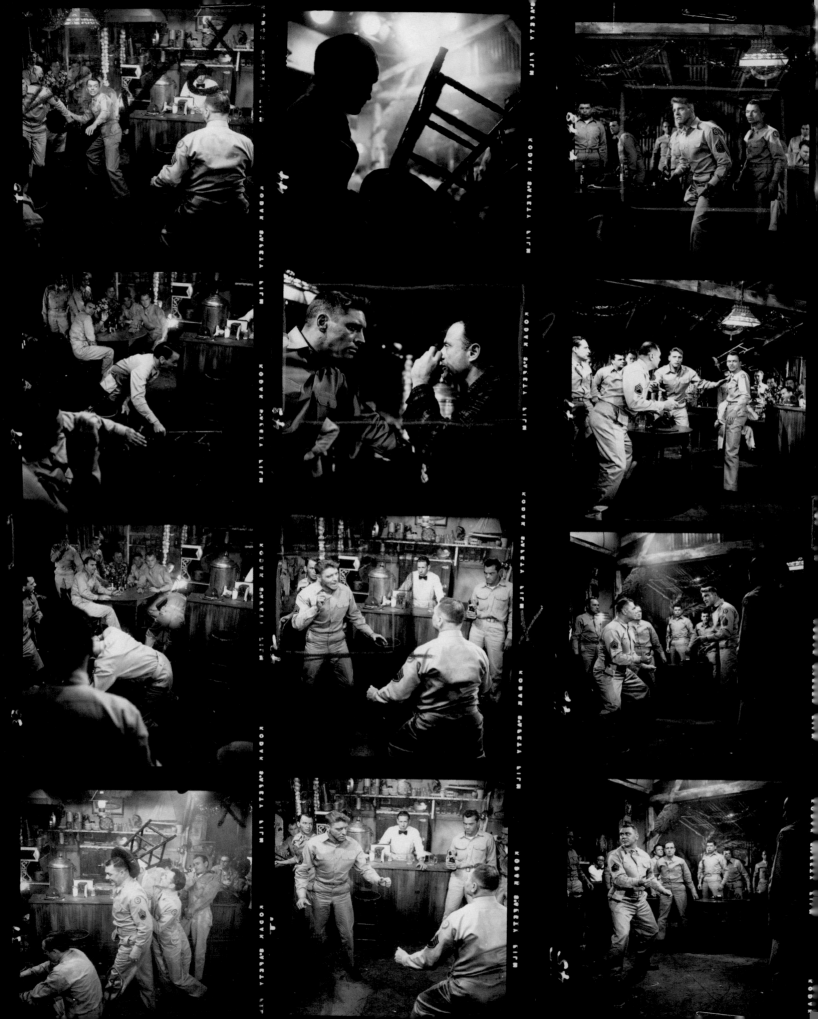

FROM HERE
TO ETERNITY
1953

Director: Fred Zinnemann
Photographer: Bob Willoughby

———

The scene of Burt Lancaster and Deborah Kerr passionately kissing on the beach, the waves breaking over their feet, is probably the most iconic image from Zinnemann's movie. These contact sheets document the staging of a scene that was perhaps harder to shoot: the bar fight between Fatso (Ernest Borgnine) and Maggio (Frank Sinatra), broken up by Lancaster's Sargeant Warden. Sinatra was not Zinnemann's or producer Harry Cohn's first choice for the role; his film career was in the doldrums and he had recently been dropped from his record company. Rumors persist that the Mafia had something to do with Sinatra's casting, due to the scene in *The Godfather* in which a Cohn-like producer wakes up next to a decapitated horse's head, and is thereby traumatized into offering a Sinatra-like crooner a coveted movie role. The real story of Sinatra's casting is much more mundane. Cohn asked his wife to watch the screen tests of Sinatra and Eli Wallach back-to-back, and she determined that while Wallach was "a brilliant actor…he looks too good. He's not skinny and he's not pathetic and he's not Italian."[9] Sinatra was all those things, and he was also cheap. Columbia Pictures got him at $1,000 a week—a pittance—and Sinatra, in turn, got a career resurgence, and a Best Supporting Actor Oscar.

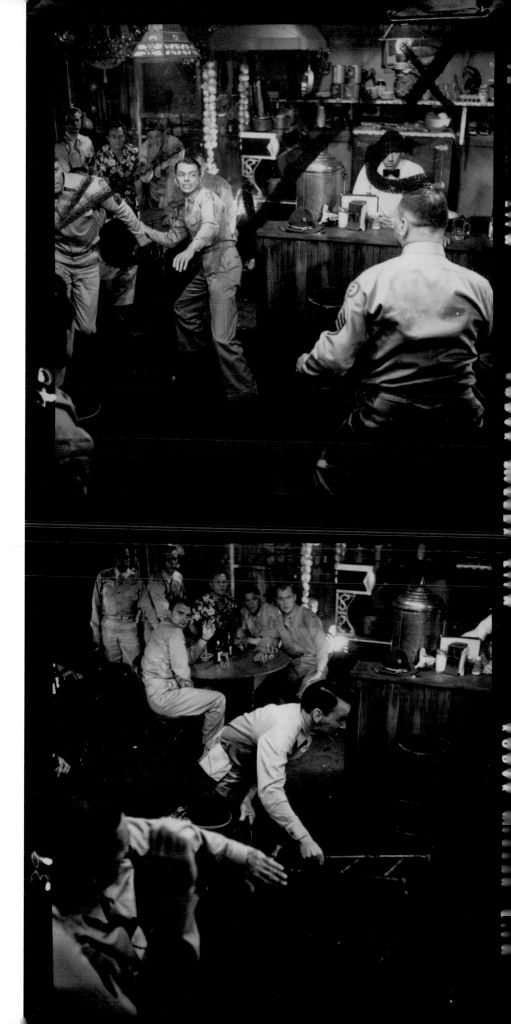

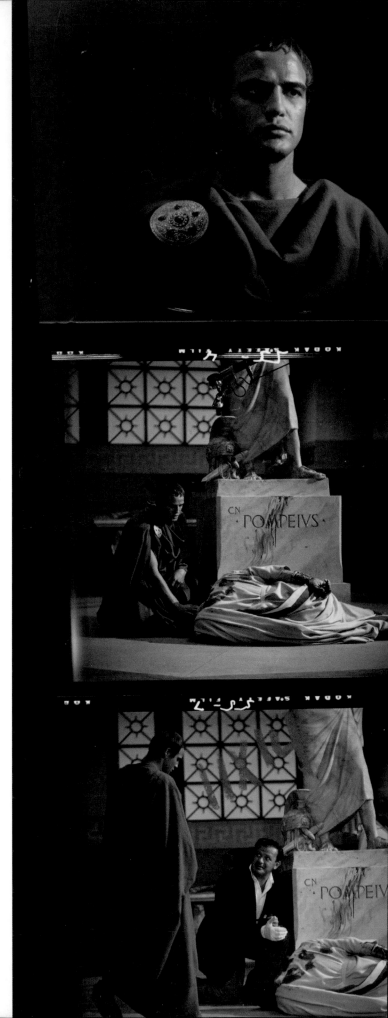

JULIUS CAESAR
1953

Director: Joseph L. Mankiewicz
Photographer: John Swope

—

His indelible performance in *A Streetcar Named Desire* (1951)
cemented Marlon Brando as Hollywood's icon of a new acting
style, influenced by the Stanislavsky method, and mocked by
some (including comedians Milton Berle and Jerry Lewis) as
worthless mumbling. This reputation made Brando an unlikely
choice for a lead role in a new filmed Shakespeare adaptation,
but Mankiewicz and producer John Houseman were convinced
Brando was an inspired choice for the part of Mark Antony
in *Julius Caesar*, and Brando himself was determined to show
his critics there was more to him than just "a blue-jeaned
slobbermouth."[10] In order to develop the voice of the character,
said Mankiewicz, "Marlon worked his ass off, and it's a very
talented ass."[11] In these images, documenting the shooting of
the "dogs of war" speech, Brando embodies what his director
referred to as "a Roman ideal."[12] Brando was nominated for an
Oscar for the role, but he apparently didn't count it amongst
his proudest achievements. In the single paragraph he devoted
to *Julius Caesar* in his autobiography, Brando dismissed his
fourth film performance as the folly of youth: "for me to walk
onto a movie set and play Mark Antony without more experience
was asinine."[13]

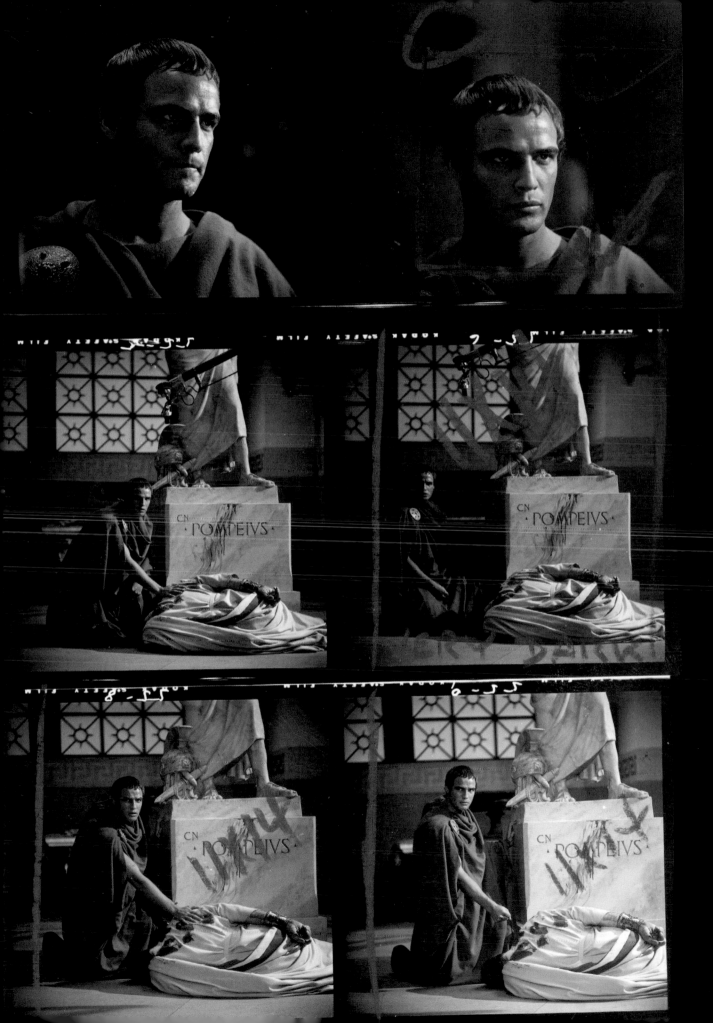

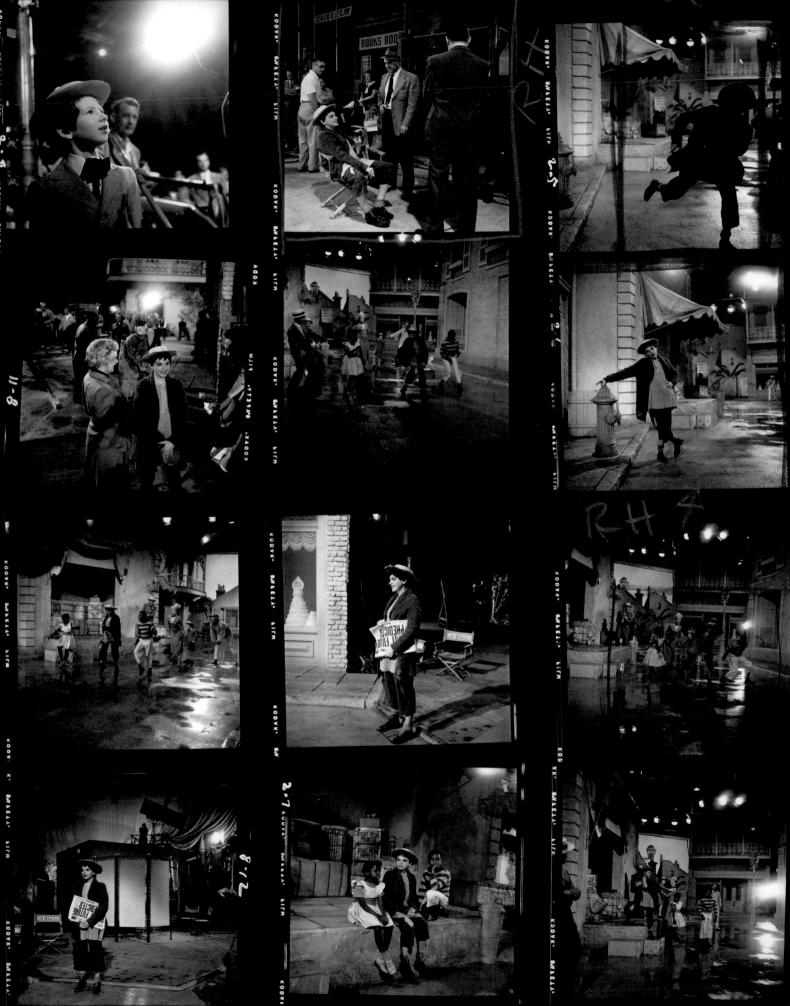

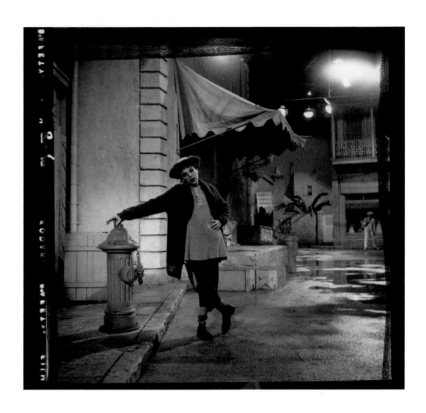

A STAR IS BORN
1954

Director: George Cukor
Photographer: Bob Willoughby

The musical remake of the 1937 Hollywood fall-and-rise story was the passion project of Judy Garland, conceived as a comeback vehicle for the singer-actress, who had been dropped from her MGM contract in 1950. An epic Technicolor production initially running over three hours, Cukor's film cost $5 million to make—a huge sum at that time. Warner Brothers executives, convinced by exhibitors that the running time would impede turning a profit, pulled the film from theaters after its premiere, cut nearly 30 minutes, and then re-released it—all without consulting with Cukor, who was in India working on another film. Two full musical numbers were stripped, including the scene photographed here, "Lose That Long Face," a four-and-a-half minute, high-spirited song-and-dance sequence that took eight weeks to film. The "Long Face" footage was considered lost for nearly 30 years, and was unseen by even the most ardent fans of the film until Los Angeles County Museum of Art curator Ronald Haver led a major recovery and restoration project, ultimately piecing together an approximation of Cukor's director's cut using alternate takes and still photographs. At the premiere of the restoration in 1983, according to Haver, as soon as Garland appeared on screen in the "ragamuffin" costume seen here, "the audience went crazy."[14] Garland's two daughters, Liza Minnelli and Lorna Luft, were there that night, and after the movie, Haver wrote, they "had to be taken into a dressing room, where they cried and held on to each other for the better part of 20 minutes: the emotions generated by the film and by seeing their mother in her favorite movie, and the intensity of the audience involvement, were more than they could handle."[15]

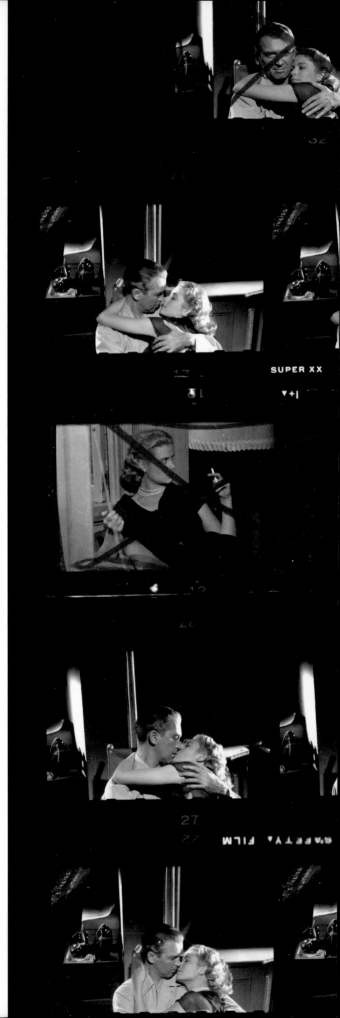

REAR WINDOW
1954

Director: Alfred Hitchcock
Photographer: Unknown

———

Perhaps Alfred Hitchock's most self-reflexive film—and certainly only second to *Vertigo* in the amount of analysis and interpretation it has inspired—*Rear Window* is the ultimate example of the Master of Suspense using a "MacGuffin" mystery plot as wrapping for a complex and deeply psychological examination of men and women, sexuality and obsession. This contact sheet shows an apparent effort to capture the film's blend of sensuality and suspense via a perfect kiss photo. The kiss photo is a genre of publicity image that dates back to the silent era, when it became apparent that the most effective romantic images depicted not simple domestic bliss, but a complicated combination of sexual promise and tension, submission and struggle. The image of James Stewart and Grace Kelly in an embrace that was ultimately used for some *Rear Window* posters shows the couple stopped just short of actually kissing, each of them frozen on the terrifying precipice of total abandon to the other. In this contact sheet, someone has crossed out a frame in which the actors' lips actually touch—perhaps indicating that a successful embrace would fail to sell the movie.

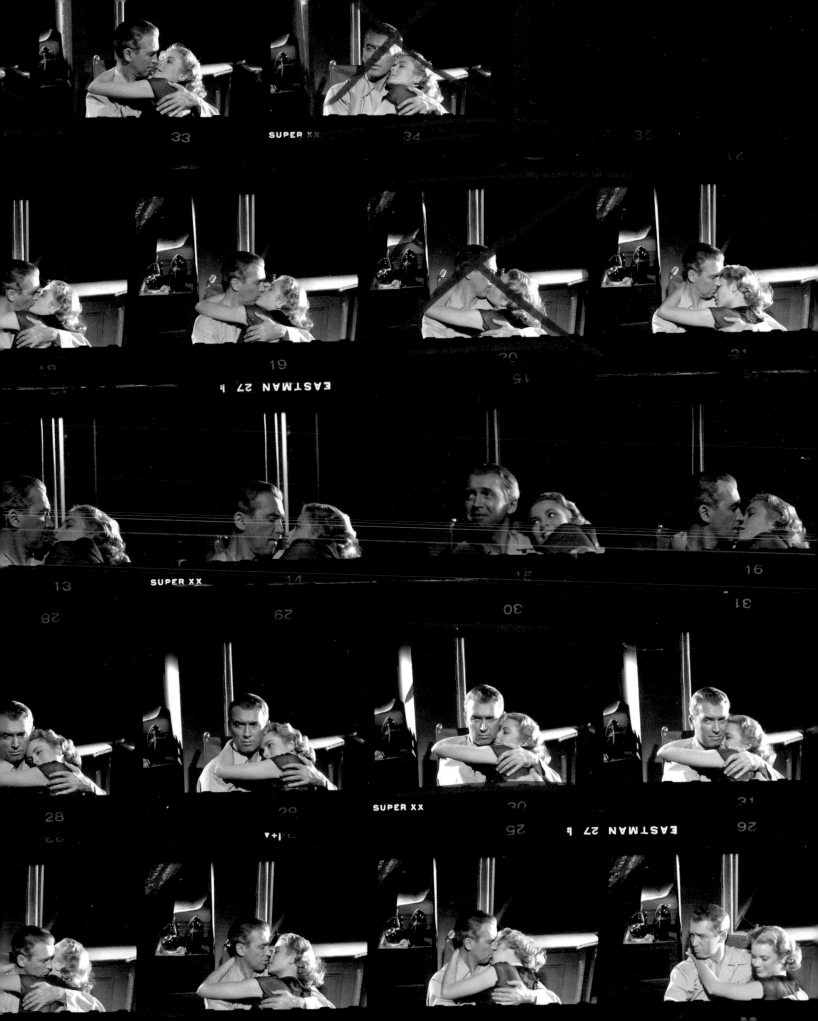

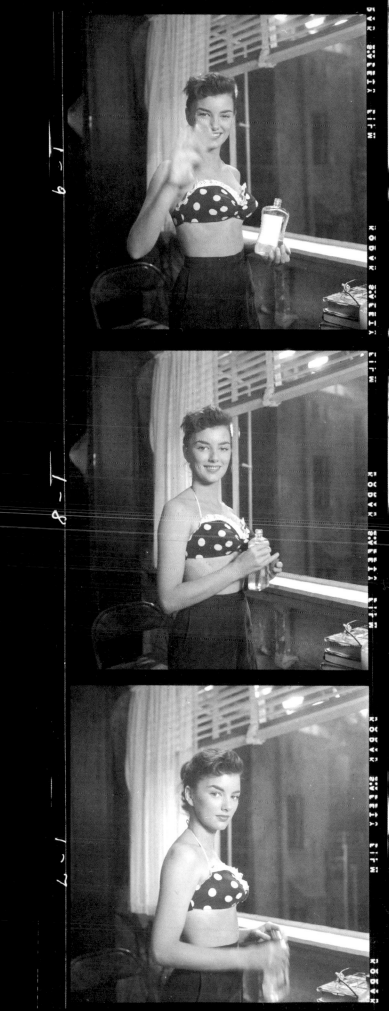

With her cool veneer and impeccable, well, grace, Grace Kelly has been called "the Hitchcock Uber-Blonde."[16] At right: Sue Casey, seen so fleetingly as "The Sunbather" in *Rear Window* that her role was uncredited, has more close-ups on this page than in the film.

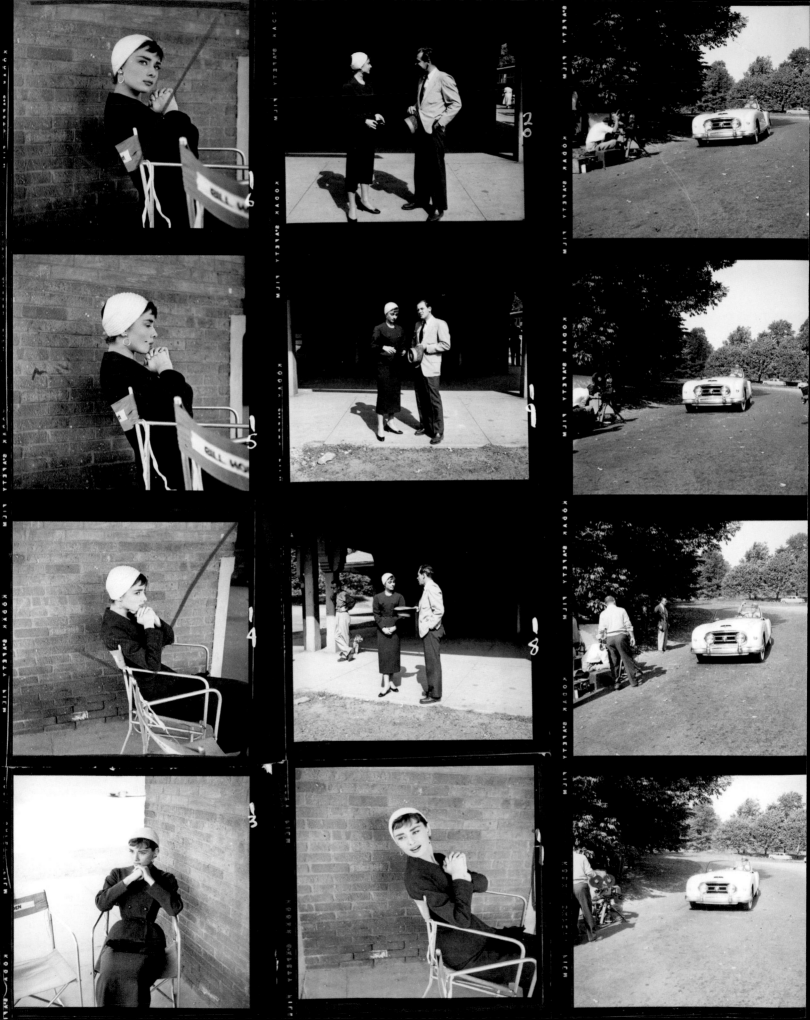

SABRINA
1954

Director: Billy Wilder
Photographer: Unknown

———

Sabrina marked the beginning of Audrey Hepburn's long run as muse and model for French fashion designer Hubert de Givenchy. Hepburn had just emerged as an apparently girlish star in *Roman Holiday*; writer and director Billy Wilder knew that the key to *Sabrina* would be selling Hepburn's character's evolution from innocent working-class suburban waif to cosmopolitan object of desire through costuming. Wilder convinced Paramount to cover the costs of a trip to Paris for the actress, where she was given a list of garments to buy from Givenchy in order to make manifest her character's transformation. When Hepburn arrived at Givenchy's studio, the designer was expecting a different Miss Hepburn—Katharine—but he allowed the younger actress to paw through his closets full of past collections and take what she liked. The suit and little white turban cap Hepburn wears on this page were among the garments the actress hand-picked.

Here and on the next page, Hepburn is photographed close to co-star William Holden, with whom the actress was carrying on a romance during production (by the time the film was released, Hepburn would have ended the affair and married Mel Ferrer). Unsurprisingly, Humphrey Bogart—the third point in *Sabrina*'s on-screen love triangle—is not seen in the off-camera candids. Already resentful of having been Wilder's second choice (after Cary Grant passed) for a role he didn't think he was right for, Bogart's antagonistic attitude increased when he saw to what extent the production was being built around the ingénue rather than him, the established mega-star. Fueled by his afternoon whiskey, Bogart would openly mimic and needle Hepburn on set every time she flubbed a take.

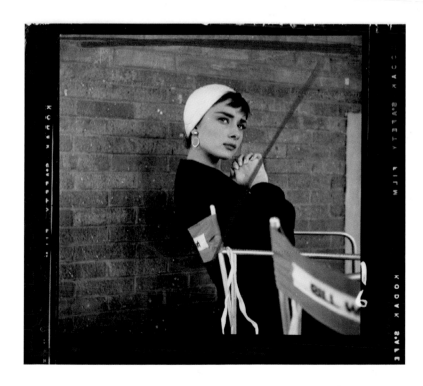

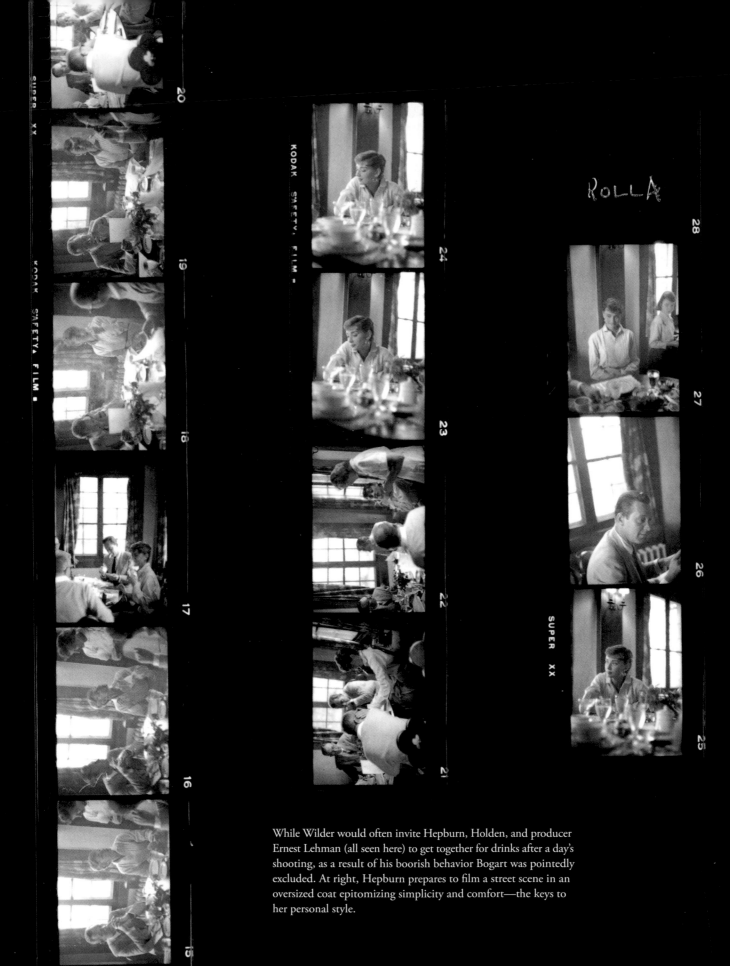

While Wilder would often invite Hepburn, Holden, and producer Ernest Lehman (all seen here) to get together for drinks after a day's shooting, as a result of his boorish behavior Bogart was pointedly excluded. At right, Hepburn prepares to film a street scene in an oversized coat epitomizing simplicity and comfort—the keys to her personal style.

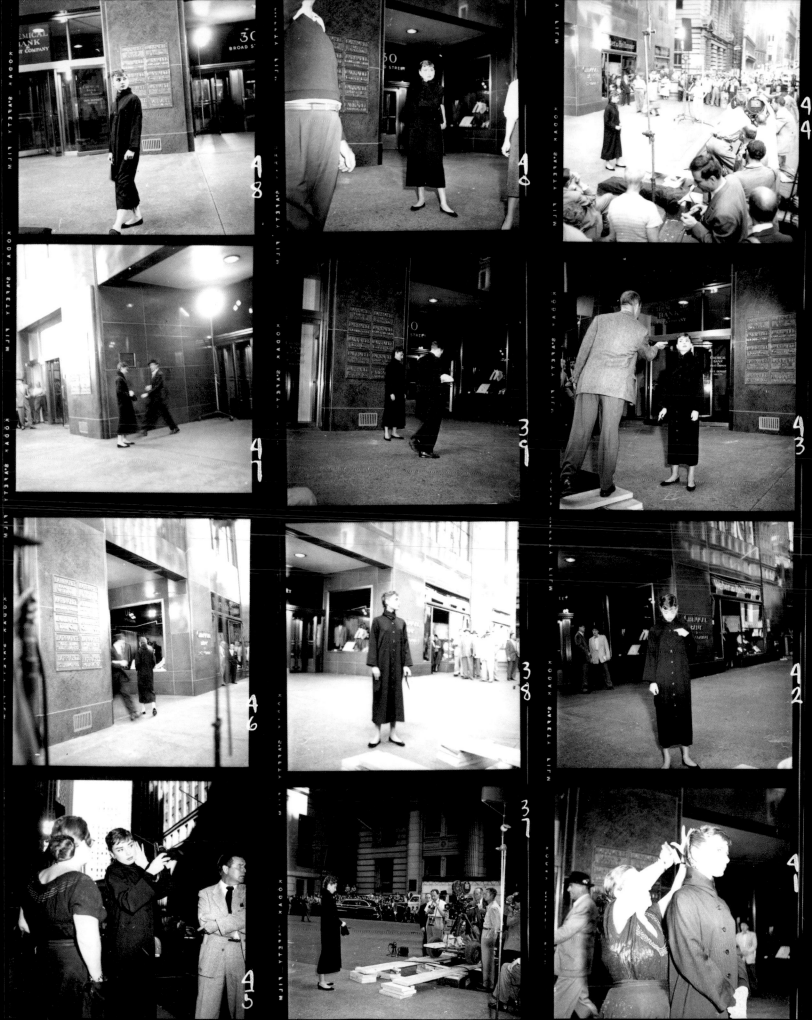

WHITE CHRISTMAS
1954

Director: Michael Curtiz
Photographer: Robert Vose

This Bing Crosby/Danny Kaye musical spectacular about two World War II veterans who mount a stage show at the Vermont Inn owned by their former commanding officer, is at times surprisingly frank regarding soldier morale, both on the battlefield and back on the home front. But that's not why *White Christmas*, built around songs by Irving Berlin, became the most successful film of 1954 by a landslide, and the biggest hit of *Casablanca* director Curtiz's entire career. Crosby and Kaye's star power went a long way, as did numbers like the medley pictured here, which combined old-fashioned pleasures with more modern wit and choreography (some of it done by Bob Fosse). That's not to say that *White Christmas* was ahead of its time, exactly. In these shots Kaye and Crosby flank co-star Vera-Ellen, as the trio performs Berlin's "Mandy"—a song written in 1919. In the two decades following *White Christmas*, the movie musical genre would fall out of fashion, in part because of its reliance on music of the past, and its general failure to respond to and incorporate popular music of the present day.

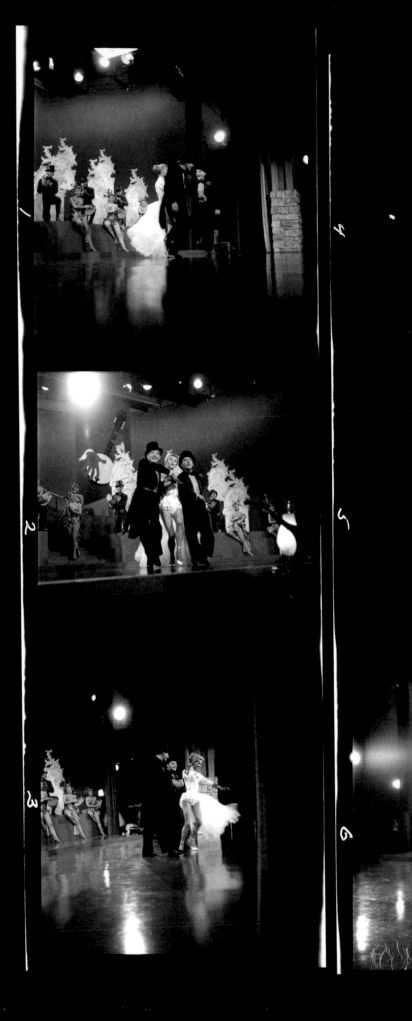

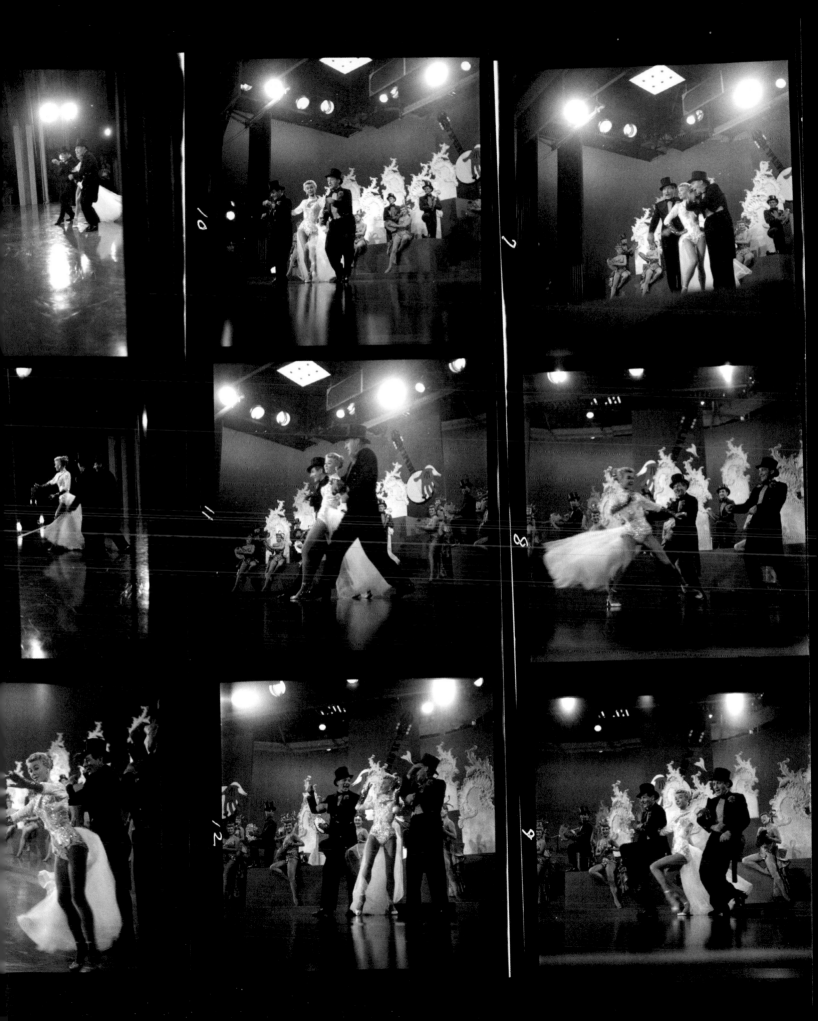

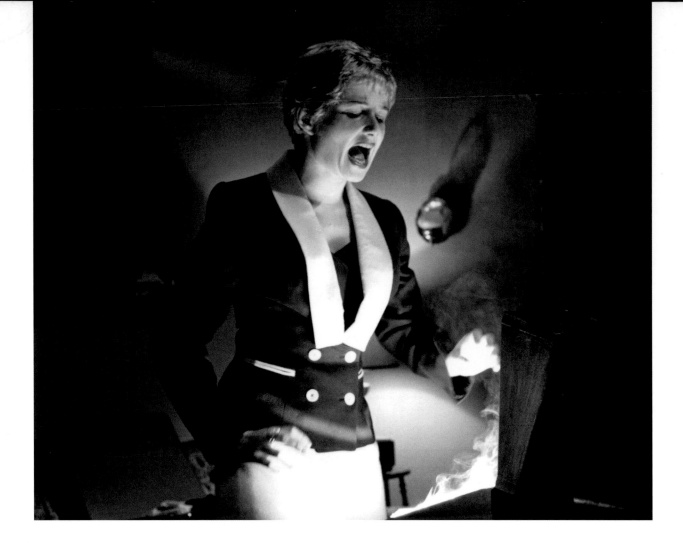

KISS ME DEADLY
1955

Director: Robert Aldrich
Photographer: Unknown

——

A low-budget B-picture shot in just 22 days, Robert Aldrich's Mickey Spillane adaptation-turned-political parable couldn't afford big stars. Actresses Cloris Leachman and Maxine Cooper were making their movie debuts; for Gaby Rodgers, who played the duplicitous blonde victim-turned-villain, it was the second and last feature film of a brief career. The real star of *Kiss Me Deadly* is the mysterious box, which Rodgers's Pandora-like moll defiantly opens, unwittingly unleashing a force of destruction that could not be re-contained. The suitcase full of a never-seen glowing substance, which ultimately results in the film-ending atomic explosion, was an invention for the film. "In Spillane's book it was jewels, but what the hell are you going to do with another jewel heist?" Aldrich remembered. "It seemed to us that the only way to inject any political significance—and that's already a heavy word—any uniqueness, was to say what if the secret were the atomic weapon? Once we made that decision everything fell into place."[17] It's a decision, and an image, that's been mimicked repeatedly, with the most notable homage being the glowing briefcase passed around in Quentin Tarantino's *Pulp Fiction*.

SUMMERTIME
1955

Director: David Lean
Photographer: Unknown

———

Katharine Hepburn did not want to go into the water. Shooting *Summertime*—in which Hepburn played a lonely, aging American tourist who has an affair with a married man while on an Italian vacation—on location in Venice, the 47-year-old movie star protested when director Lean insisted that a scene in which Hepburn's character falls into the canal could only be shot with the star doing the stunt herself. Hepburn was hardly being a prima donna. "Nobody in his right mind would risk coming into contact with the water in Venice's canals, a heady blend of garbage, ordure, mud, and putrefactions—let alone plunging into it fully dressed several times," wrote Michael Korda, nephew of *Summertime* producer Alexander Korda. "The health authorities of Venice were anxious to avoid the scandal that would be caused by Miss Hepburn's succumbing to typhoid, skin diseases, or dysentery, and suggested that the scene should be shot in a swimming pool."[18] But Lean insisted on realism. In these frames, Hepburn is dressed in the costume from the canal scene, and Lean seems to be talking his none-too-enthused actress through the set-up. Eventually she ceded to her director's wishes—falling in the water backwards, getting out and drying off, and then doing it again and again for multiple takes. Even with cleaning agents added to the water, Hepburn said, "It still tastes lousy."[19] Hepburn's performance in *Summertime* is often praised as one of her best, but she may have been right to resist the stunt: she contracted a staph infection in her eyes while shooting the scene, from which she suffered lingering effects for the rest of her life.

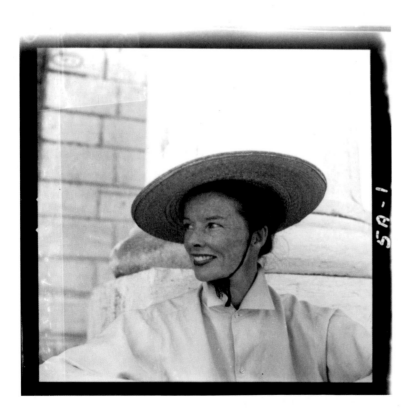

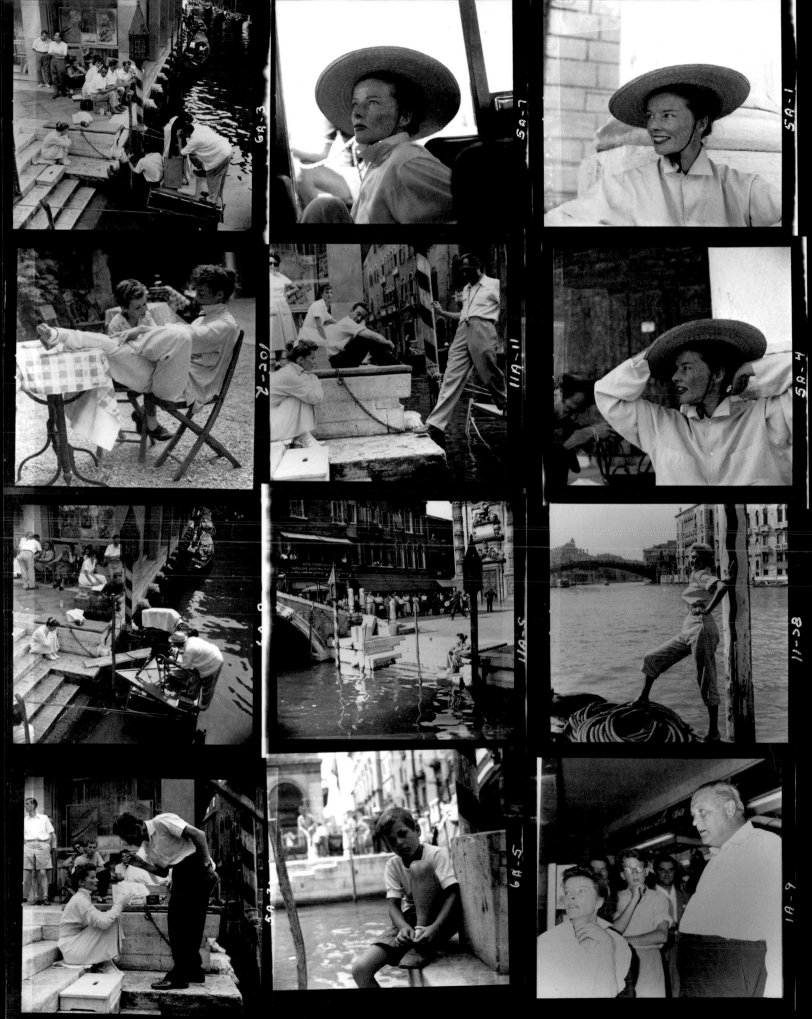

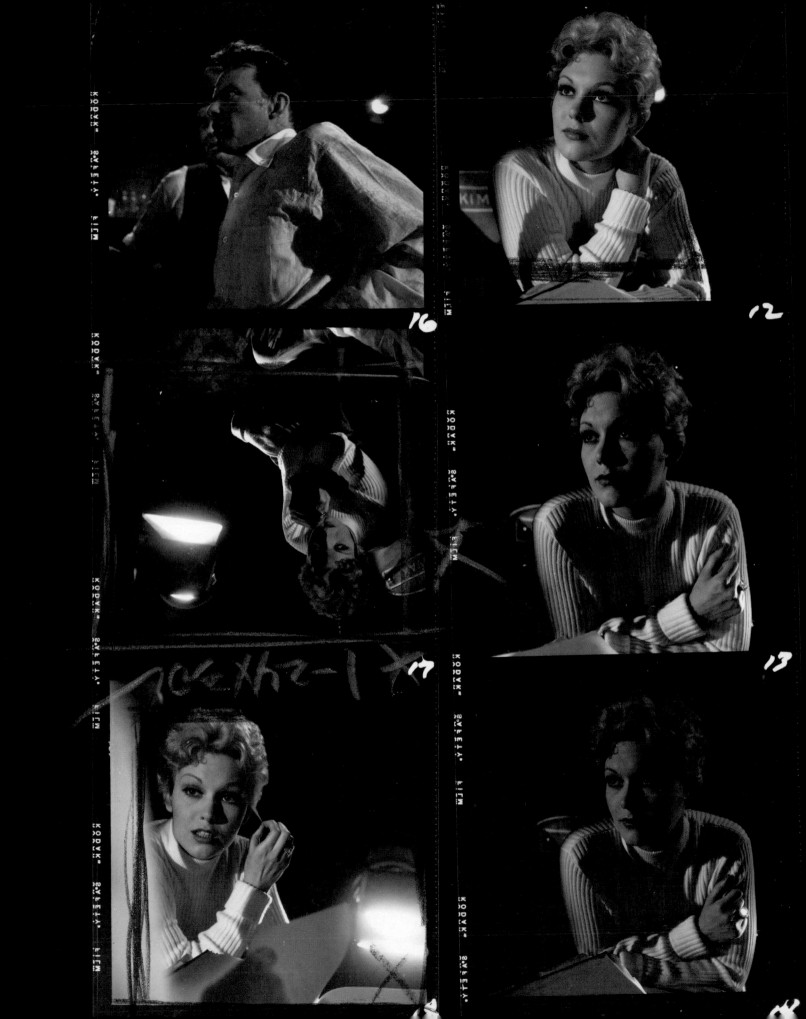

THE MAN WITH
THE GOLDEN ARM
1955

Director: Otto Preminger
Photographer: Bob Willoughby

—

Frank Sinatra jumped at the chance to play a heroin-addicted drummer in Otto Preminger's drama, and he took the part seriously, even spending time at a drug rehabilitation clinic as part of his preparation. His Oscar-nominated performance proved that his acclaimed turn in *From Here to Eternity* was no fluke. But if *The Man with the Golden Arm* was a validation of gravitas for Sinatra, for his co-star Kim Novak, it was a showcase for a breakout. The blonde bombshell Novak, then just 22, had been discovered barely a year earlier and signed to a contract by Columbia; by 1956, she was considered the studio's top box office draw. Despite her meteoric rise, Novak, who suffered from depression, had trouble sustaining stardom. She was admonished by Columbia chief Harry Cohn for her close friendship with Sammy Davis, Jr.; *Vertigo*, probably her most memorable film, flopped on its initial release; and she never earned the stamp of industry approval of an Oscar nomination. Novak retired from acting in the early 1990s, later noting, "I don't think I was ever cut out to have a Hollywood life."[20]

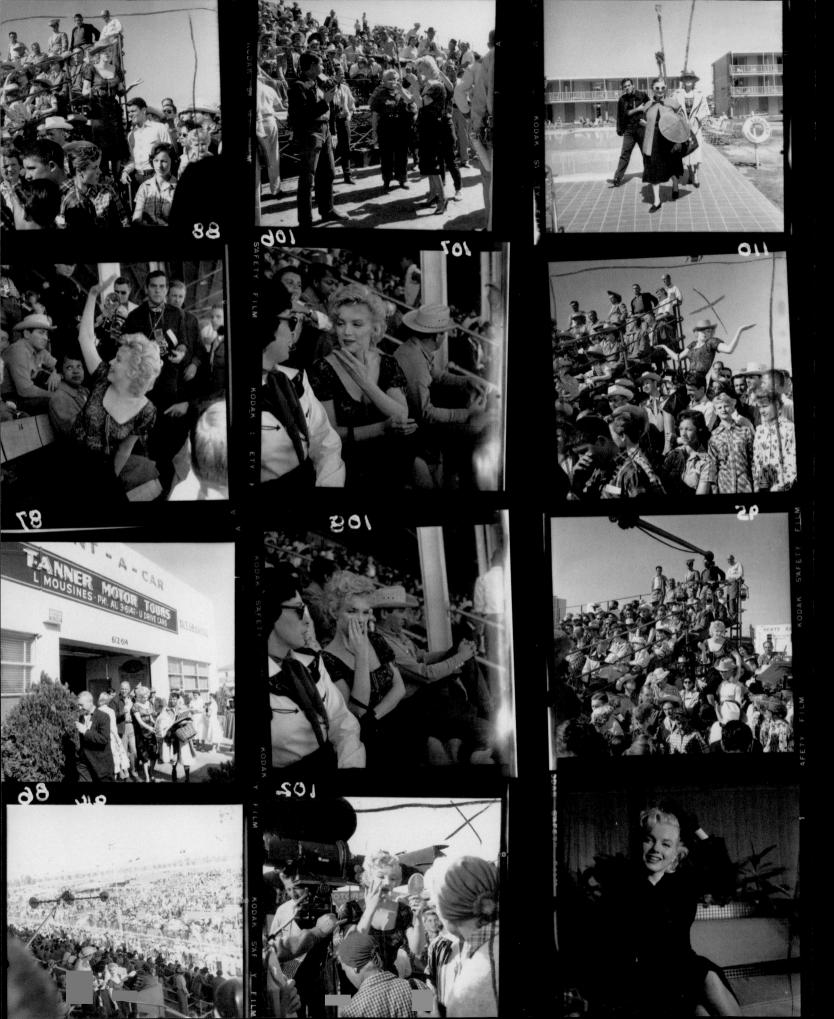

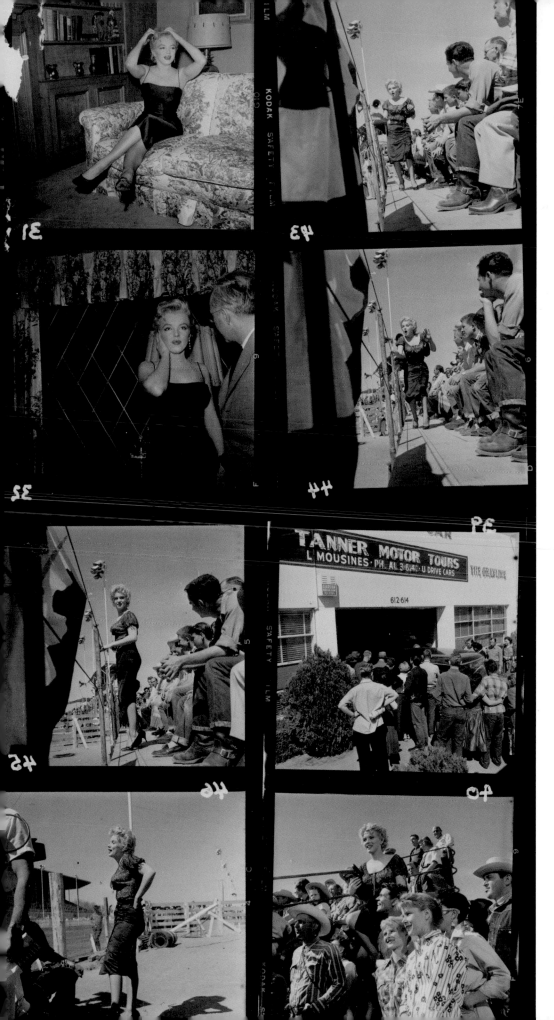

BUS STOP
1956

Director: Joshua Logan
Photographer: Unknown

Over the course of 1954, Marilyn Monroe married Joe DiMaggio, filmed three movies (including Billy Wilder's *The Seven Year Itch*), filed for divorce from DiMaggio, and fought so bitterly with 20th Century Fox over her image that she finally fled Hollywood for New York. At the time the top box office attraction in America, Monroe exiled herself from the studio system for a full year, which she spent studying with Lee Strasberg at the Actors Studio, and starting a production company with the photographer Milton Greene. *Bus Stop*, the actress's comeback film after her hiatus, was also, as the first film from Marilyn Monroe Productions, the first film for which the superstar was fairly paid. Though as ever an erratic presence on set—the Actors Studio had not taught Monroe anything about how to make it to set on time, and co-star Don Murphy has claimed the actress "couldn't put three sentences together"[21]—her new training and confidence stemming from her greater degree of control combined to produce what is often thought of as Marilyn's best performance. *Bus Stop* was the film in which, as the *New York Times*'s critic Bosley Crowther put it, Monroe "finally proved herself an actress."[22]

43

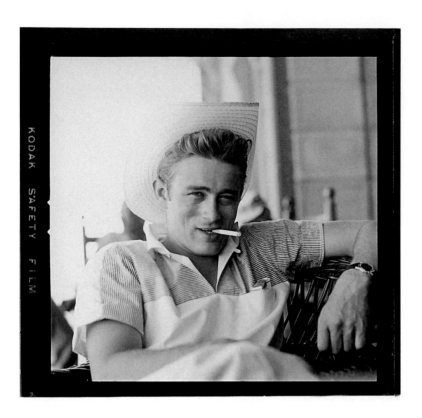

GIANT
1956

Director: George Stevens
Photographer: Sid Avery

—

Of the three film roles James Dean took before his tragic 1955 death in
a car accident at age 24, perhaps the most ambitious was that of Jett Rink,
the ranchhand-turned-oil millionaire in the epic family saga *Giant*. The part
required Dean to age several decades, a process he submitted to fully by dyeing
his hair silver and even shaving his forehead to mimic a receding hairline. While
on the film's Marfa, Texas set, Dean, dressed as Rink, filmed a Public Service
Announcement warning of the dangers of high-speed highway driving, which
concluded with the actor joking, "Take it easy driving—the life you save might
be mine." Months later, Dean's Porsche Spyder collided head-on at 85 MPH
with another speeding vehicle, killing the actor on impact. In death, Dean's face
became the ultimate symbol of youthful angst and alienation, but Avery's photos
show another, more playful side of a star enjoying what he couldn't have known
were his last days on a film set.

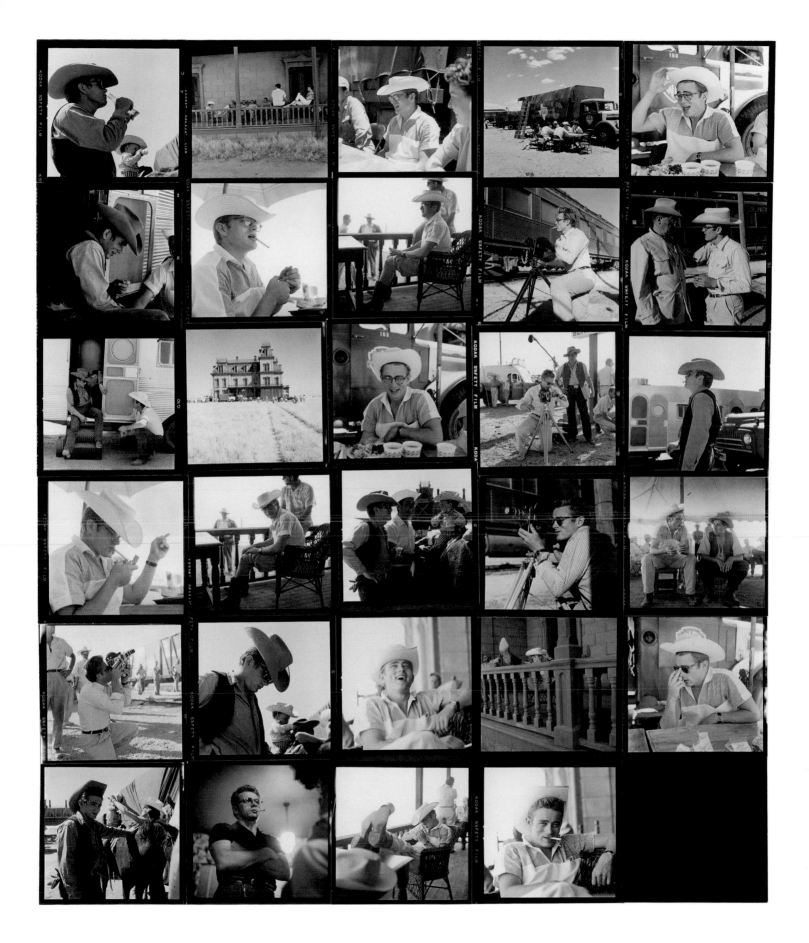

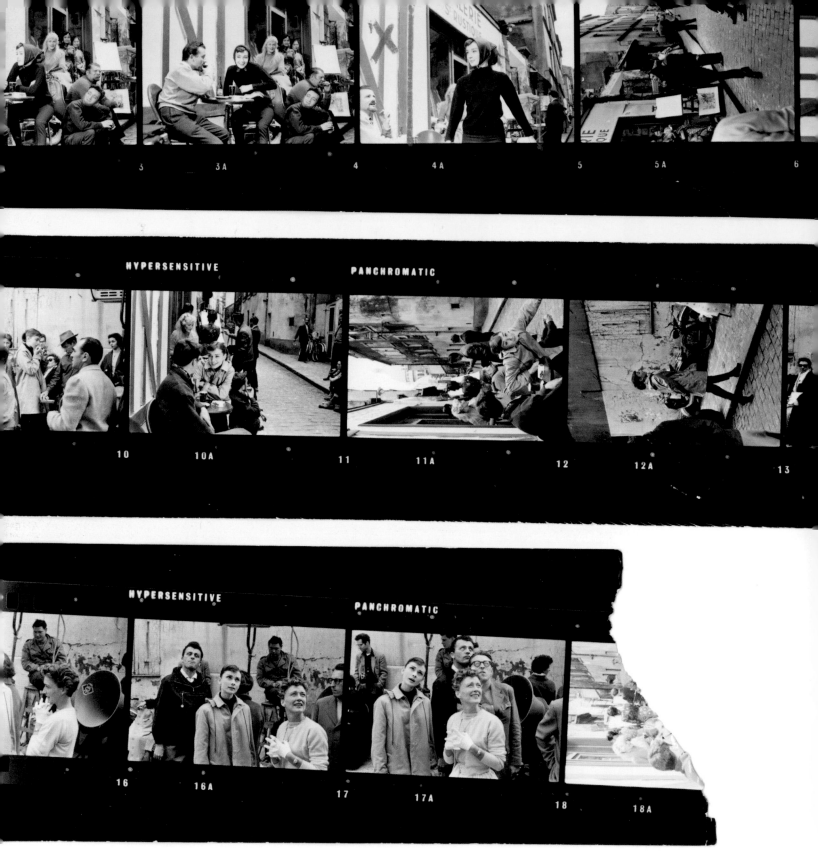

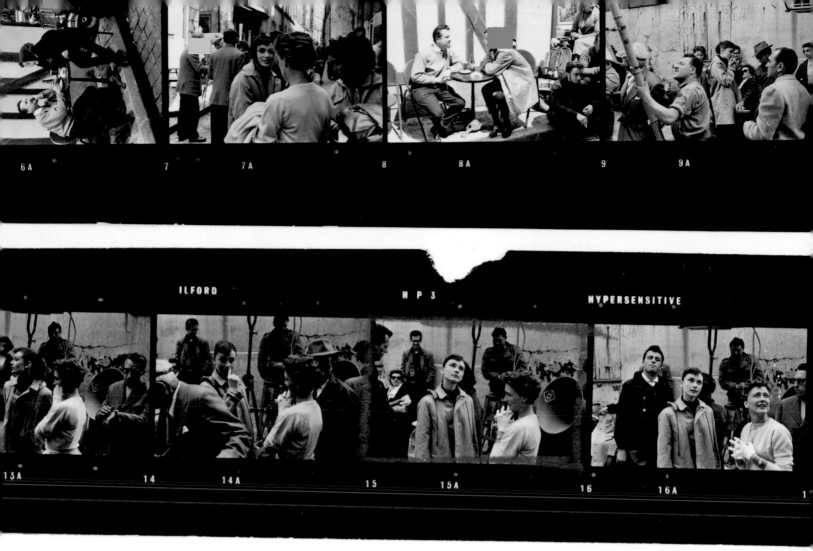

FUNNY FACE
1957

Director: Stanley Donen
Photographer: Bert Hardy

Starring Fred Astaire as an old-school fashion photographer and Audrey Hepburn as the bohemian new face he discovers and then molds into the epitome of mainstream glamour, today *Funny Face* is one of Hollywood's quintessential makeover romances. It was also one of the last great glossy studio musicals of the classical era; as the studio system fell in thrall to a generation even younger and far more rebellious than Hepburn's existentialist gamine, the genre that had been invented around stars like Astaire would submit to its own makeover to keep up with the times. These off-camera candids by British photographer Bert Hardy, who had made a name for himself as a photojournalist during World War II and had been an early adopter of the 35mm Leica camera, were taken for *Picture Post*, the British

answer to *LIFE*. Hardy first encountered Hepburn in the early 1950s, and found her to be "a bit different from the usual type of starlet." Shooting portraits in a park in London, Hardy lost his cigarette lighter, and Hepburn joined him in crawling through the grass to find it. "She was very nice about it," Hardy remembered. "The next time I met her, years later, she wasn't quite so nice. She was famous now, and starring with Fred Astaire in a film being made in Paris. This was the first time he was dancing with a partner other than Ginger Rogers. She would have nothing to do with me when I asked her for the first pictures of her dancing with Fred Astaire." Hardy added, "Even so, I was still grateful to Audrey Hepburn for helping me to find my cigarette lighter."[23]

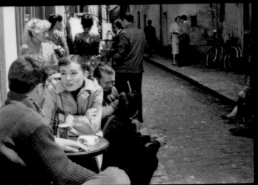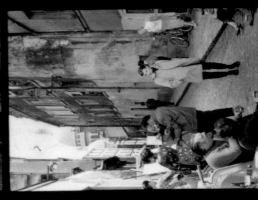

19A 20 20A 21 21A

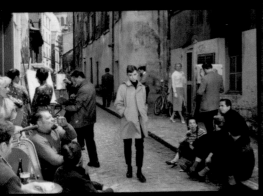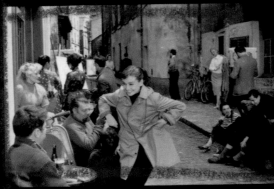

25A 26 26A 27 27A

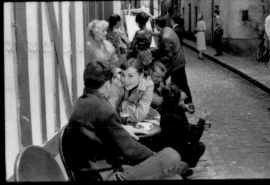

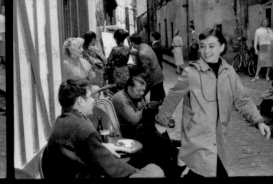

PERSENSITIVE PANCHROMATIC

22A 23 23A 24 24A

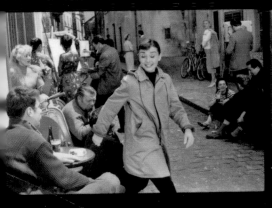

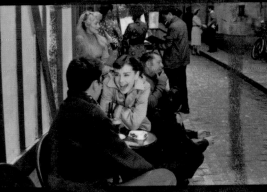

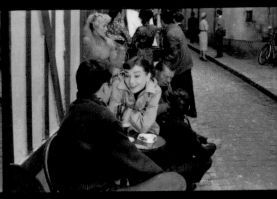

ERSENSITIVE PANCHROMATIC

28A 29 29A 30 30A

49

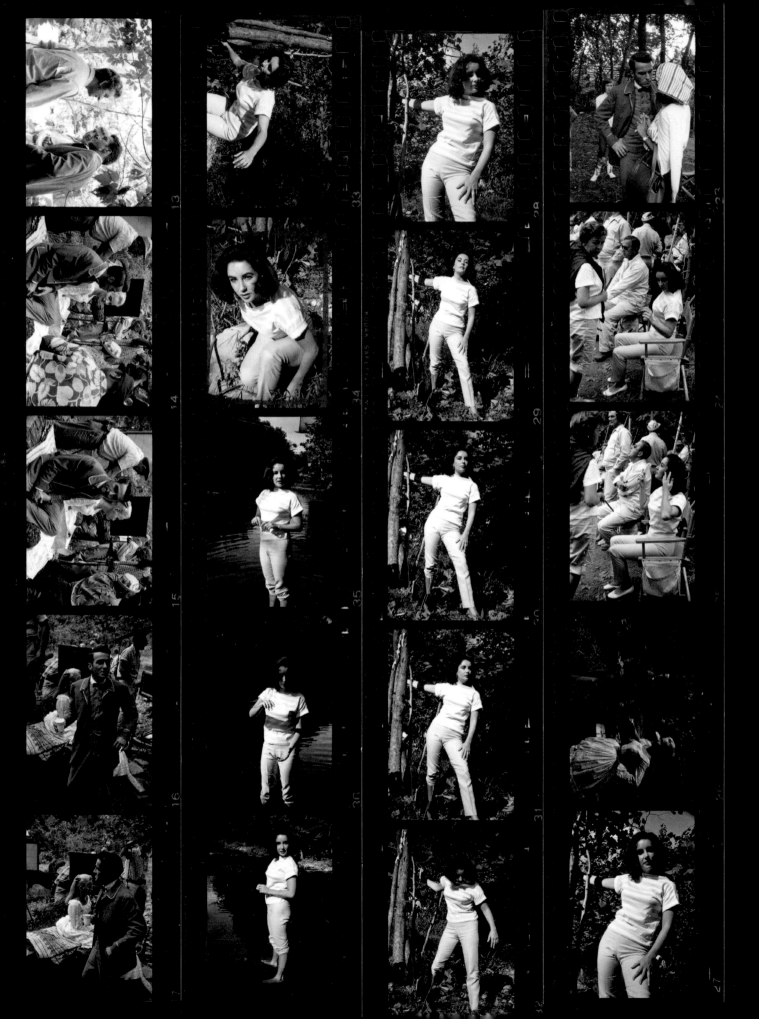

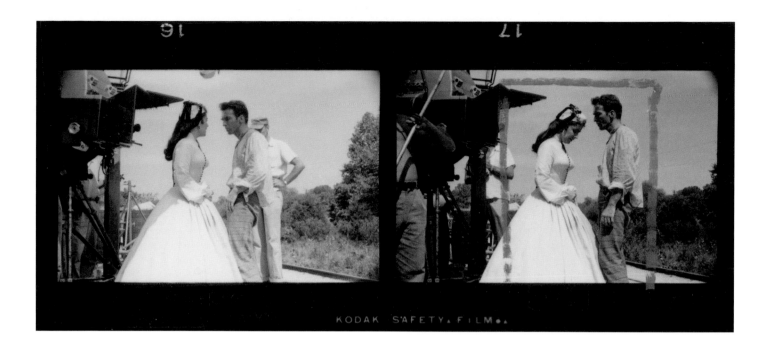

RAINTREE COUNTY
1957

Director: Edward Dmytryk
Photographer: Unknown

This misbegotten Civil War epic should have solely attracted attention as a reunion project for Montgomery Clift and Elizabeth Taylor, who had become best friends but hadn't had a chance to work together since *A Place in the Sun*. Instead, it's mostly remembered as the film Clift was making when a terrible accident scarred his face and sparked the decline of his life and career. On the night of May 12, 1956, while driving home from a party at Taylor's house, Clift crashed his car into a telephone pole. "His face was torn away—a bloody pulp,"[24] remembered Clift's friend, the actor Kevin McCarthy. McCarthy, who had been driving his own car ahead of Clift's, ran back to Taylor's house for help, and the actress rushed to Clift's side, sticking her fingers down her best friend's throat to retrieve the two front teeth which had been knocked out by the crash. After two months of recovery, including facial reconstruction surgery, Clift returned to the set of *Raintree*, noticeably worse for wear—over-reliant on painkillers, the left side of his face immobile. For the last half of the shoot, Dmytryk tried to shoot Clift carefully so as to minimize the evident change in his appearance, but there was only so much that could be done. Clift thought the film to be "a monumental bore," but he predicted that fans would turn out in droves to gawk at his post-accident visage. He was right—despite bad reviews, the film did well at the box office. Over the next decade, Clift's abuse of painkillers and alcohol intensified. He died in 1966, at the age of 45; his acting teacher Robert Lewis called Clift's decline "the longest suicide in Hollywood history."[25]

THE PRIDE AND THE PASSION
1957

Director: Stanely Kramer
Photographer: Ernst Haas

In these images of Sophia Loren on the set of one of her first Hollywood films, groundbreaking photojournalist Ernst Haas shows the then-emerging Italian star surrounded by men—which she certainly was when the cameras stopped rolling. Loren was conducting affairs during shooting with two co-workers, both of them considerably older and married to other women. One of Loren's two male co-stars, Cary Grant, was prepared to leave his wife to legitimize the affair. (The other high-billed actor on set, Frank Sinatra, only took his part in order to have an excuse to follow his own wife, Ava Gardner, to Spain in order to attempt to save their embattled marriage.) Perhaps it was Grant's attention that prompted producer Carlo Ponti, who had been Loren's mentor and secret lover for several years already, to finally move to end his own marriage in order to make Loren his wife. A year later, after Ponti and Loren were publicly living together in Hollywood, Grant and Loren were re-teamed on the movie *Houseboat*, and Grant pushed Loren for an off-screen reunion, too. "I was very affectionate with Cary," Loren admitted years later, "but I was 23 years old. I couldn't make up my mind to marry a giant from another country and leave Carlo."[26] Haas—who is best remembered for his pioneering innovations in color photography—captures a seemingly private, enigmatic moment in the image circled right, offering testimony to the element of mystery that was so key to Loren's allure. As Loren herself is often quoted saying, "Sex appeal is 50 percent what you've got and 50 percent what people think you've got."[27]

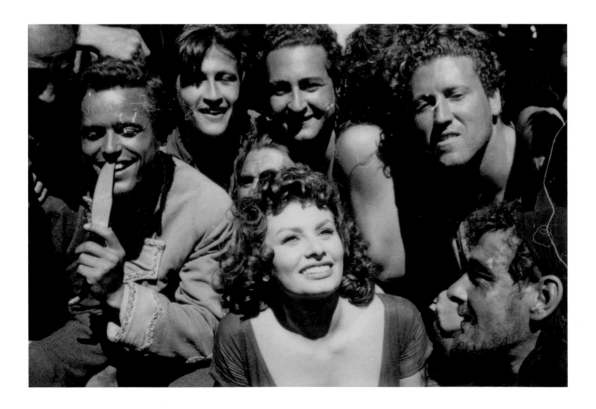

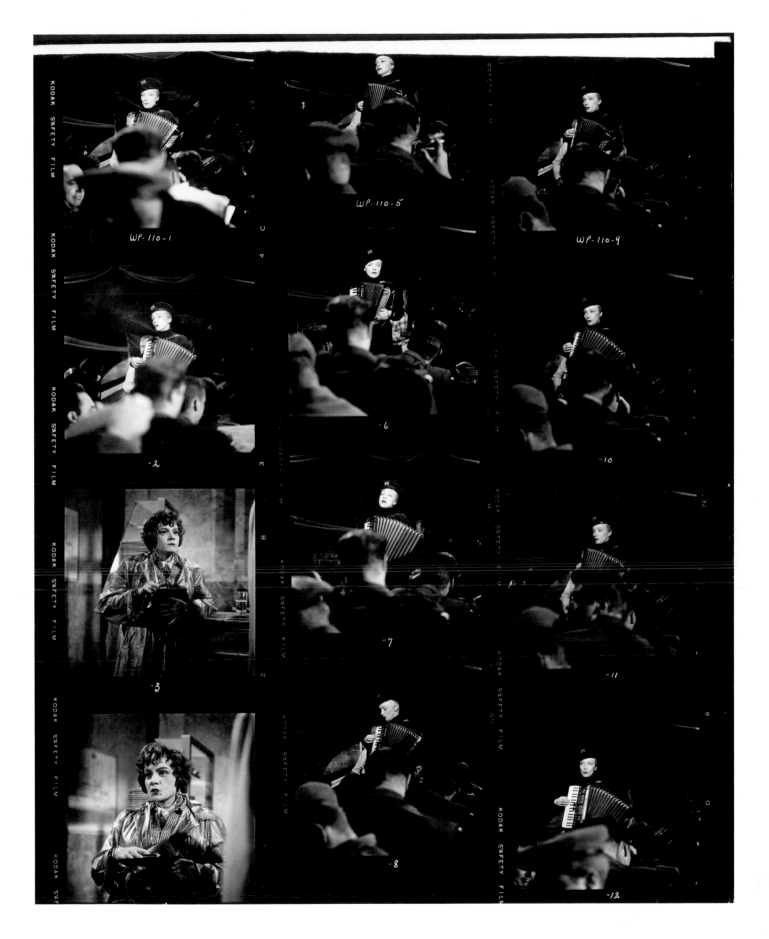

55

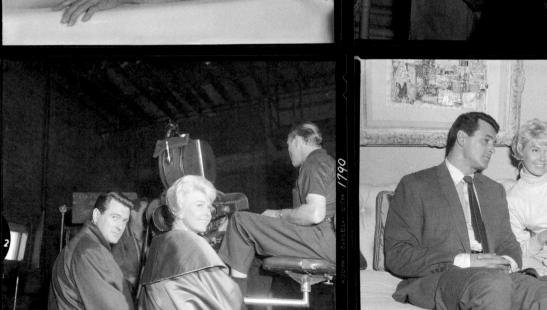

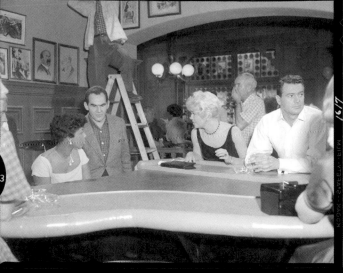

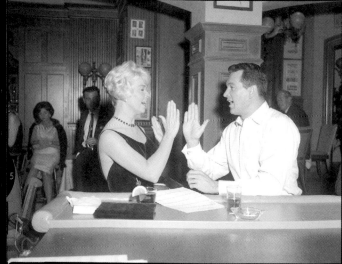

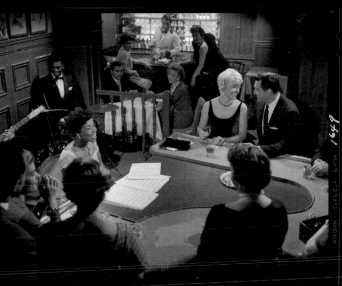

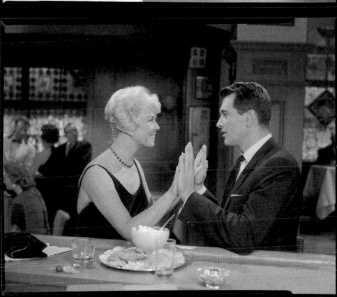

In the two decades since Rock Hudson—a gay man who masqueraded as a straight sex symbol for his entire career—died of AIDS, *Pillow Talk* has often been held up as emblematic of the facade Hudson was forced to create in order to maintain his stardom in mid-century Hollywood. In this daring-for-its-day sex farce, Hudson's character is an exaggeration of a heterosexual ideal who creates a more effeminate alter ego for himself as part of his seduction of Day's career girl, only to assert his masculine prowess by making coded gay jokes about his other self and, at the film's climax, physically lifting Day's character out of her own bed and carrying her down the street to his own apartment.

Pillow Talk was a big hit, one much needed by two stars whose careers were thought to be on the decline, and Day and Hudson would go on to re-team in two variations on the same themes, *Send Me No Flowers* and *Lover Come Back*. Hudson's all-American bachelor act was so convincing that his 1985 confirmation of his HIV infection had a huge impact, and not just on AIDS awareness. For many fans, it offered a first chance to contemplate the way all images produced by Hollywood were exactly that—produced, designed to conceal more truth than they revealed.

SOME LIKE IT HOT
1959

Director: Billy Wilder
Photographer: Unknown

——

Some Like It Hot would turn out to be the biggest commercial success of both Marilyn Monroe's and Billy Wilder's careers, but the shoot was a nightmare, largely due to Monroe's personal problems, her debilitating anxieties and diva-like demands. These stunning black-and-white images taken on the set speak to why, even as Wilder complained about the time-suck of her Actors Studio-sourced preparations ("...she should have gone to a train-engineer's school instead," the director grumbled, "to learn something about arriving on schedule..."[28]), he still felt that working with her was worth it, thanks to her unmatchably dynamic relationship to the camera. "Whatever she did, wherever she stood," Wilder marveled, "there was always that thing that comes through."[29] Ironically, Monroe hated being photographed in black and white; her contract with Fox stipulated she could only be filmed in color, a clause that she tried to enforce on this independent production. It was only when Wilder showed her tests proving that color film would distort the appearance of the drag makeup worn by her co-stars, Jack Lemmon and Tony Curtis, that Monroe finally conceded.

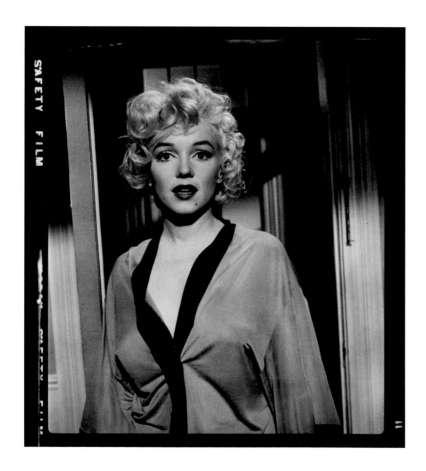

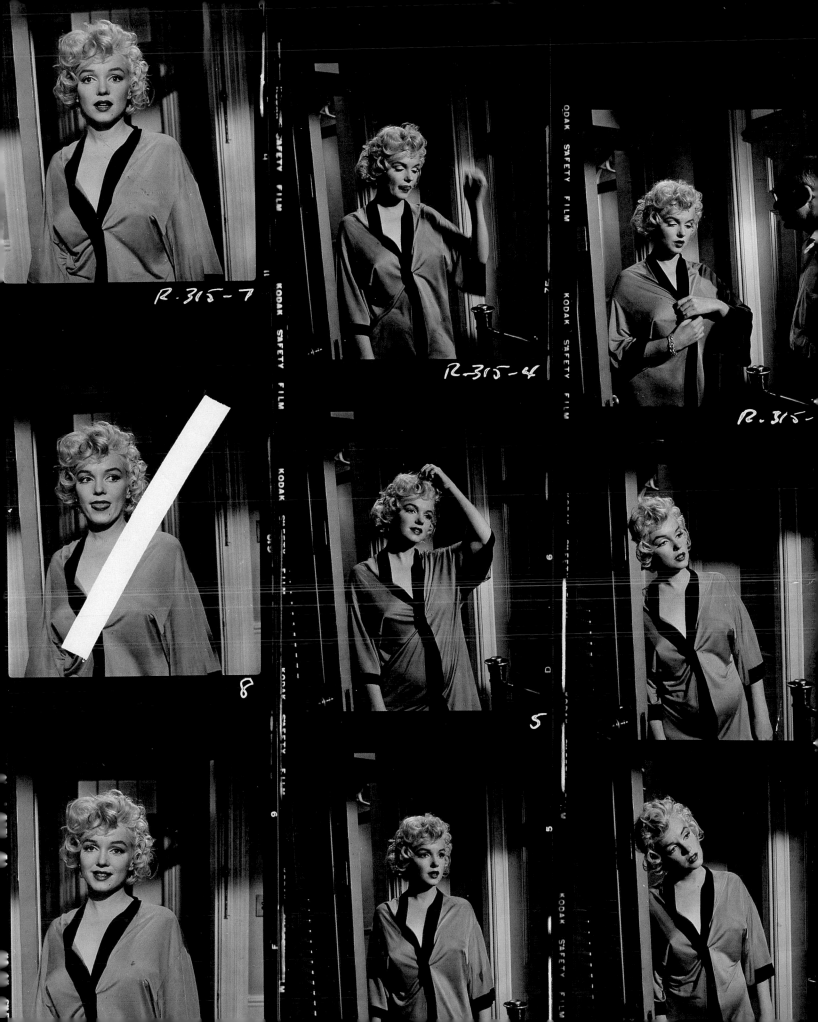

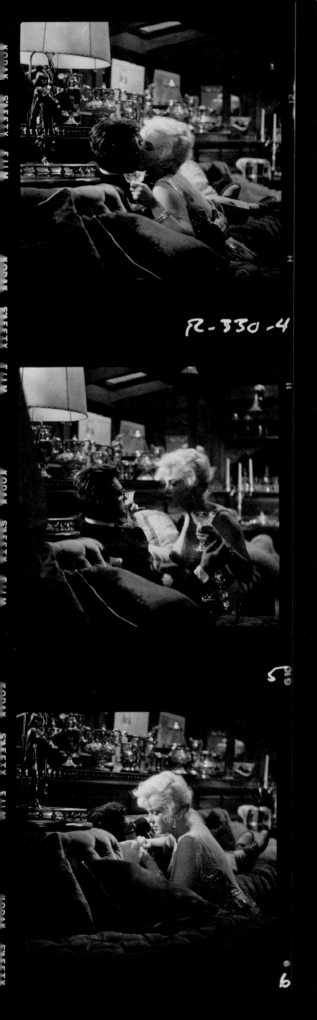

Tony Curtis famously quipped that kissing Marilyn Monroe was "like kissing Hitler." That was a joke, he claimed, but in 2008, Curtis elaborated, describing shooting the scene at left as being "awful": "She nearly choked me to death by deliberately sticking her tongue down my throat into my windpipe."[30] At right, Monroe laughs between takes on the beach in San Diego, California.

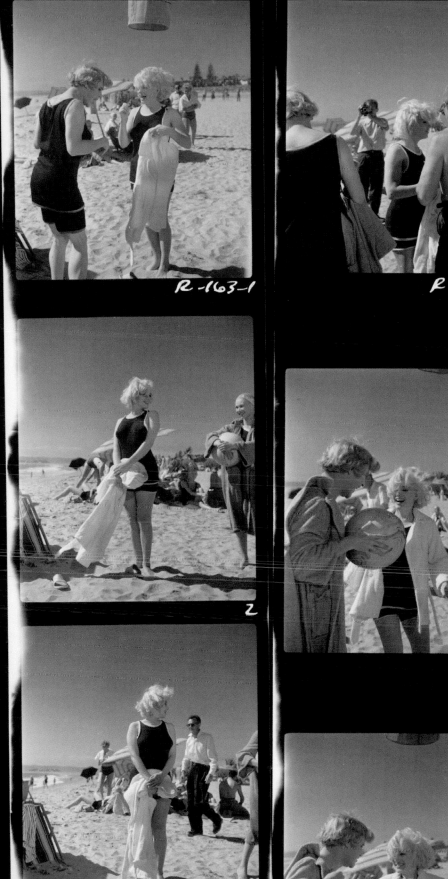

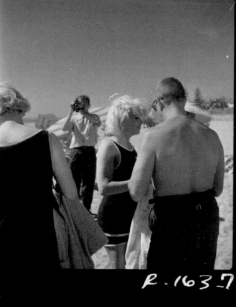

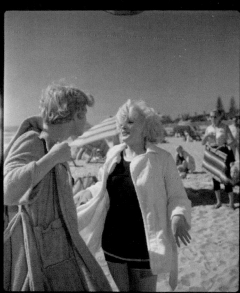

R-163-1

R-163-7

R-163-4

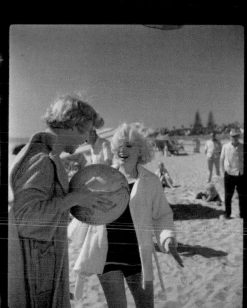

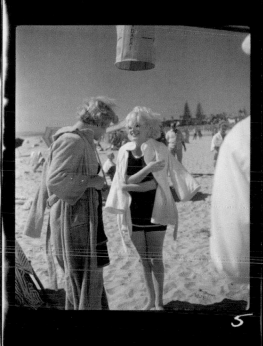

2

8

5

3

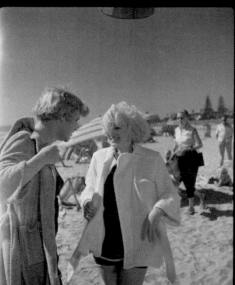

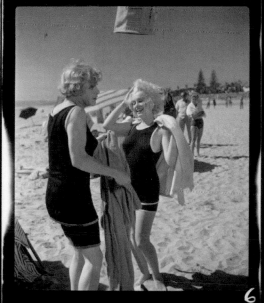

6

Despite his criticisms of her kissing style, Curtis has boasted in his memoirs to having had two affairs with Monroe: one in the early 1950s, and one during the making of this film. "When I was in bed with Marilyn, I was never sure, before, during, or after, where her mind was," Curtis wrote. "She was an actress. She could play a part."[31]

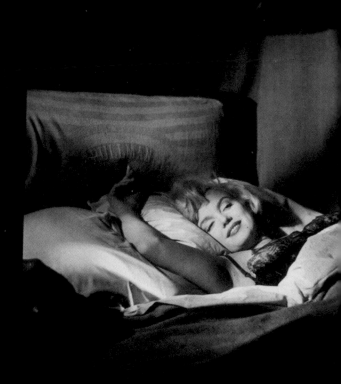

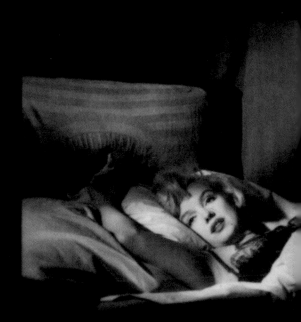

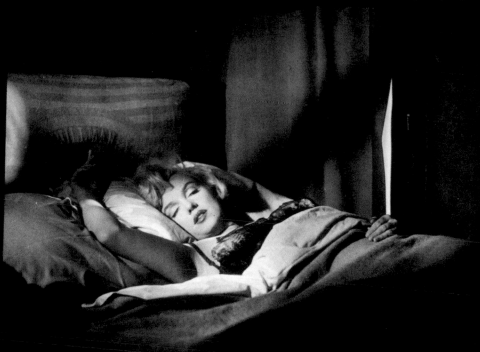

R-213-4

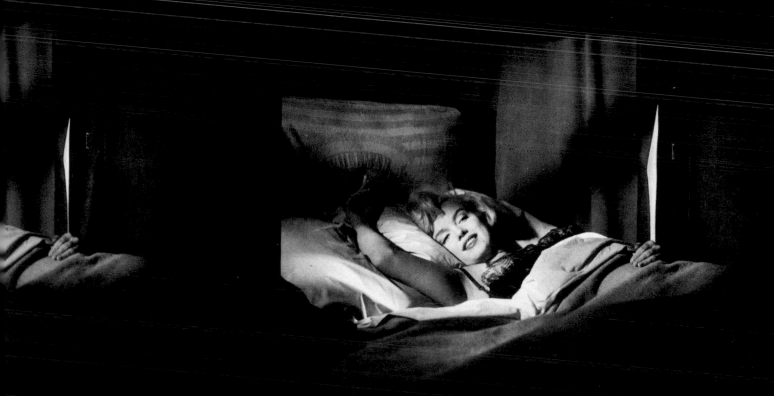

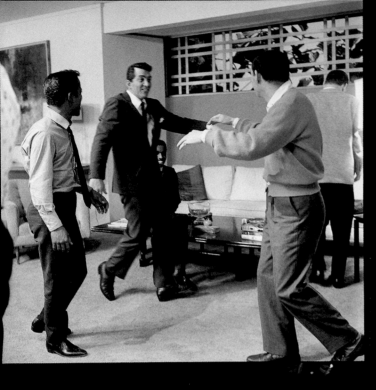
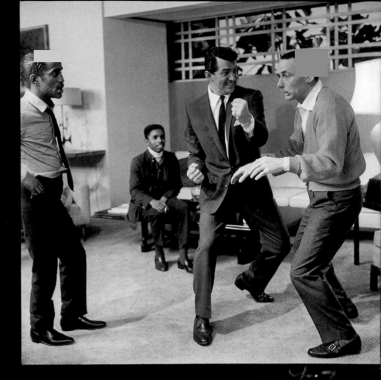
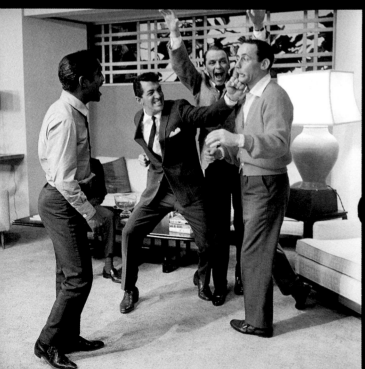
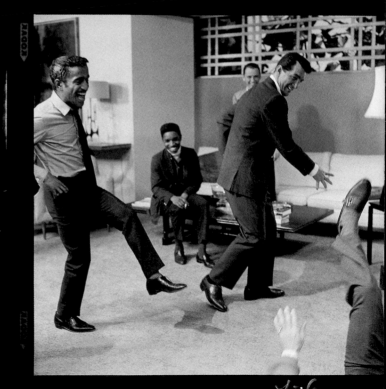

Director: Lewis Milestone
Photographer: Sid Avery

———

These images of the Rat Pack at play came out of an assignment: Sid Avery had to photograph Sammy Davis, Jr. for the *Saturday Evening Post*. Known for his uncanny ability to capture major stars with their guards down, Avery was not only one of the most important photographers of Hollywood's Golden Age, but he was also instrumental in promoting still photography on film and television sets as an art form worthy of preservation. In 1983, he co-founded the Hollywood Photographer's Archive, a non-profit organization that sought to save negatives, prints, and contacts documenting productions from the dustbin of history (and, in some cases, from the dumpsters of studios). Sid Avery died in 2002, but his son Ron Avery has continued his father's efforts, maintaining the archive and licensing images through the website, mptvimages.com. Four decades after this image was taken, Julia Roberts, who was starring in Steven Soderbergh's remake of *Ocean's 11*, bought a print from this shoot at Avery's New York gallery. Avery was then asked to direct a shoot of the cast of Soderbergh's remake, posed to replicate his famous cast photo from the original film.

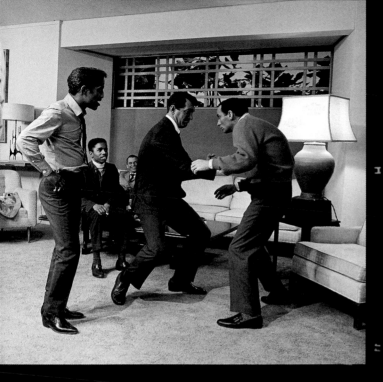

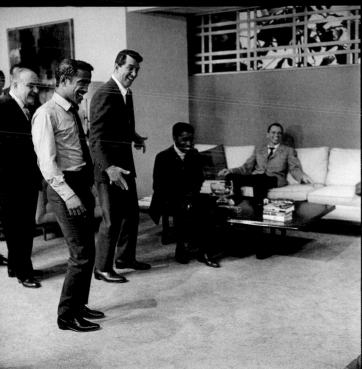

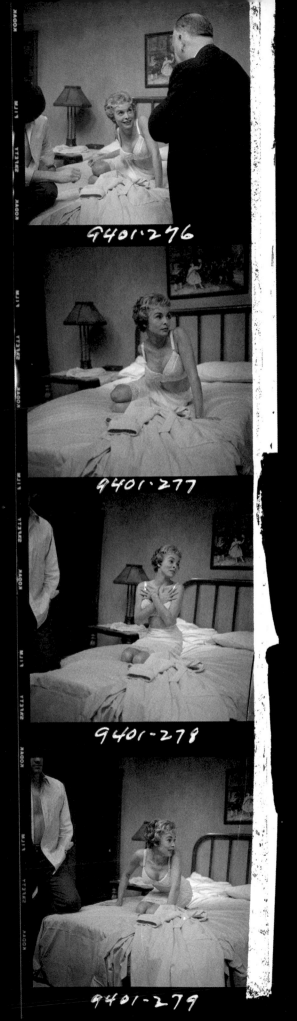

PSYCHO
1960

Director: Alfred Hitchcock
Photographer: William Creamer

———

With *Psycho*, Alfred Hitchcock challenged the Production Code censors in several ways, beginning with this first scene, in which Marion Crane (Janet Leigh) rolls around in bed with her lover Sam (John Gavin) in a motel on her lunch break. That Leigh was photographed in just a bra and half slip was racy for the time, but Hitchcock, seen above left closely directing his actors, would have pushed further if he could. "In truth, Janet Leigh should not have been wearing a brassiere," he said. "I can see nothing immoral about that scene and I get no special kick out of it. But the scene would have been more interesting if the girl's bare breasts had been rubbing against the man's chest."[32] Hoping to preserve the shock of his film's story by misleading audiences into thinking that ingénue Leigh's character would thus make it out of the picture alive, Hitchcock insisted that still photographers only be present on the set of *Psycho* on specific days, so that there was no chance of fan magazines publishing anything too narratively revealing. This scene was likely deemed safe for still photographers because of its potential to mislead audiences. If the average fan saw these pictures and assumed they were in for a romantic thriller along the lines of Hitchcock's previous hit, the glossy *North by Northwest*, they'd stand to be all the more horrified by *Psycho*'s twists and turns.

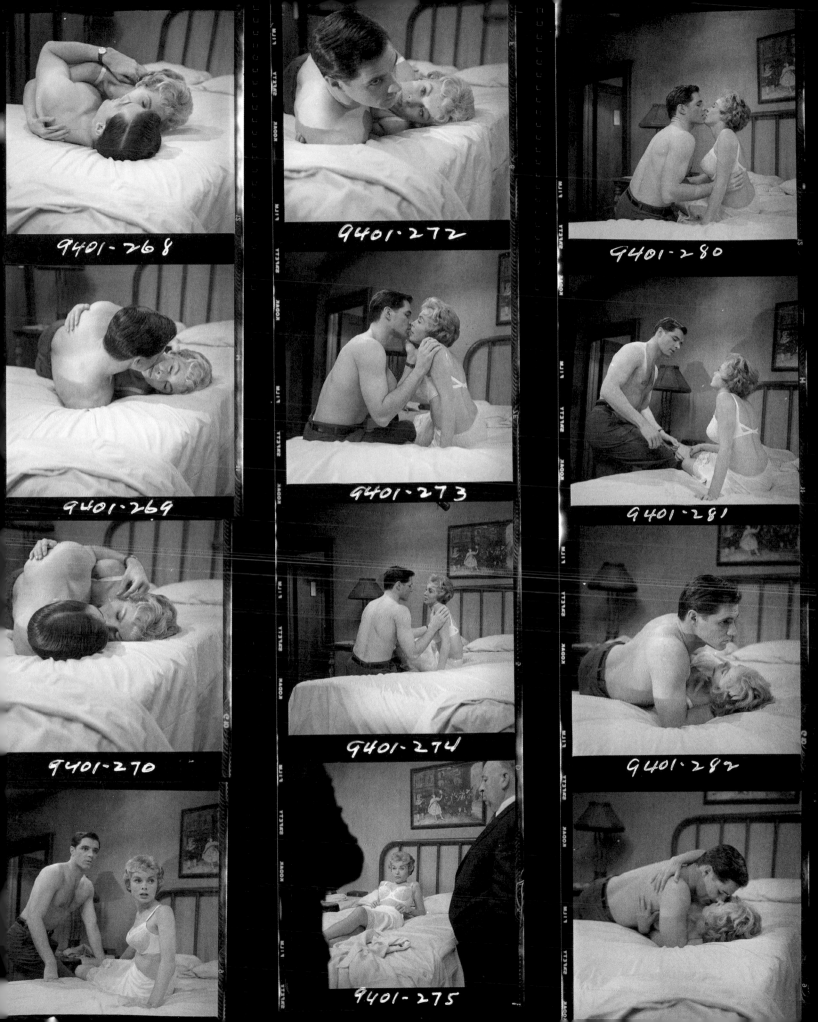

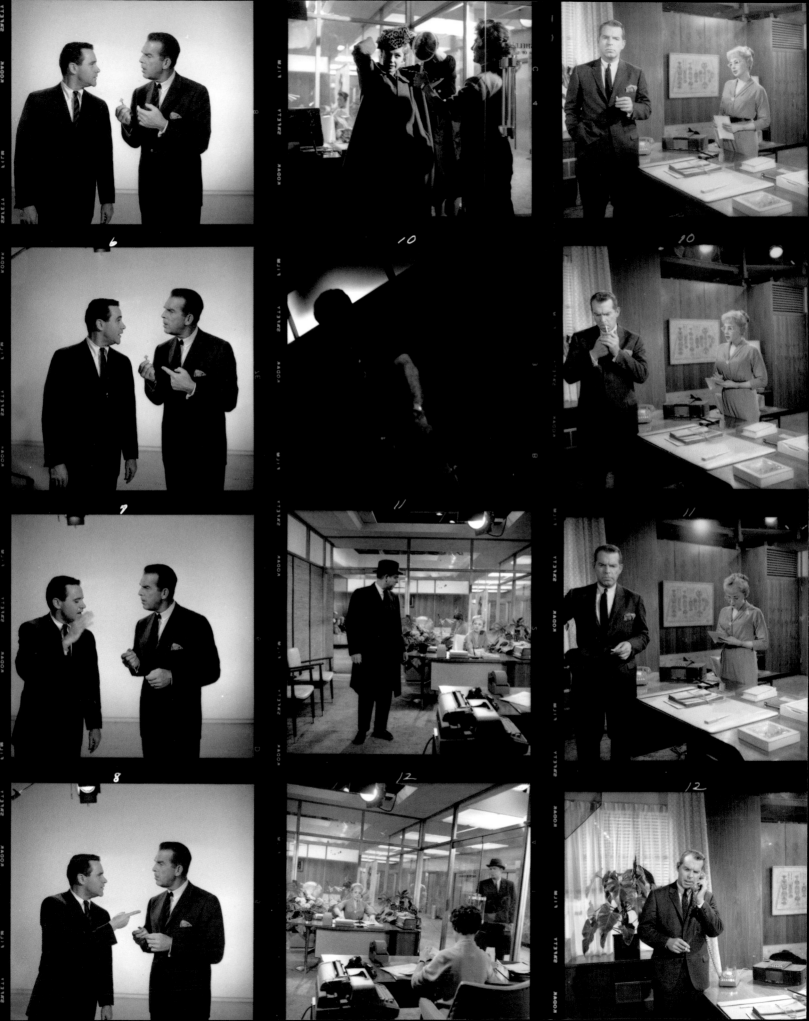

THE APARTMENT
1960

Director: Billy Wilder
Photographer: Jack Harris

———

Billy Wilder had first thought of the idea for *The Apartment* ten years before he made the movie. While watching David Lean's *Brief Encounter*, as he later recalled, he thought, "How will it feel for the guy who crawls into that bed after the lovers have left?"[33] But Wilder didn't initially think he could make the film under the Production Code and its restrictions on depictions of sex. By the time the film was released, in 1960, Hollywood's internal censorship code was starting to relax some, but there was still the question of how to market a movie about a miserable corporate drone who, as a career move, lends out his bachelor pad to his bosses for extra-marital affairs. Making matters more complicated was the fact that the cad was played by Fred MacMurray, who was then under contract with Disney to star in wholesome family films like *The Shaggy Dog*. In the end, most of the promotion for the film elided the film's darker elements, and focused on the love triangle between MacMurray, Jack Lemmon, and Shirley MacLaine. One poster, based on the photos at left, showed MacMurray and Lemmon passing, and apparently arguing about, the coveted key that unlocked the apartment door. The film turned out to be a huge hit, even winning the Best Picture Oscar from the generally conservative Academy, but some viewers still weren't ready for a comedy-drama that so frankly dealt with matters like drunken one-night stands, suicide attempts, and adultery. "[P]eople came around and said, 'You did a dirty fairy tale'—that no such things existed,"[34] Wilder remembered, laughing. MacMurray would emerge with his wholesome dad persona mostly unscathed— although he did claim that one woman approached him on the street and hit him with her purse, chastising the actor for having made "a dirty, filthy movie."[35]

THE MAGNIFICENT SEVEN
1960

Director: John Sturges
Photographer: Jack Harris

—

Aside from Yul Brynner, who had already won an Oscar for *The King and I*, most of the soon-to-be major stars peopling the cast of this American remake of Akira Kurosawa's *Seven Samurai* were at the beginning of their careers. It was James Coburn's third film, and the first hit for Steve McQueen, who had been hand-picked by Frank Sinatra the year before to be his co-star in *Never So Few*, directed by *The Magnificent Seven* helmer John Sturges. Sturges also brought Charles Bronson over from *Never So Few*, and went on to cast both Bronson and Coburn in *The Great Escape*. These shots of the actors sipping coffee, playing poker, and generally appearing to have a grand old time out of their gunman gear are typical of the "candid" style of celebrity photography that was in vogue at the time. The images suggest a peek behind the Hollywood facade, showing movie actors apparently at leisure and off-the-clock; in reality, this was probably a staged-for-the-camera situation, designed to sell the notion that the actors shared a camaraderie off-screen as well as on, and to give the illusion of intimacy without actually revealing anything specific about these men or their private lives.

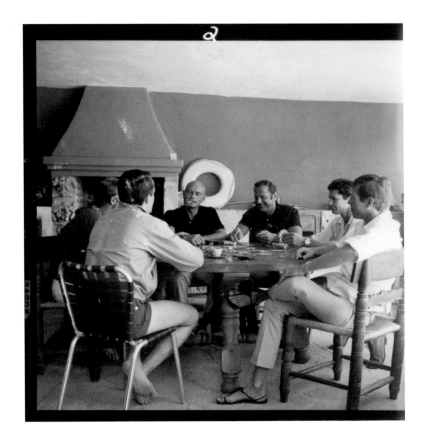

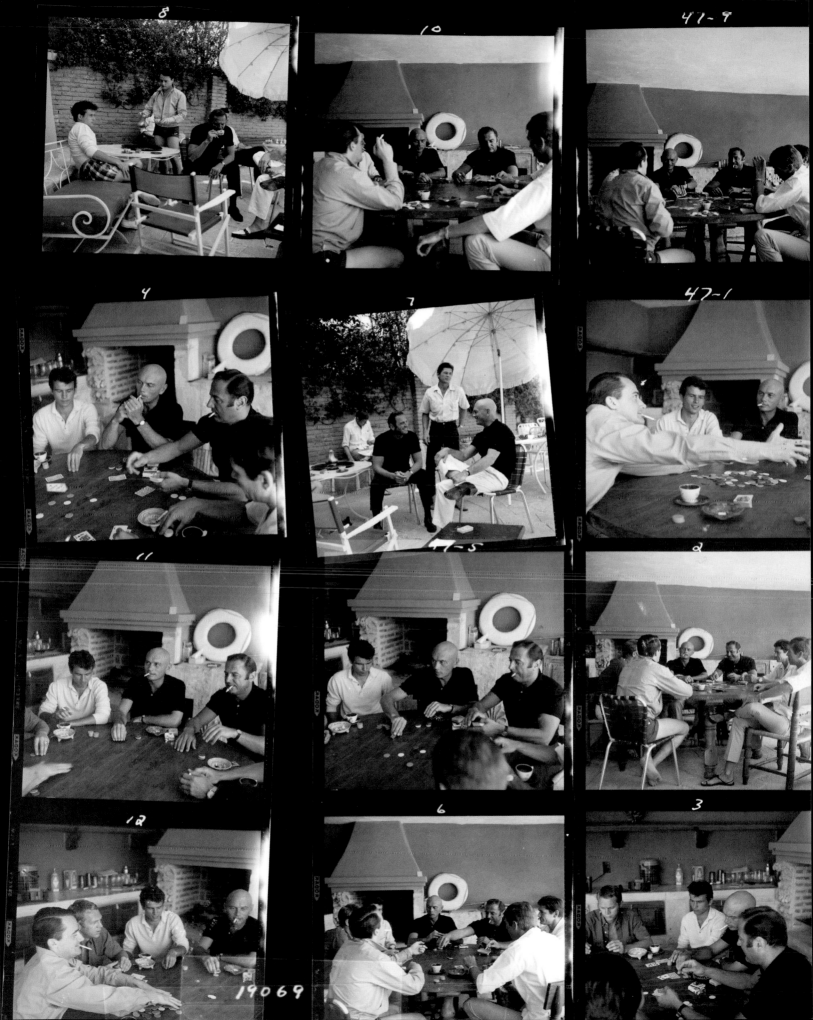

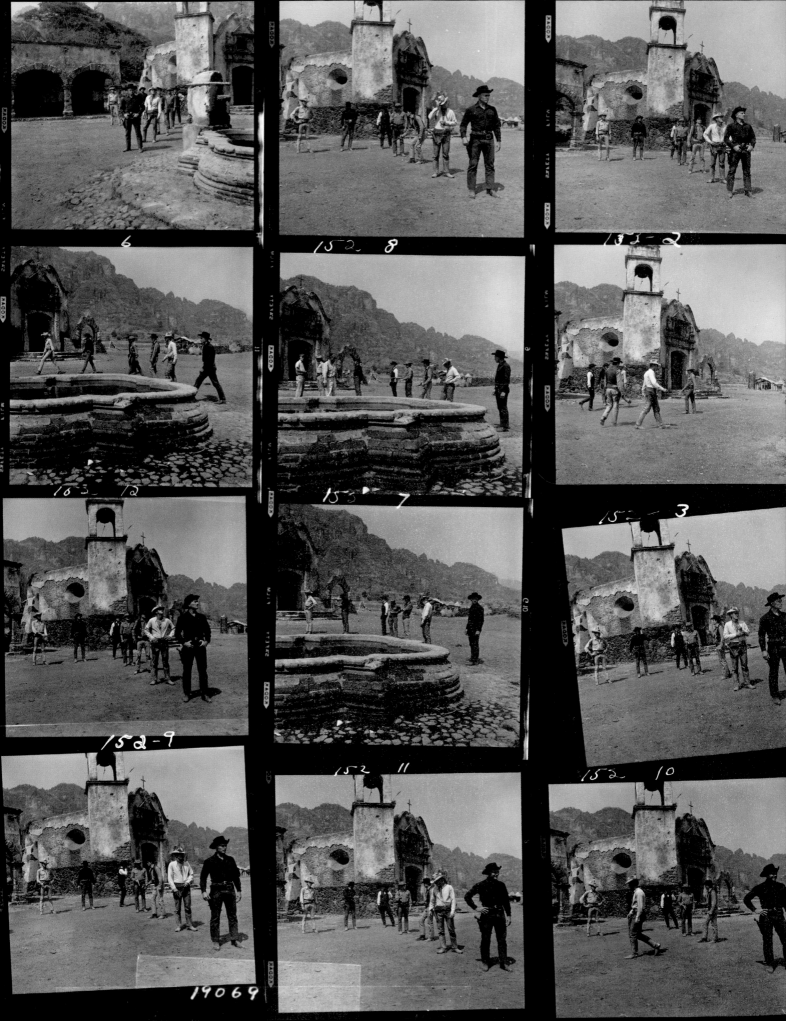

29-11

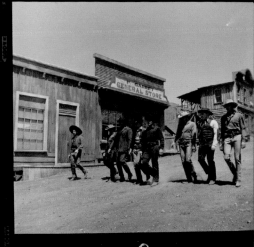

29-1

29-2

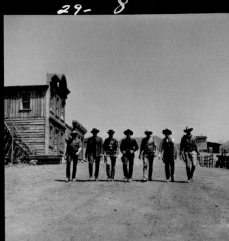

29-8

3

29-7

29-9

4

29-6

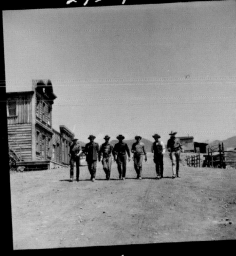

29-8

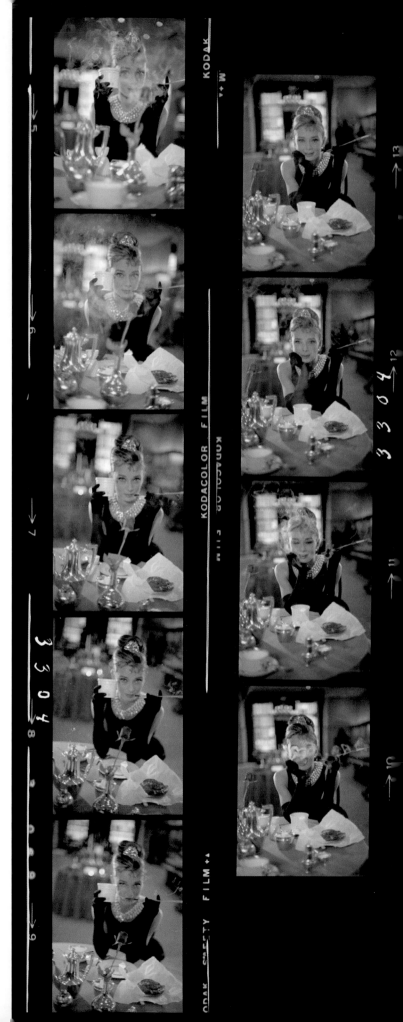

BREAKFAST AT TIFFANY'S
1961

Director: Blake Edwards
Photographer: Howell Conant

Before *Breakfast at Tiffany's*, Audrey Hepburn was known—to borrow a phrase from Patricia Neal's character in the film—as "a very stylish girl." But playing Holly Golightly cemented her status as a fashion icon. The film, based on a novella by Truman Capote, softened the main character from a blatant prostitute into a girl-about-town with an innocence and charm that belied the way she made a living. As we saw with *The Apartment*, these still images offer a glimpse into the magic trick of marketing that made this potentially taboo subject matter safe for a fluffy, stylish comedy, via careful presentation of the Givenchy-outfitted Hepburn. The actress, who winces through smoke in the frames at right, looks older and more world-weary than she does in the movie. The images opposite and overleaf are infused with the light, carefree spirit that Hepburn indelibly stamped on the character. The images fit right in with the Paramount publicity department's aim to position Hepburn-as-Holly not as the "wild thing" she's branded in the screenplay, but as a "kook"—eccentric without threatening the status quo. More importantly, the playfulness of shots like these allowed Paramount to suggest that Hepburn was in a sense innocently playing dress-up, taking a break from but not violating a persona that a studio press release described as "pure, polite, and possibly a princess."[36]

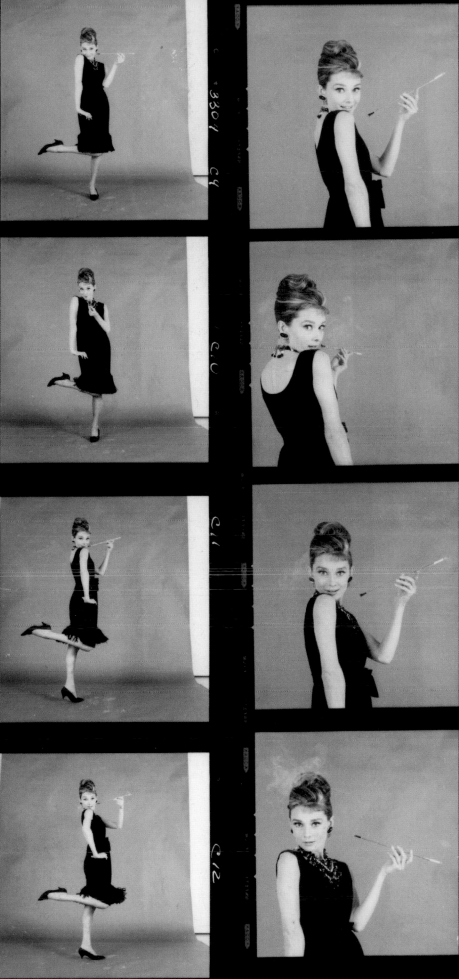

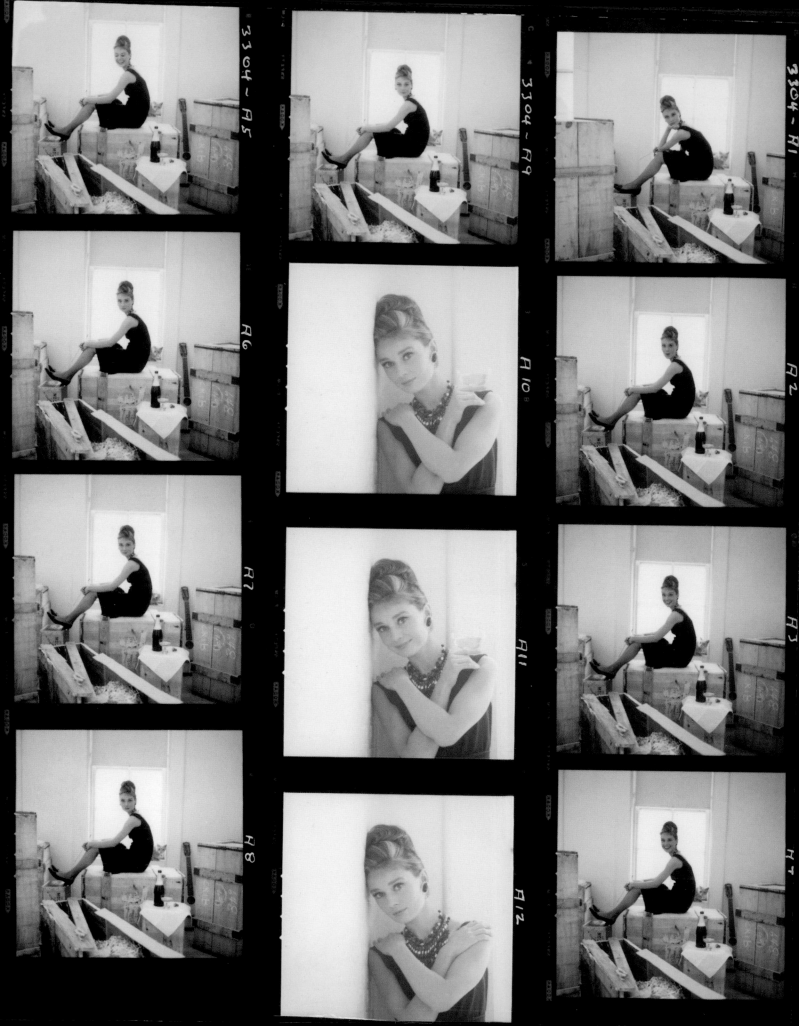

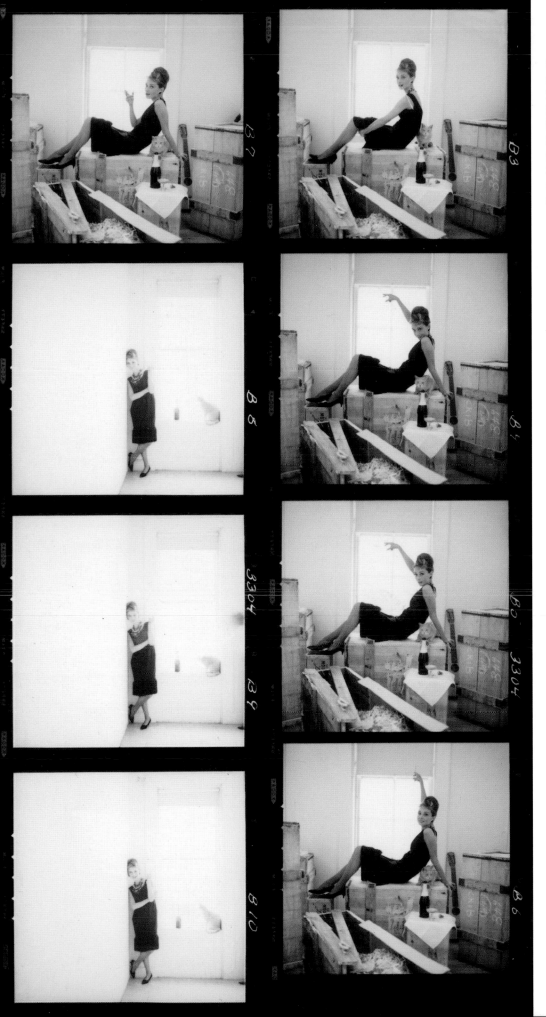

Givenchy didn't invent the little black dress—that was Coco Chanel—but the ideal of the little black dress as a synonym for accessible glamour was given perhaps its best advertisement by *Breakfast at Tiffany's*. Hepburn's minimalist frock is now maybe the most famous "LBD" of all time; in 2006, it sold at auction for £410,000 ($686,000), then a record for the highest amount ever paid for a dress from a film.

THE HUSTLER
1961

Director: Robert Rossen
Photographer: Unknown

———

Known for films that explored American working-class life in a style he called "neo-neo-realism," in turning the 1959 novel by Walter Tevis into a movie, director Rossen made authenticity a top priority. A former pool hustler himself, Rossen hired Willie Mosconi, one of the world's top billiard champs, to work on set as a technical adviser. It was the job of Mosconi, seen in these frames posed at the pool table with *Hustler* star Paul Newman, to both teach the billiard-novice actor how to credibly hold and strike a pool cue, and also to give him a model for the attitude and body language of a creature of the pool hall. Mosconi was perhaps too good a model, and not skilled enough as a teacher: according to some reports, Rossen made use of trick photography, subbing in Mosconi's hands on the stick in some places for Newman's.

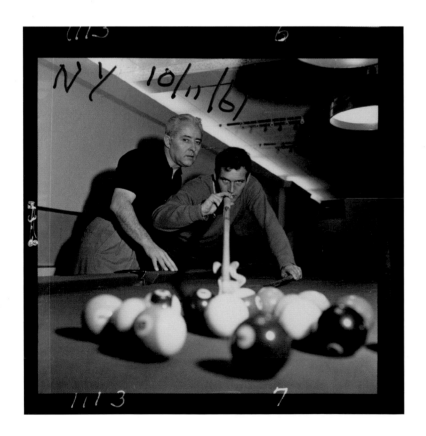

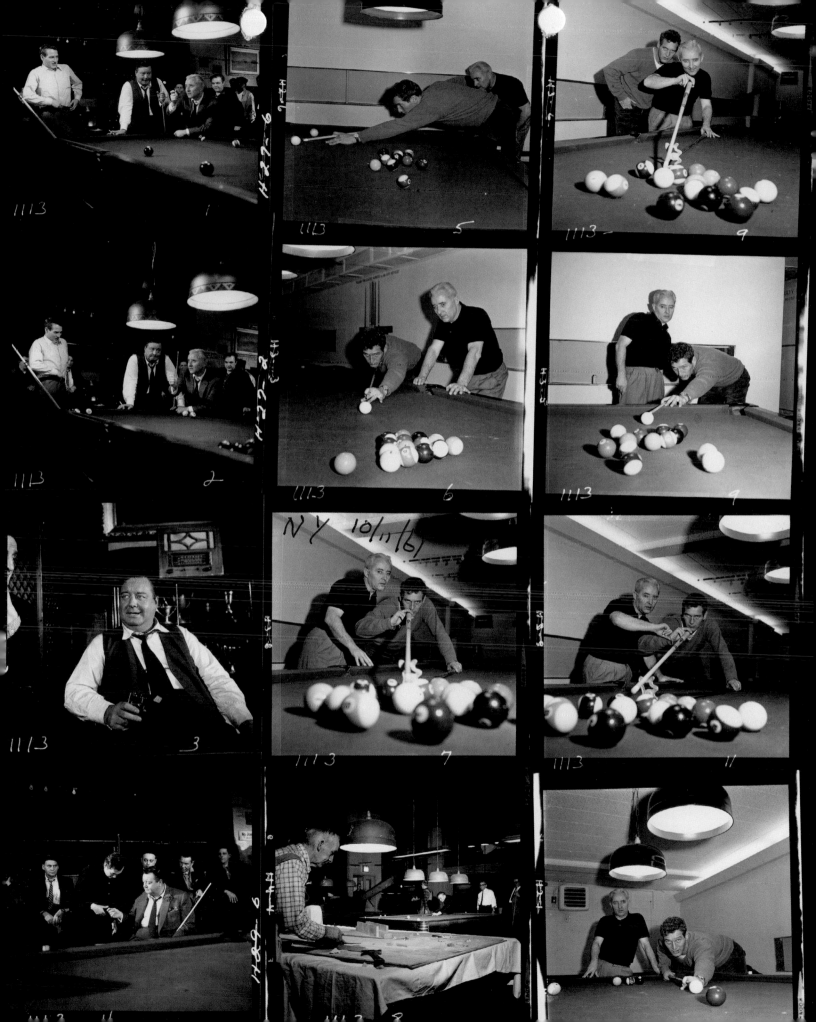

1113 1

1113 2

1113 3

1113 5

1113 6

N Y 10/11/61

1113 7

1113 9

1113 9

1113 11

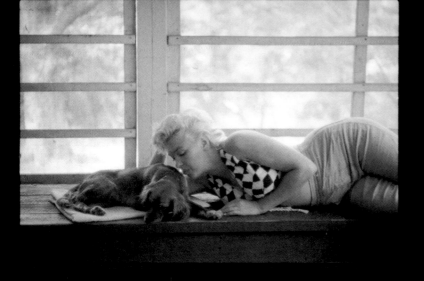
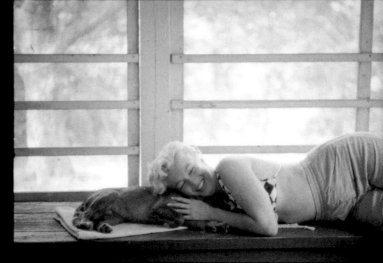

THE MISFITS
1961

Director: John Huston
Photographer: Ernst Haas

———

This gleeful image of Marilyn Monroe, above right, in repose on the set of her last finished movie, is in some sense the perfect behind-the-scenes film still: it gives the illusion of exposing a star in a private moment, while really revealing nothing about her nightmarish personal life, and actually obscuring the truth of an extremely troubled set. While shooting on location in the Nevada desert, where outside temperatures would regularly exceed 100 degrees fahrenheit, director Huston periodically drank himself into a stupor and had to have his gambling debts paid off out of the production budget. Monroe, who is seen right sipping from a can of beer, battled drug and alcohol addiction on set, and production shut down for two weeks in August 1960 so that she could detox. Days after the film wrapped, Monroe announced she was separating from her husband, Arthur Miller (seen in the frames right looking down on Monroe and co-star Clark Gable), who had written *The Misfits* for her. Her addictions would resurface, and in August 1962, Monroe was found dead of an overdose. *The Misfits* would be the final film for Gable, too; the great star would die weeks after production wrapped, after suffering a heart attack that may have been caused by the stress of the job, in combination with a crash diet he undertook to lose 35 pounds for filming.

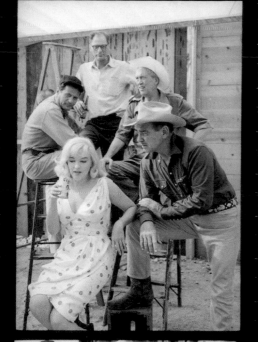
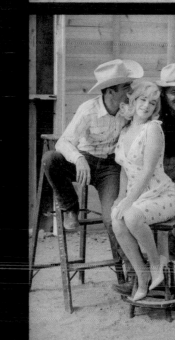
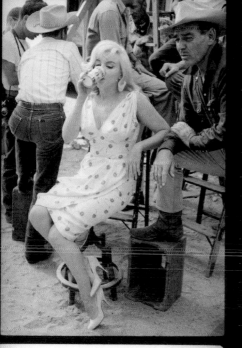
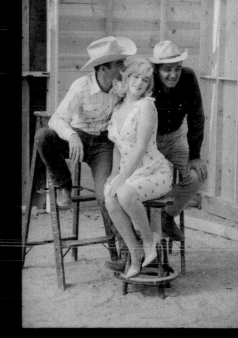
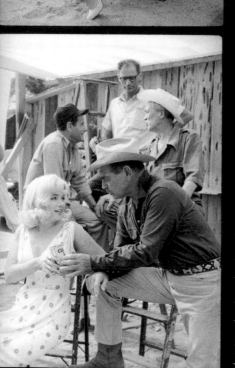
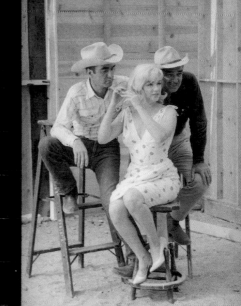

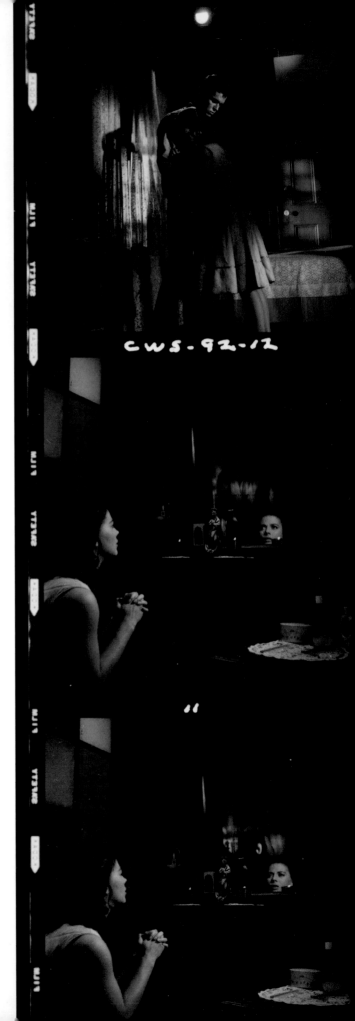

WEST SIDE STORY
1961

Director: Jerome Robbins & Robert Wise
Photographer: Jack Harris

The filmic adaptation of the hit, *Romeo and Juliet*-inspired Broadway musical had an agonizing production. Stars Richard Beymer and Natalie Wood were inexperienced dancers and their singing voices had to be dubbed; co-director/choreographer Robbins was fired mid-way through the shoot for causing delays; and the budget eventually went over projections by $2 million, an enormous sum in the early 1960s. It was all worth it: today the film is remembered as one of the last great movie musicals of the classical Hollywood era, as well as a groundbreaking effort in 70mm color cinematography. This rare color contact sheet by Jack Harris (still photographers who did shoot in color on sets often used transparency film, which created higher-quality images, but was never printed in sheets) offers a glimpse of the care taken by co-director Wise and Oscar-winning cinematographer Daniel L. Fapp to use highly stylized color as both a design element and an emotional force. Meanwhile, the black-and-white 35mm images on the following pages are evidence of another, seemingly incompatible aspect of *West Side Story*'s production: Wise's decision to shoot some of the film, including musical numbers, on actual New York City streets. "I fought from the beginning to open the film in New York in its setting, in its background, because we couldn't put stylized sets on movie stages like they had on the theater stage—they don't work in films," Wise explained. "Stylized sets only work if you're doing an utter fantasy like *The Wizard of Oz*."[37]

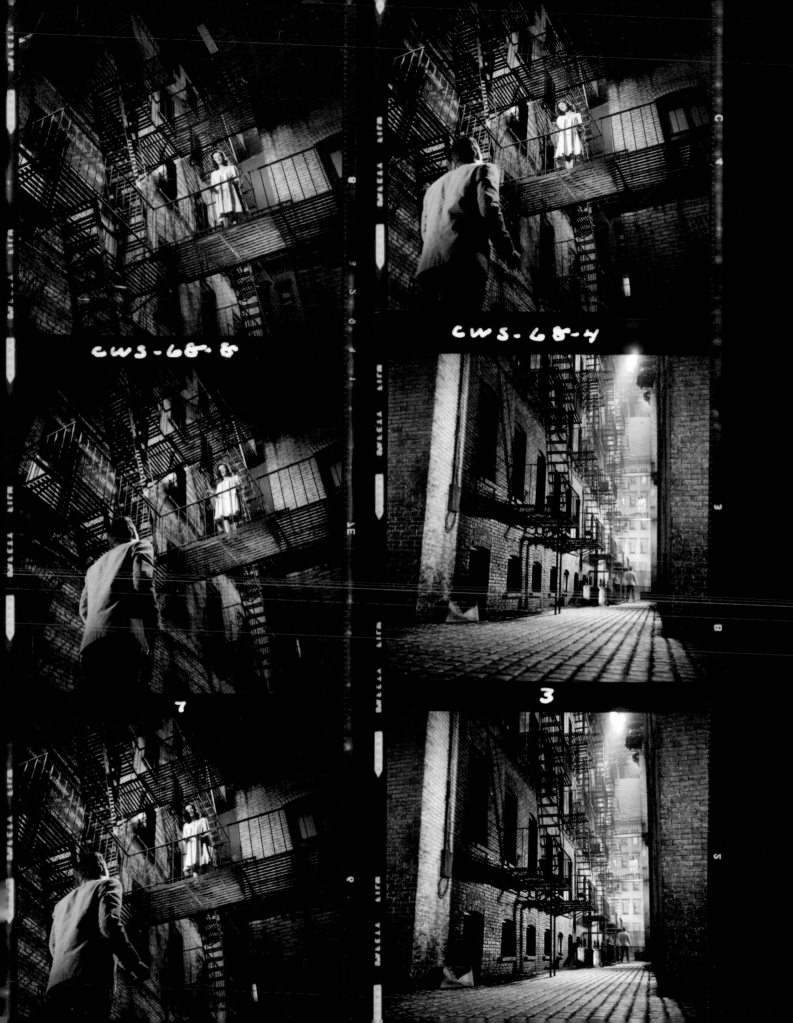

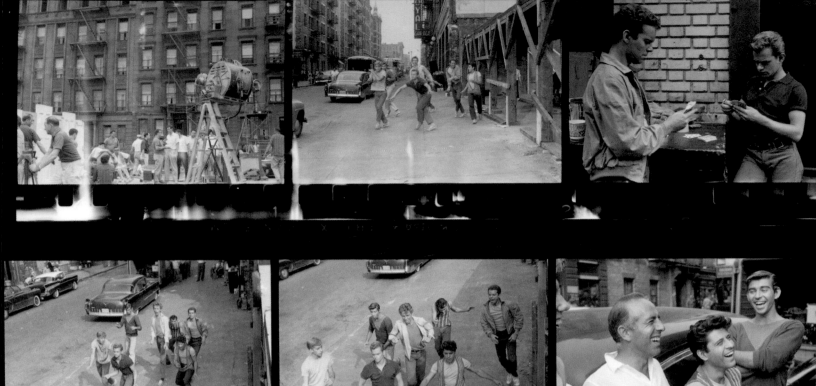

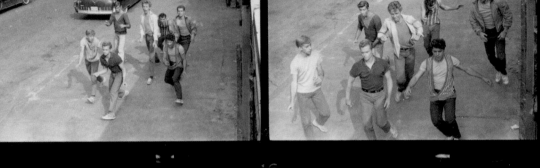

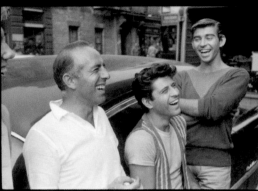

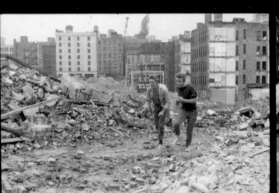

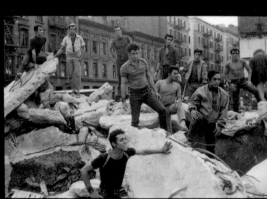

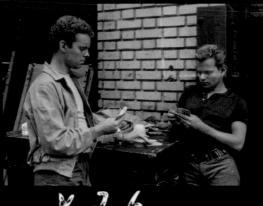

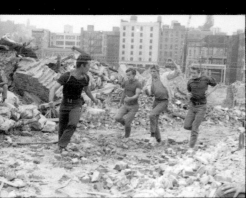

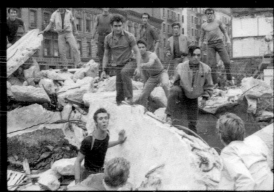

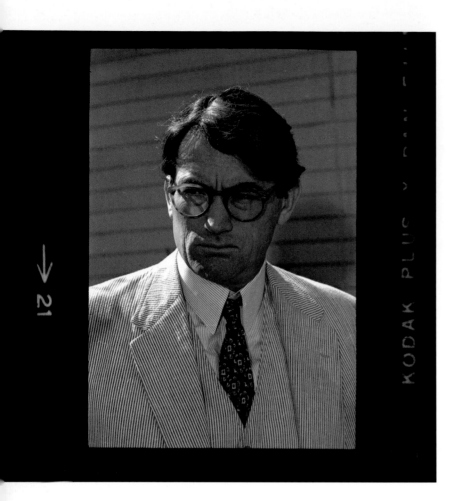

TO KILL A MOCKINGBIRD
1962

Director: Robert Mulligan
Photographer: Leo Fuchs

—

The embodiment of capable American manliness on-screen for much of the second half of the 20th century, Gregory Peck won his sole Best Actor Oscar nearly 20 years into his film career, for his turn as Atticus Finch, single father and attorney, in this adaptation of Harper Lee's only published novel. It seems as though there's no off-camera break in character in these on-set stills, perhaps because Peck and those close to him felt that Atticus was the role he was born to play, the closest representation of who Peck really was possible within the realm of fiction. In the eulogy delivered at Peck's memorial by actor Brock Peters—who played Finch's client in *Mockingbird*, a black man wrongly accused of raping a white woman—Peck's co-star put it simply: "Atticus Finch gave him an opportunity to play himself."[38]

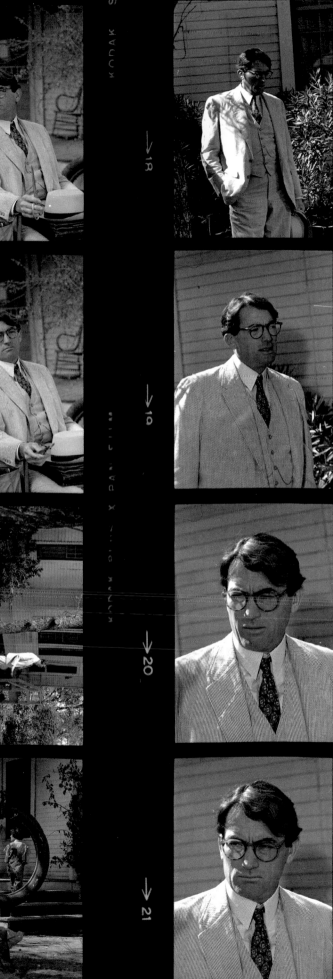

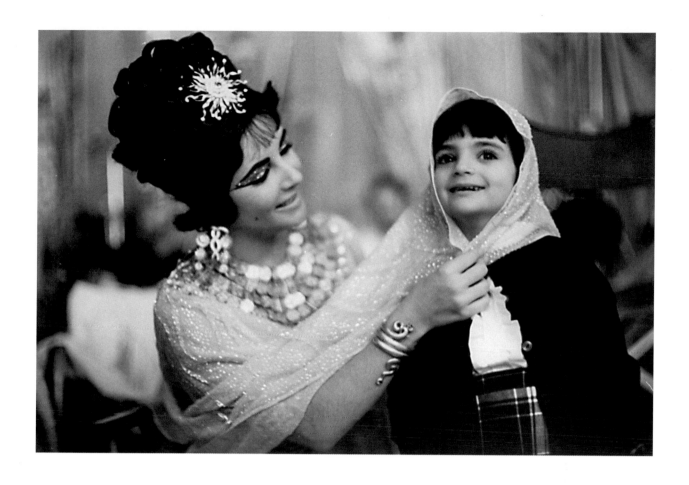

CLEOPATRA
1963

Director: Joseph L. Mankiewicz
Photographer: Paul Schutzer

—

The most storied Hollywood romance of the 20th century began on the set of Mankiewicz's troubled epic, when oft-married former child actress Elizabeth Taylor, for whom Eddie Fisher had recently left Debbie Reynolds, met Shakespearean thespian Richard Burton, who had a wife and children of his own. Burton and Taylor's initially adulterous, always tumultuous relationship—which included two marriages and a divorce—was an open secret on the *Cleopatra* set, captured by Roman paparazzi and, here, by *LIFE* magazine photographer Paul Schutzer. For all the reported angst of the production (its famous budget over-runs and delays were not helped by its stars' extracurricular activities), Schutzer managed to capture Burton and Taylor looking wholesome and happy. His images of the lovers playing with Taylor's daughter, Liza Todd, contain the promise of a domestic life whose serenity the volatile pair rarely equaled in their 13 years of on-again, off-again partnership.

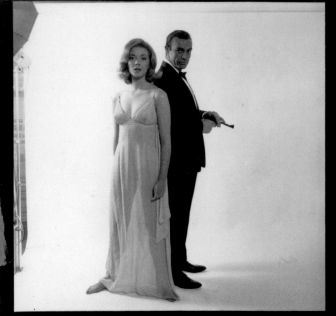

FR-DH-46

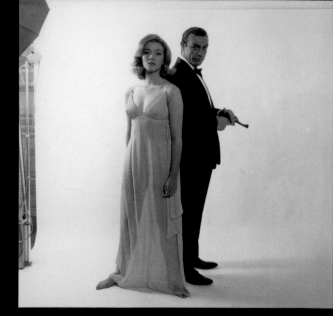

FR-DH-43

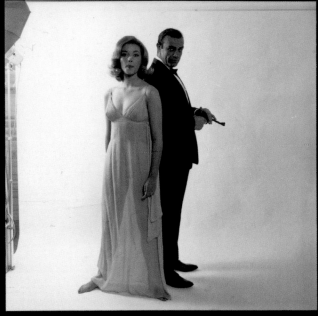

47

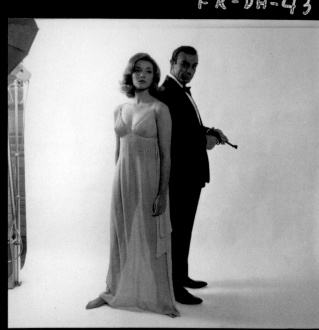

44

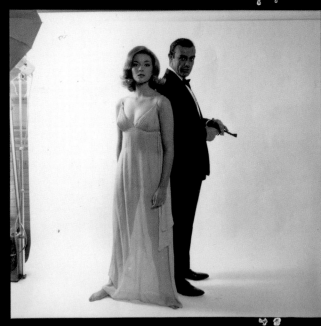

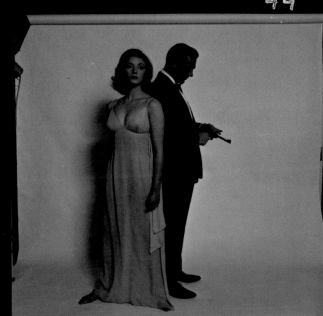

45

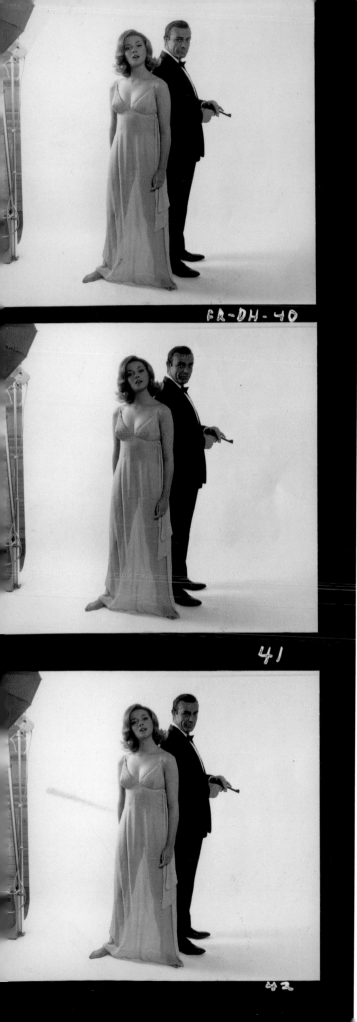

FR-DH-40

41

FROM RUSSIA WITH LOVE
1963

Director: Terence Young
Photographer: Unknown

—

Most contact sheets juxtapose familiar or theoretically usable images with evidently unusable outtakes. This collection of shots taken off-camera to publicize the second film in the James Bond franchise is unique, in that each frame seems slightly imperfect. Sean Connery and Daniela Bianchi look attractive enough, but there's a distinct lack of chemistry between the Italian actress (whose voice was dubbed in *From Russia with Love* by British actress Barbara Jefford) and the actor, who was at the beginning of his run as Bond, and has seemingly not yet perfected the character's effortless insouciance. *From Russia with Love*, of course, came along early in the Bond film evolution, and it remains notable for codifying a number of aspects that would become signatures of the franchise—the pre-credits sequence, the unique-to-the-film theme song. While *From Russia with Love* was successful, at the box office and with critics, the Bond phenomena arguably didn't fully hit its stride until the next outing, *Goldfinger*, which was released the following year and is still considered one of the finest films in the most successful movie franchise in history.

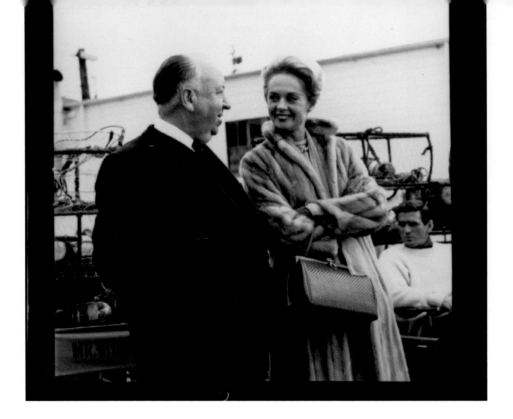

THE BIRDS
1963

Director: Alfred Hitchcock
Photographer: Unknown

———

These frames, featuring Alfred Hitchcock and actress Tippi Hedren laughing off-camera on the set of *The Birds*, might give the impression that the pair was having a grand old time together. In fact, according to Hedren, working with Hitchcock was "difficult, embarrassing, and insulting." The actress has accused the director of all manner of unprofessionalism, from having her followed, to taunting her with dirty jokes, to refusing to release her from his contract with her so that she could capitalize on the success of *The Birds* by making other movies. Given Hitchcock's famous knack for psychological brinkmanship, it's not hard to imagine that some of his unconventional manipulations were, in a sense, a form of directing, of pushing Hedren into a state of terror that Hitchcock could then capture on film. That's certainly what he appears to have done in the attic scene from *The Birds*, documented in the sheet overleaf. Hedren had been prepared to act the scene opposite an artificial threat. "When I got to the set I found out there had never been any intention to use mechanical birds because a cage had been built around the door where I was supposed to come in," Hedren remembered, "and there were boxes of ravens, gulls, and pigeons that bird trainers wearing gauntlets up to their shoulders hurled at me, one after the other, for a week." Wearied and bleeding from the onslaught, Hedren collapsed, and was advised by a doctor to rest for a week. But Hitchcock refused to give the actress time off from shooting. As Hedren tells it, "the doctor said, 'What are you trying to do? Kill her?'"[39]

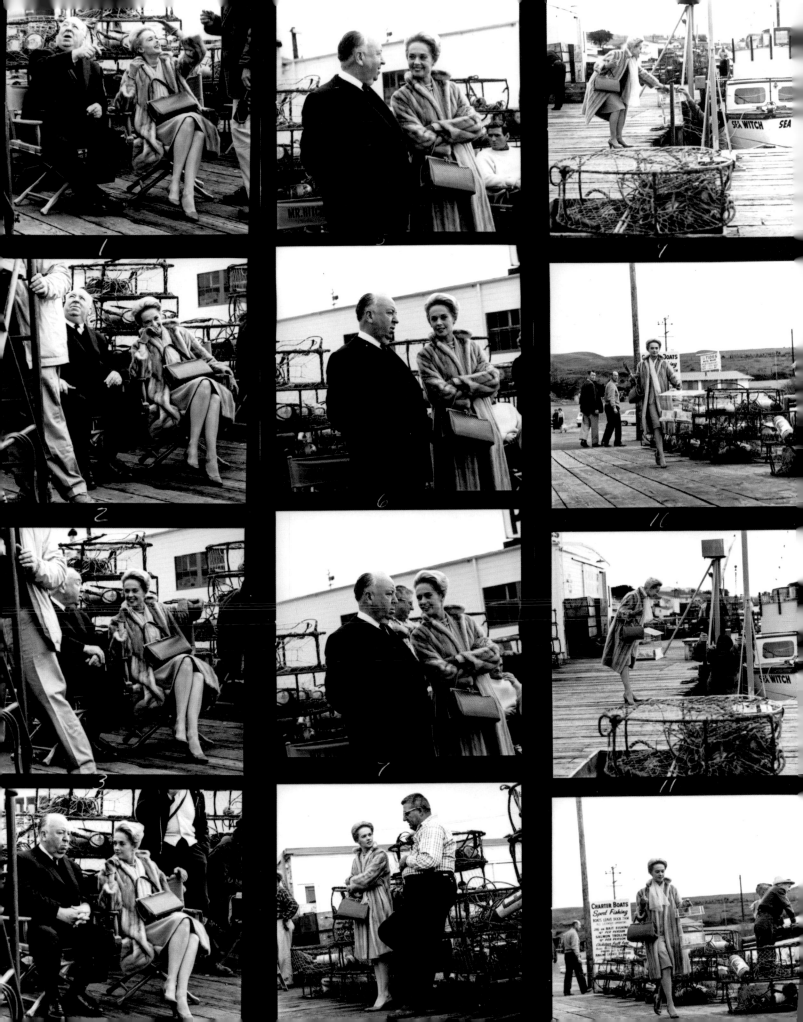

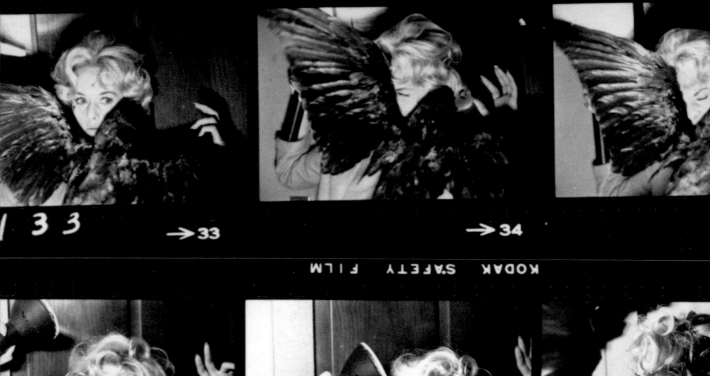

/ 3 3 →33 →34 →35

KODAK SAFETY FILM

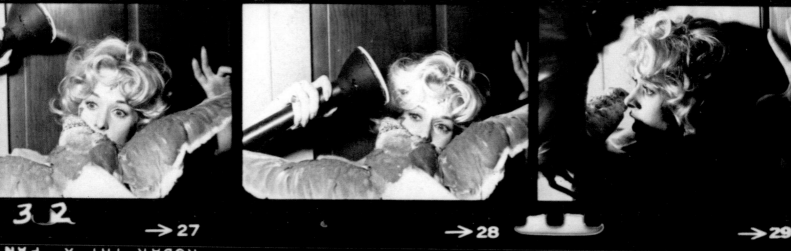

3 2 →27 →28 →29

KODAK TRI X PAN TY FILM

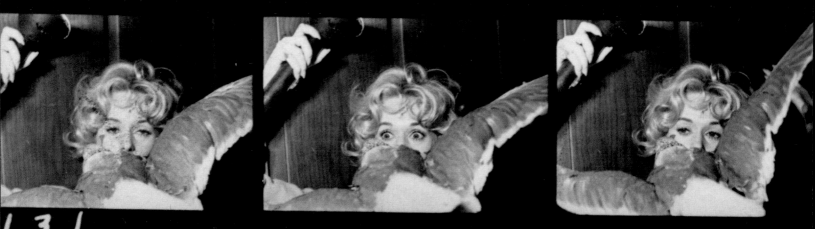

1 3 1 →21 →22 →23

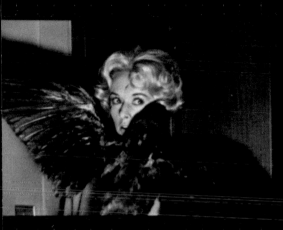
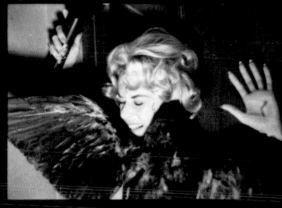
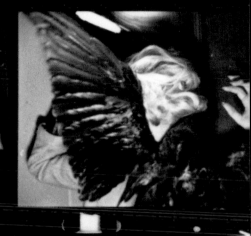

→36

→30

→31

→

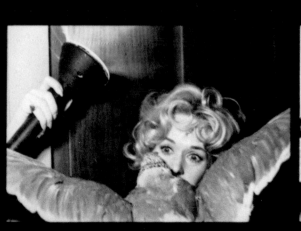
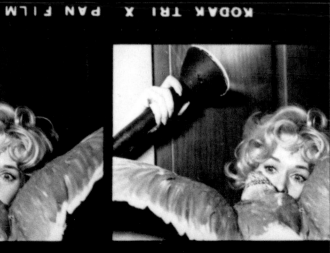

→24 C B J C →25

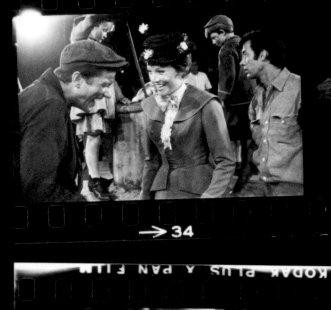
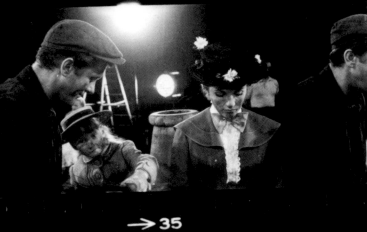

→ 34

→ 35

KODAK PLUS X PAN FILM

→ 2

→ 3

KODAK PLUS X PAN FILM

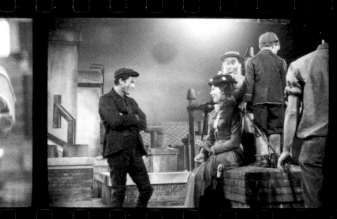
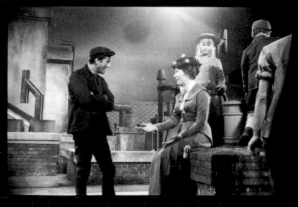

D J F → 25

→ 26

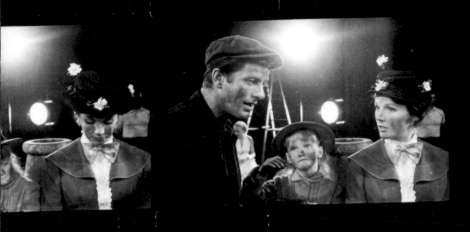

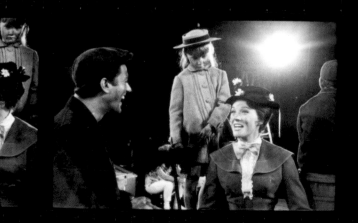

MARY POPPINS
1964

Director: Robert Stevenson
Photographer: Earl Theisen

—

In 1964, Dick Van Dyke's eponymously named sitcom was one of the most popular and highest acclaimed shows on American television, and *Mary Poppins*, in which Van Dyke co-starred as the singing, dancing, jack-of-all-trades Burt, was the most profitable film of the year. But in addition to his success, Van Dyke had a secret: by night, he was an alcoholic. "I would go to work with terrible hangovers," the actor recalled later, "which if you're dancing is really hard."[40] Van Dyke got sober in the 1970s, and became one of the first celebrities to speak out about their struggles with addiction. His off-screen illness could hardly be less noticeable in his performance in *Mary Poppins*, which is not to say that his work in the film has escaped criticism: his Cockney accent is widely regarded as one of the least accurate vocal performances of all time. "I was concentrating on the dancing, mostly, and they had given me a [voice] coach who turned out to be an Irishman, and his Cockney wasn't much better than mine," Van Dyke explained in 2009. "During the making of the picture nobody kidded me about the accent, but I sure took it afterwards."[41]

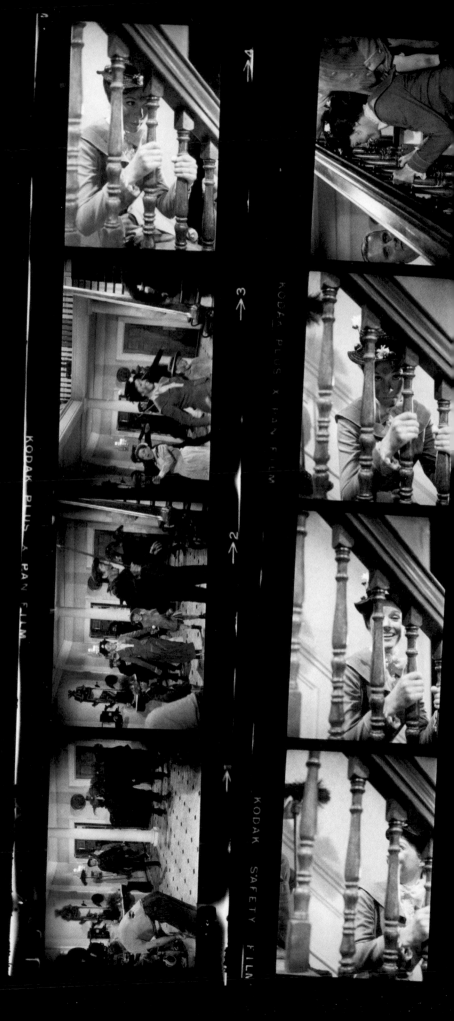
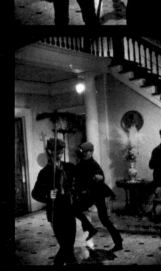

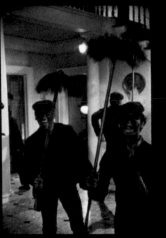
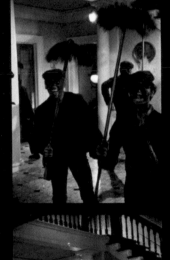

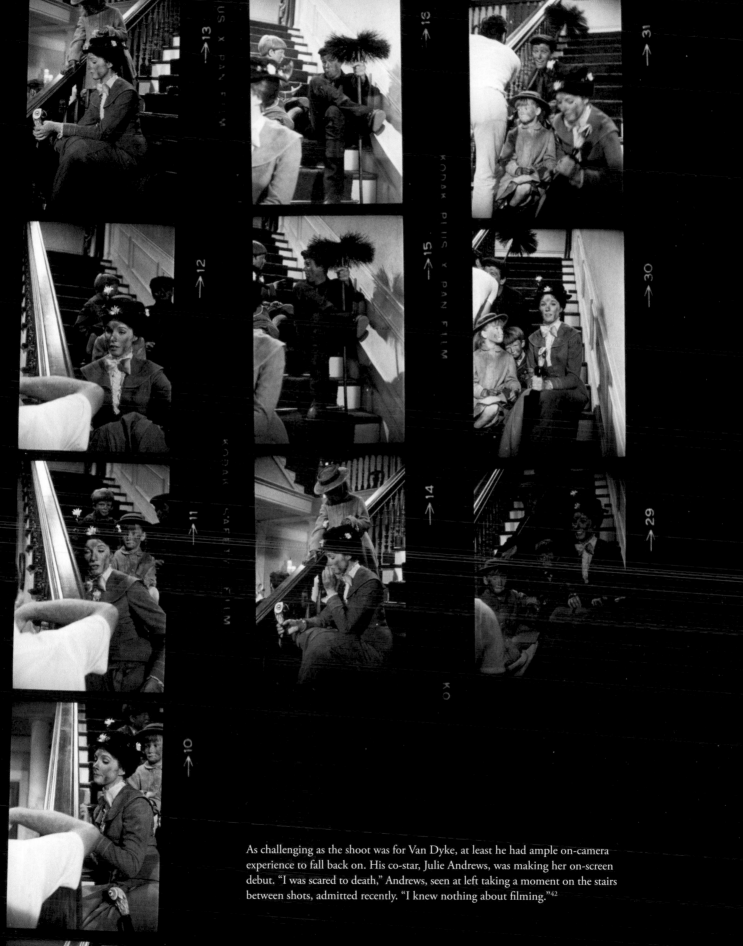

As challenging as the shoot was for Van Dyke, at least he had ample on-camera experience to fall back on. His co-star, Julie Andrews, was making her on-screen debut. "I was scared to death," Andrews, seen at left taking a moment on the stairs between shots, admitted recently. "I knew nothing about filming."[42]

MY FAIR LADY
1964

Director: George Cukor
Photographer: Cecil Beaton

———

Designer, painter, photographer, and diarist Cecil Beaton
considered the costumes he created for George Cukor's film
of *My Fair Lady* to be a crowning career achievement. Some
of these photographs Beaton took of Hepburn modeling his
creations appeared in *Vogue*, the fashion magazine for which
Beaton had penned an ode to Hepburn ten years earlier, raving
that the ingénue's beauty "succeeds because it embodies the spirit
of today."[43] Hepburn, of course, continued to exemplify chic for
many years to come, and Beaton was more than just an admirer
of her image; on the set of *My Fair Lady*, he was intimately
invested in creating that image, fussing over (and photographing)
every detail of Hepburn's costuming and style to the point that
his directions often usurped those of the film's actual director,
Cukor. Photo shoots like the one that produced these images
were a major bone of contention between Beaton and Cukor.
"There are all kinds of ways and times to do publicity shots, but
you don't interrupt the director's day to do them," said Cukor's
art director, Gene Allen. "That's never taken place in the history
of the business. It may be with some lesser directors, but you
don't take Audrey Hepburn away from George Cukor."[44] In the
end, Cukor let Beaton win a few battles, but the director won
the war: Beaton left Hollywood before shooting was completed.
After the film's London premiere, Beaton wrote in his diary,
"Now it is time I forget the whole bloody business…"[45]

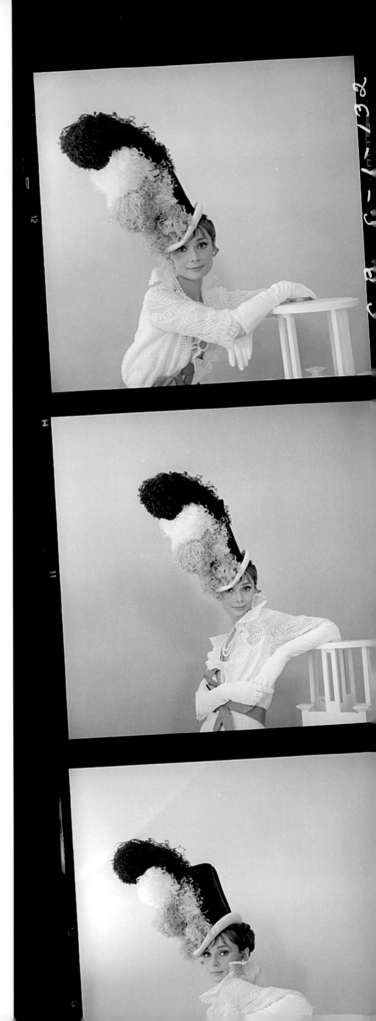

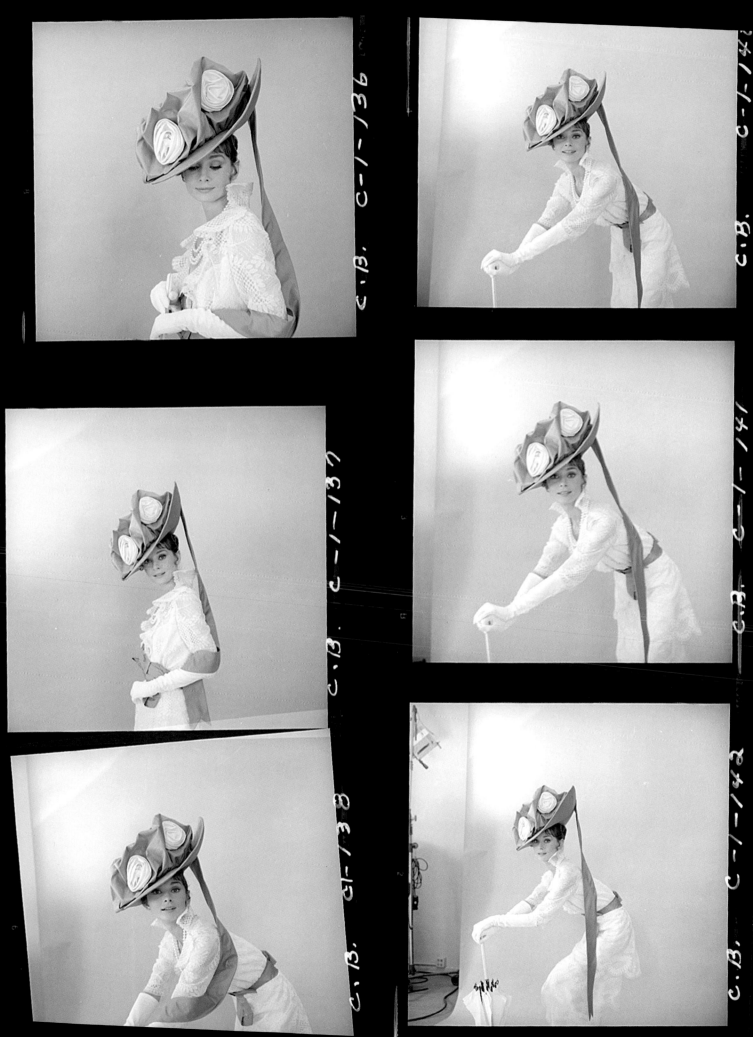

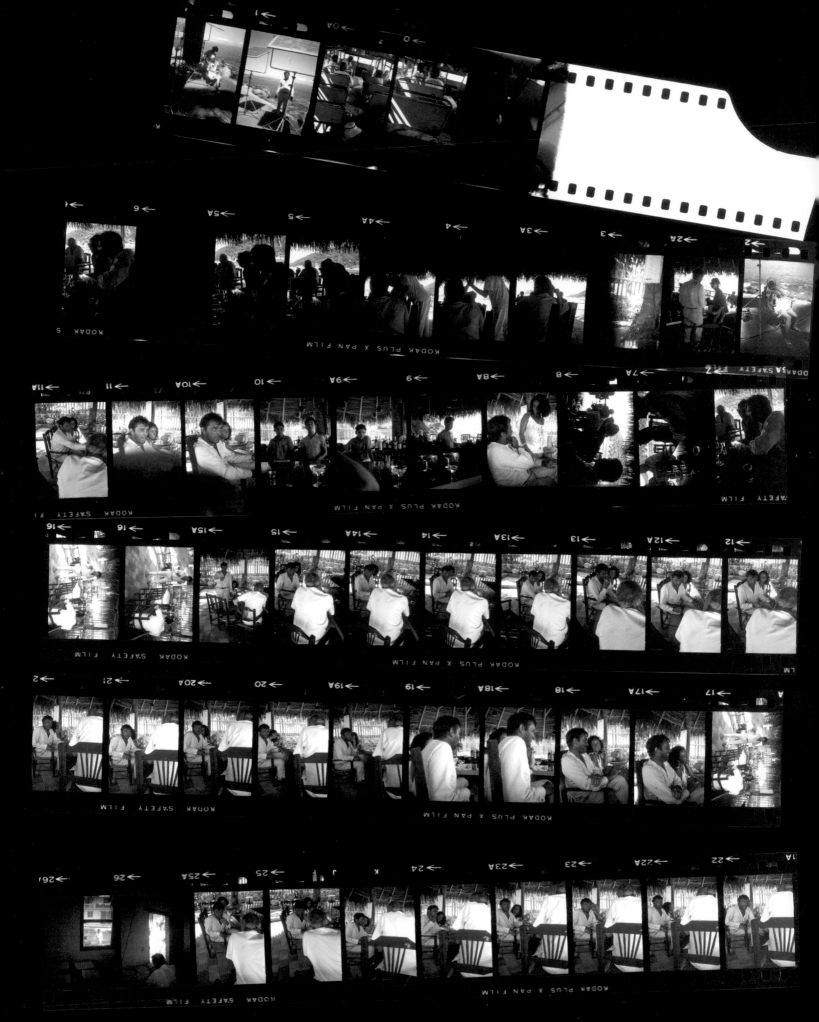

THE NIGHT OF THE IGUANA
1964

Director: John Huston
Photographer: Gjon Mili

—

Though she had no role in the film, Elizabeth Taylor accompanied her lover, Richard Burton to the Mexican set of Huston's Tennessee Williams adaptation, likely in part to assert herself in the presence of Burton's three gorgeous co-stars: Ava Gardner (who was notorious for on-set affairs), Deborah Kerr, and *Lolita* herself, Sue Lyon. As these contact sheets show, Taylor stuck close to her man on set, often hovering right off-camera, particularly when Burton was shooting with Gardner. Just as Taylor seems to upstage the actual stars of the film in the eyes of this off-camera still photographer, Burton and Taylor's romance overshadowed the production itself, attracting the international press to the Mexican jungle. Director Huston seemed amused by the promise of friction on set; before shooting began, he gave Taylor, Burton, and his three female co-stars gold-plated pistols, each filled with bullets engraved with the names of the other four. Perhaps the gift diffused tension before it could build. "There were no fireworks," Huston wrote in his memoir. "All the members of our cast—especially the stars—got on famously."[46] Burton and Taylor's relationship not only survived the booze-soaked shoot, but thrived. The couple would buy the beach-side villa in which they lived during production, and would return to it in tougher times, hoping to recapture their honeymoon-like happiness.

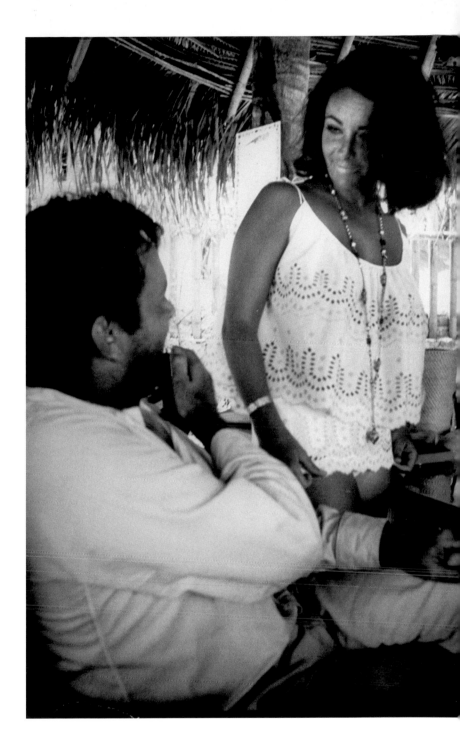

DOCTOR ZHIVAGO
1965

Director: David Lean
Photographer: Kenneth Danvers

———

David Lean was hoping to find a young Greta Garbo-type for the role of Lara, the eventual lover of Doctor Yuri Zhivago, who is a virginal teenager at the beginning of the movie. Carlo Ponti, the film's producer, wanted Lean to cast his wife, 30-year-old internationally known bombshell Sophia Loren. "This is why I want a young actress..."[47] Lean explained. "I would not believe this was Miss Loren's first encounter with sex and if I don't believe it I would think she is a bitch." After considering a number of other actresses, including Jane Fonda, Lean remembered having seen Julie Christie in *Billy Liar*. Christie screen tested and got the part—her first in a large-scale Hollywood film. On set, observed Christie's co-star Rod Steiger, "Julie seemed partially paralyzed. She looked as if she had tripped over a brick in the King's Road and come up with the part of Lara."[48] By her own admission, Christie behaved badly on set—complaining about the regimented rules of production, segregating herself from older members of the cast and crew, refusing to dress in full period costume until the last minute—but as she got deeper into the work, her attitude changed. "Towards the end of the film when we got to my most difficult and lovely stuff I was so potty about the film I would have done anything."[49] And, with the release of *Doctor Zhivago*, the world went equally "potty" for Christie.

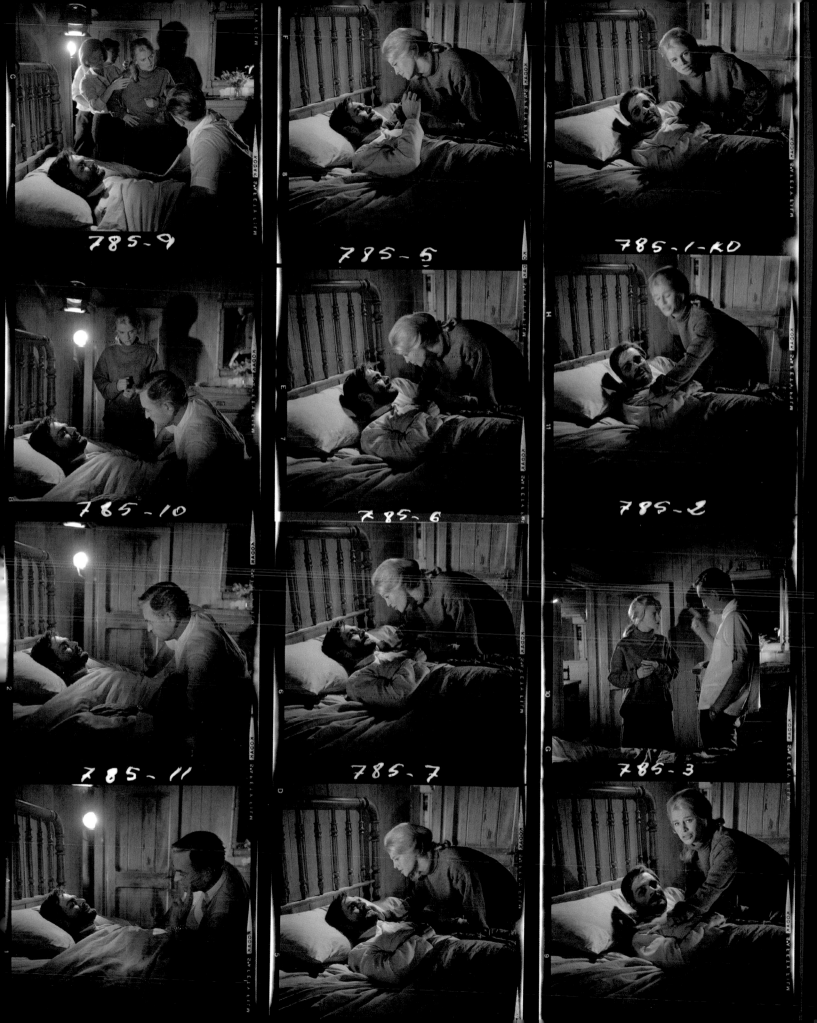

FAHRENHEIT 451
1966

Director: François Truffaut
Photographer: Paul Schutzer

For his first and only English-language film, French New Wave legend François Truffaut cast Julie Christie in two roles: as Clarisse, a young, activist schoolteacher; and as Linda Montag, the pill-addled wife of Guy Montag (Oskar Werner), a member of the book-burning brigade the Firemen. After the part of Clarisse had been turned down by both Jean Seberg and Jane Fonda, Truffaut decided to offer both roles to Christie, who had just won an Oscar for *Darling* (1965) and had also starred in *Doctor Zhivago* that same year. Actress and director got along well, as these images show, but her casting was controversial. As though the challenge of playing two roles wasn't enough, casting Christie as Clarisse meant also asking one of the most beautiful women in the world to play a character the director described as having been "de-sexed...so as to get neither her nor Montag mixed up in an adulterous situation which has no place in science fiction."[50] Though Ray Bradbury, author of the dystopian novel on which the film was based, approved of some of Truffaut's changes to the story, in 2009 Bradbury said he felt "the mistake" made with the film was "to cast Julie Christie as both the revolutionary and the bored wife," adding, "screenwriters don't know a goddamn thing about writing."[51]

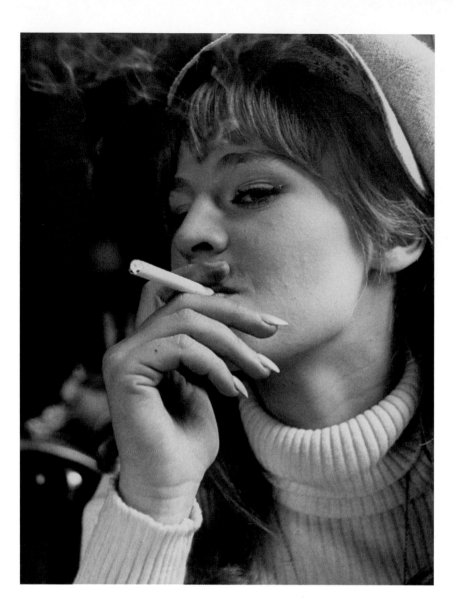

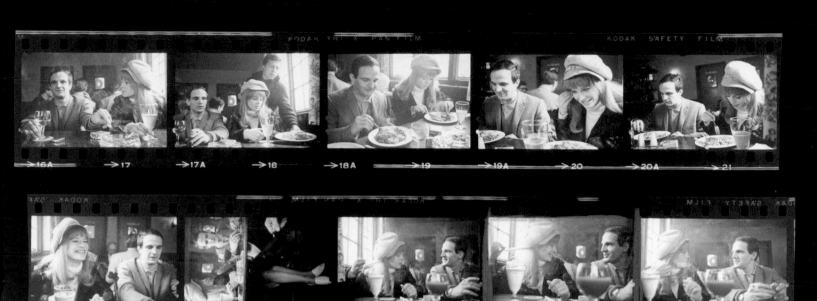

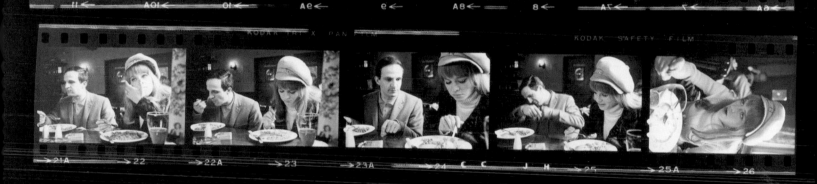

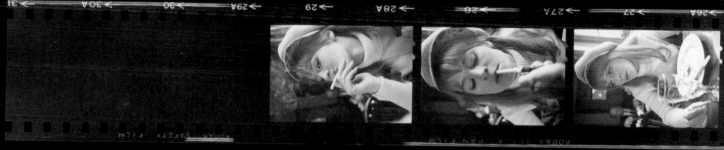

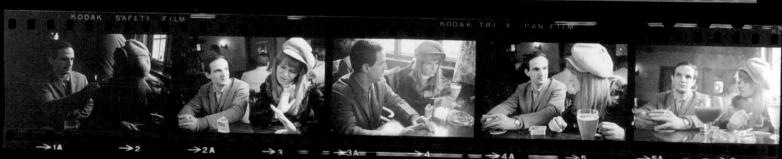

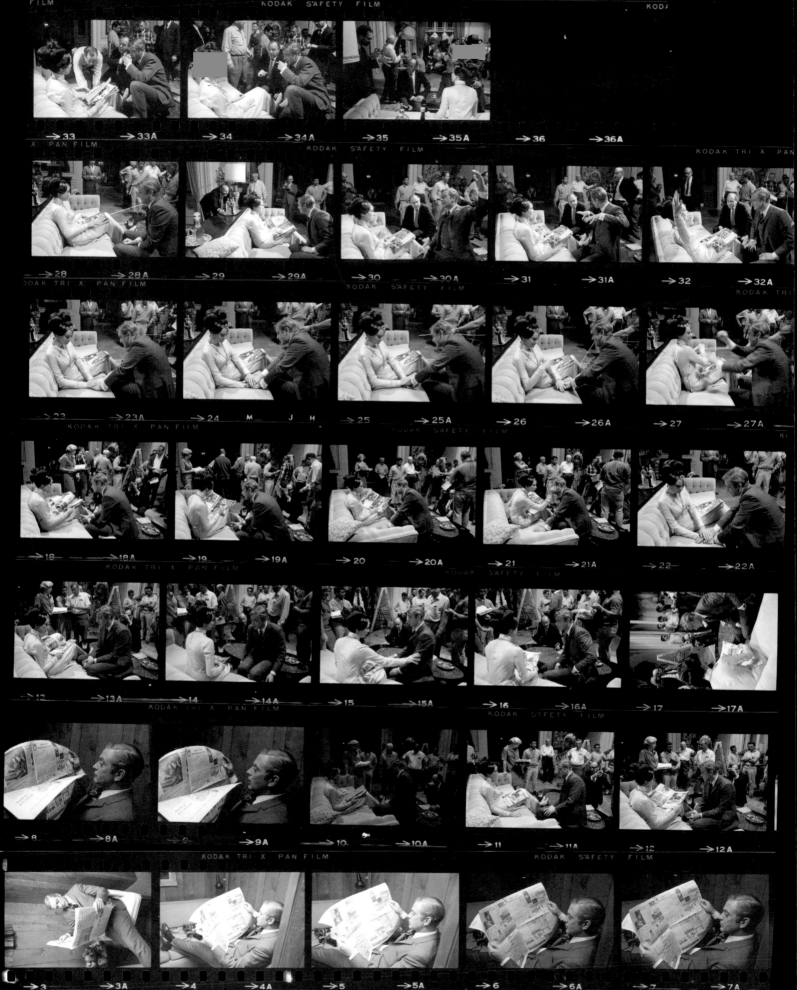

GAMBIT
1966

Director: Ronald Neame
Photographer: Bill Ray

———

In 1966, fresh off of *Alfie*, Michael Caine was just becoming a movie star. *LIFE* magazine commissioned a lengthy profile of the British up-and-comer, and sent photographer Bill Ray to trail Caine as he shot the heist film *Gambit* in Los Angeles, opposite Shirley MacLaine. "Michael Caine seemed to find his newly minted stardom and just about everything else about movie-making amusing," Ray remembers. "When the break for lunch came around, everybody, cast and crew, were happy to walk the 300 or 400 yards to the commissary to stretch their legs. Not Michael Caine. He had a seven passenger Cadillac limousine waiting at the door. 'It's in the contract.' he quipped to me, 'might as well take it.'"[52] The marks on the contact sheet were likely made by *LIFE* photo editor Peggy Sargent. The magazine ran the marked image of Caine reading a newspaper article about himself, headlined "Mind-Changer Caine?"

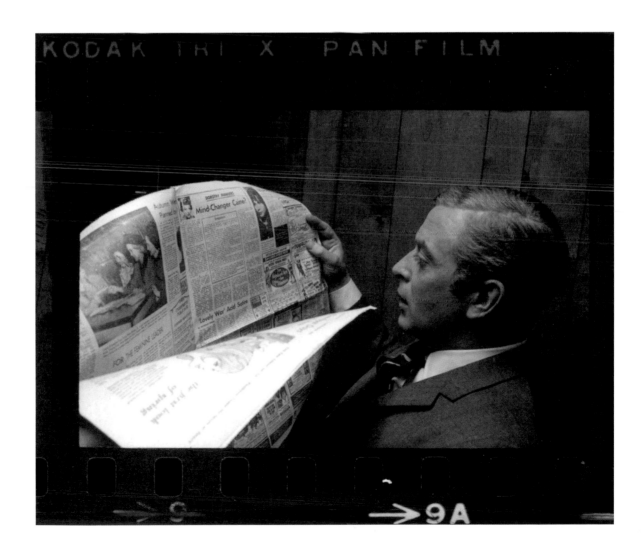

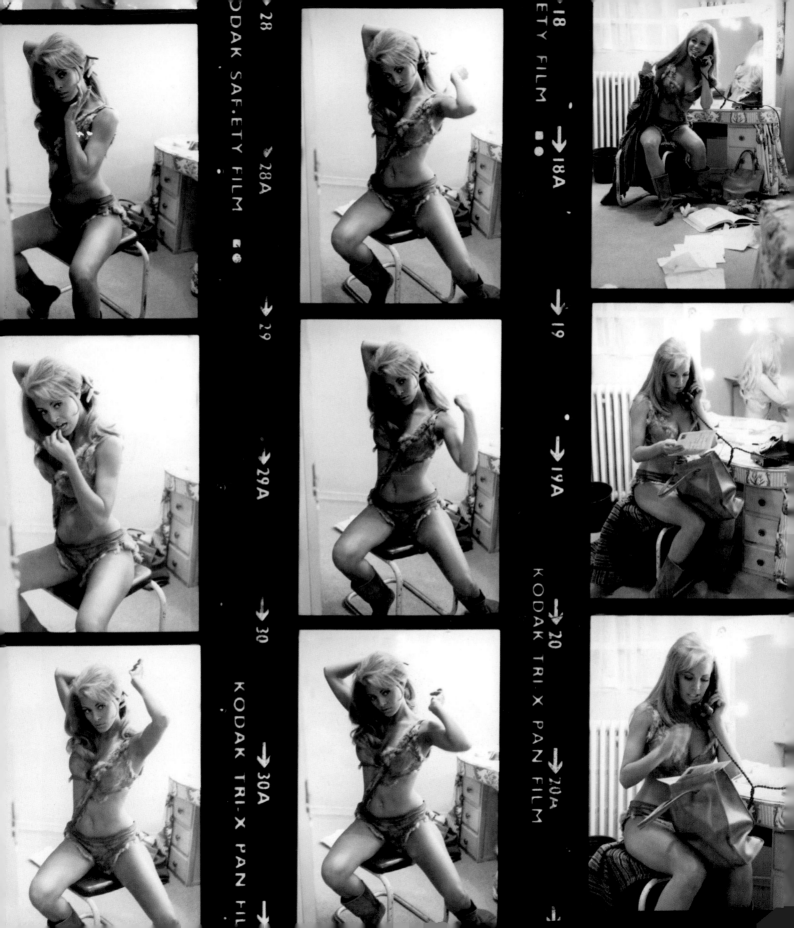

ONE MILLION YEARS B.C.
1966

Director: Don Chaffey
Photographer: Terry O'Neill

———

In 1961, 21-year-old Bolivian-American Jo-Raquel Tejada was a single mom of two young kids, an ex-weather girl then barely making a living as a model and cocktail waitress. Five years later, under the name Raquel Welch, she was a global superstar. After landing a leading role in the sci-fi cult classic *Fantastic Voyage*, Welch was given a small part in *B.C.* as the wearer of "mankind's first bikini," seen here. A photo of Welch in the fur two-piece was used for the film's poster, which became a massive success as a pin-up. "You can't really plan something like that," Welch remembered in 2012. "Every once in a while a unit photographer would come by, during our breaks in shooting, and snap a few pictures of me. I had no idea that those photos would go anywhere, much less be distributed all over the planet. And it happened so fast. After the shoot was over, I flew into Heathrow and the moment I walked off the plane, I knew everything had changed. Suddenly everybody knew who I was."[53]

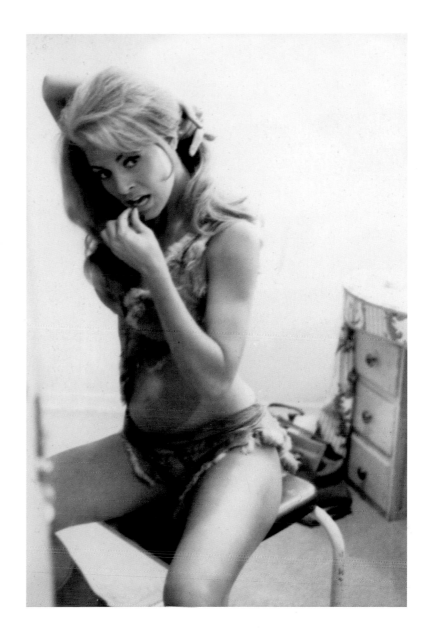

AN INDUSTRY
IN TRANSITION
1967–1980

Still photography has never been the most exalted craft on film sets: as far back as 1946, Jack Warner was ordering his publicity department to cut back on the shooting and printing of stills in order to save money. But like so many institutions in Hollywood, the stills trade underwent massive changes in the late 1960s and 1970s. Studios, weakened by television and by the business and structural changes mandated by anti-monopoly decrees of the late 1940s, stopped signing contract players and promoting their personas in the same heavily artificial way. The portrait galleries, which had been installed on virtually every lot in the 1920s, were depleted as needed to cut costs. And as the fan and picture magazines went into decline, there was simply less need for photos. Later, the advent of the Polaroid camera made it superfluous to have a professional photographer taking continuity images of things such as costumes, props, and makeup. Still, almost all film sets continued to employ a still photographer to take images primarily used for publicity, and outside photographers were still sent to document productions for newspapers and magazines.

The images in this chapter differ from those in the first chapter in a few ways. Though there is no definitive date for the end of Hollywood's classical "golden era," many factors were at work to assure its decline. With the cultural changes ushered in by the rise of Baby Boomer youth culture, the industrial transformations made necessary by the rise of television and international art cinema, the decline of revenue that occurred when the studios were forced to divest their exhibition businesses, and the deterioration of the Production Code system of censorship, by the mid-1960s little was still the same as it had been even a few years earlier.

The logical place to start a chapter documenting Hollywood from the late-1960s through the mid-1980s is with *Bonnie and Clyde*, the film often credited as the first shot fired in the New Hollywood revolution. The contact sheets from this film demonstrate the role of photography in the creation of a different type of movie star, one whose image was that he or she didn't have an image—at least, not in the same heavily constructed manner of the past. Through images shot on the sets of *Once Upon a Time in the West, Apocalypse Now*, and *Raging Bull*, we also see directors beginning to exert a fascination on par with stars. With the shifts in both the power structure in studio filmmaking and the manner in which the media covered Hollywood (not to mention the international advent of auteur studies), there was suddenly a demand for images of filmmakers like Sergio Leone, Martin Scorsese, and Francis Ford Coppola at work, and a growing fascination with directors as personalities.

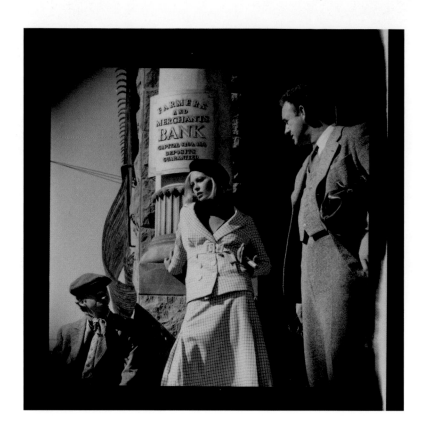

BONNIE AND CLYDE
1967

Director: Arthur Penn
Photographer: Unknown

———

"They're young...they're in love...and they kill people." That was Warner Brothers's ingenious tagline for *Bonnie and Clyde*, the violent art film whose unexpected success helped to usher in a new phase of Hollywood movies focused on charismatic anti-heroes that, over the next decade, would speak to the nation's growing disillusionment. These images of star and producer Warren Beatty, and co-stars Faye Dunaway and Gene Hackman, posed laconically in their period costumes with their guns and their getaway car, are emblematic of the way the film and its promotion centered on the creation of images of rebellious cool. "*Bonnie and Clyde* is about style and people who have style," wrote the film's co-screenwriter David Newman in 2000. "It is about people whose style set them apart from their time and place so that they seemed off and aberrant to the general run of society...surely, their skill as bank robbers was pathetic. But their skill at creating images for the public could have gotten them the Coca-Cola account today."[54] As these frames show, *Bonnie and Clyde* the movie became the source of images symbolizing the change that was coming as a new generation of filmmakers took advantage of the crumbling studio system to launch a brief wave of anti-establishment cinema.

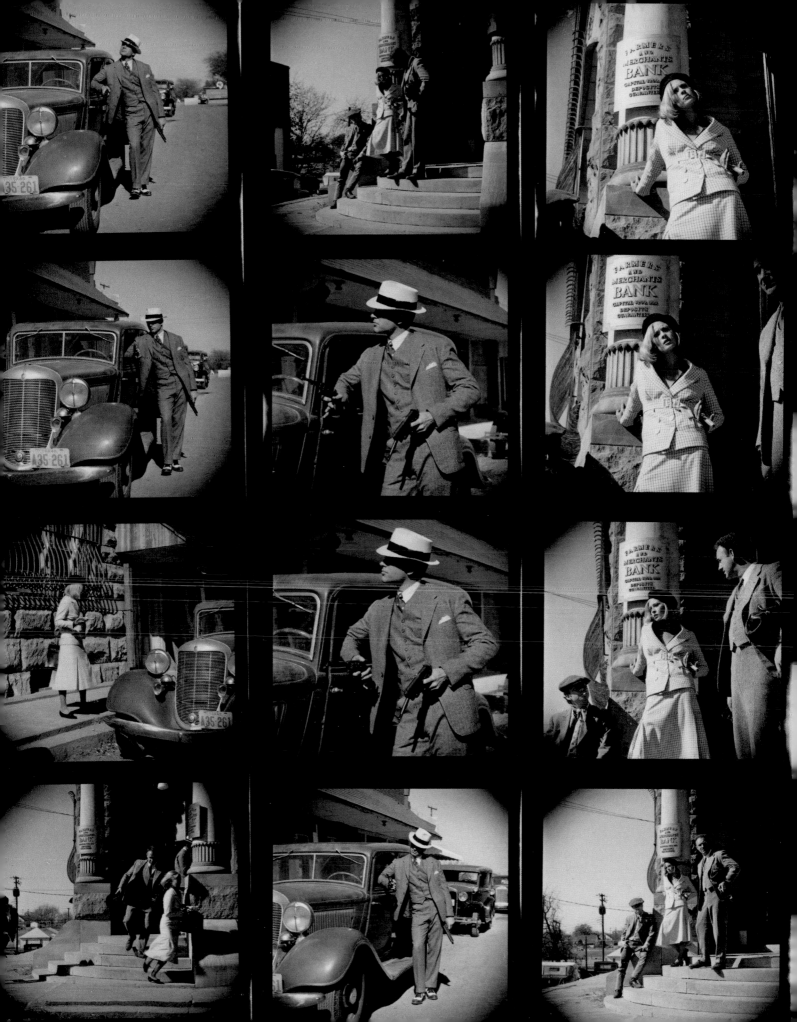

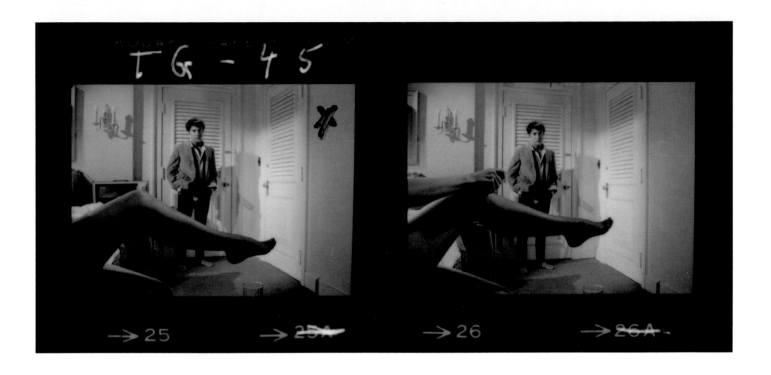

THE GRADUATE
1967

Director: Mike Nichols
Photographer: Frank Shugrue

—

This contact sheet would seem to document the creation of two of the most memorable images from the classic satirical drama that made Dustin Hoffman a star, and with *Bonnie and Clyde*, touched off a new era in American film: the scene in which Benjamin (Hoffman) attempts a post-coital conversation with Mrs. Robinson (Anne Bancroft); and the shot of Benjamin obstructed by his older lover's outstretched leg, which was used for the movie's famous poster. But when it comes to movie still photography, appearances can be deceiving. While the first half of the sheet resembles frames from the finished film closely enough that they could have been shot during the filming of that awkward, intimate scene, the even more famous frames below and shown above were likely taken outside of the shooting schedule, solely for publicity purposes—and the leg likely doesn't belong to Bancroft. Actress Linda Gray, the future star of the TV series *Dallas*, has admitted that she stood in for Bancroft as the uncredited model for *The Graduate*'s poster shoot. "I got paid $25," Gray has said. "For one leg, that was good."[55] Gray would later get to play Mrs. Robinson with her entire body, in a 2001 London theater production of *The Graduate*.

> 32 → 32A → 33 → 33A → 34 → 34A

> 27 → 27A → 28 → 28A → 29 → 29A

.22 → 22A → 23 → 23A → 24 C J L

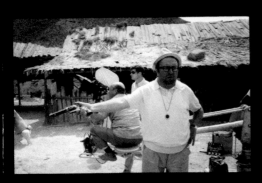

> 17 → 17A → 18 → 18A → 19 → 19A

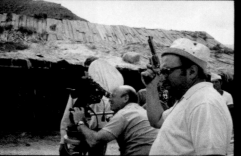

35 → 35 A → 36 → 36 A

Y FILM

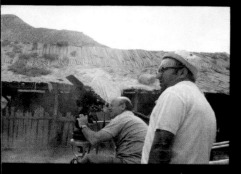
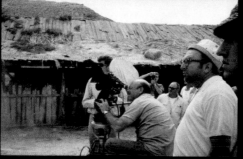

0 → 30 A → 31 → 31A →

5 → 25 A → 26 → 26A →

→ 20A → 21 → 21A →

ONCE UPON A TIME IN THE WEST
1968

Director: Sergio Leone
Photographer: Bill Ray

The Spaghetti western to end all Spaghetti westerns, Leone's epic stands as both a deconstruction of the tropes of the American white hat-black hat saga, and the ultimate embodiment of its pleasures. On assignment from *LIFE* magazine, photographer Bill Ray was embedded in the replica of an American old west town that Leone had built in Almeria, Spain, where cast and crew communicated in a motley mix of English, Spanish, Italian, Serb, and Croatian. "Sergio's English was a bit dodgy and could leave him completely when he got excited," Ray remembers. "If all else failed he would act out in a pantomime how he wanted a scene played." Ray's famous photo of Leone on set, gun in hand, likely documents just such a performative act of direction. "What is Leone doing with a gun? He must be showing an actor what to do with it," Ray recalls. "I don't remember him killing anyone."[56]

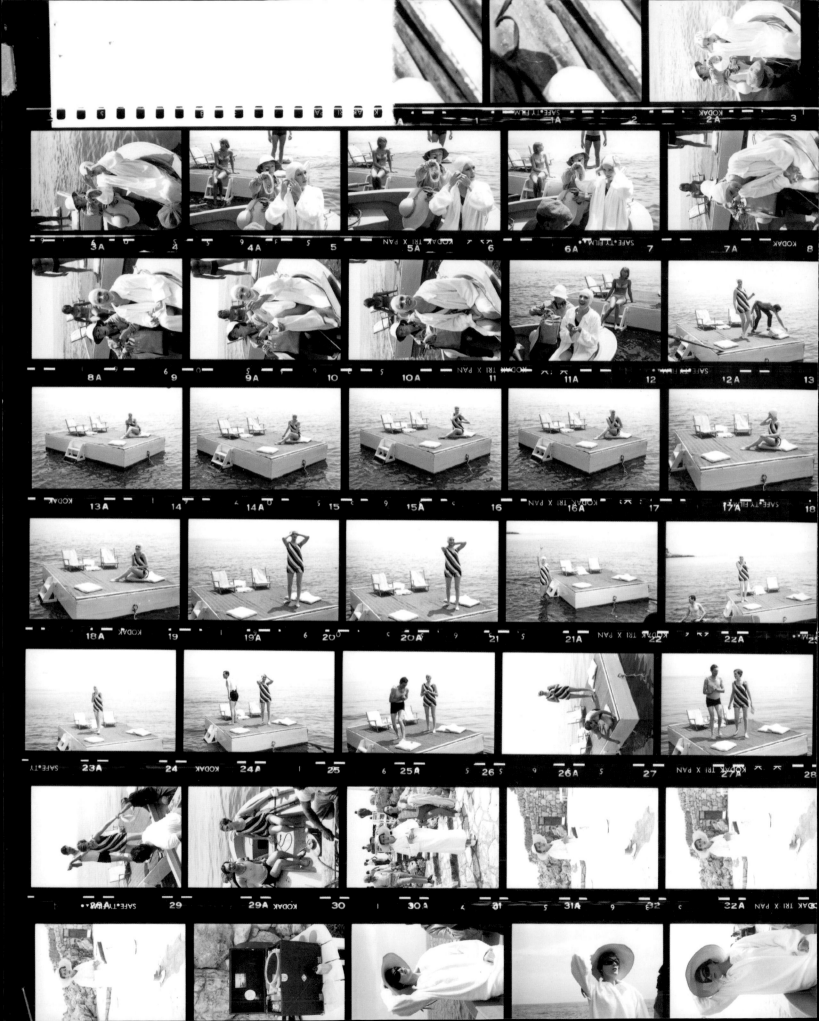

STAR!
1968

Director: Robert Wise
Photographer: Terry O'Neill

—

Musical theater star Gertrude Lawrence was, according to her friend and collaborator Noel Coward, "Magical but quite mad...She had affairs with just about everyone."[57] In casting Julie Andrews—fresh off her triumphs in *Mary Poppins* and *The Sound of Music*—as Lawrence in his lavish musical biopic, director Wise was hoping "to celebrate Julie—with whatever feeling of Gertrude she could get into it."[58] Certainly, there were aspects of Gertrude that were unfamiliar to Julie. In one of the film's most noted scenes, the hard-living Lawrence drinks herself into a stupor at a party thrown in her honor; Wise would later admit that he wasn't sure Andrews had ever been drunk in her life. But other elements hit closer to home. Here Andrews is seen filming in the south of France, a scene that emotionally mirrored what was going on in her own personal life. As Gertie explained to her teenage daughter that she and the girl's father's divorce was mutual, Andrews's own young daughter—the product of the actress's marriage to Tony Walton, which had recently ended—looked on. "I think I understand many of Gertie's problems," Andrews said. "She was terribly insecure and, for much of her life, I think she was very lonely."[59] Coward was not impressed, describing Andrews's performance as "charming, efficient, and very pretty but not very like Gertie."[60] Coward was not the only one disappointed. Released within months of daring and groundbreaking films like *Bonnie and Clyde*, *2001: A Space Odyssey*, and *The Graduate*, the inflated spectacle of *Star!* was out of fashion. It lost millions of dollars.

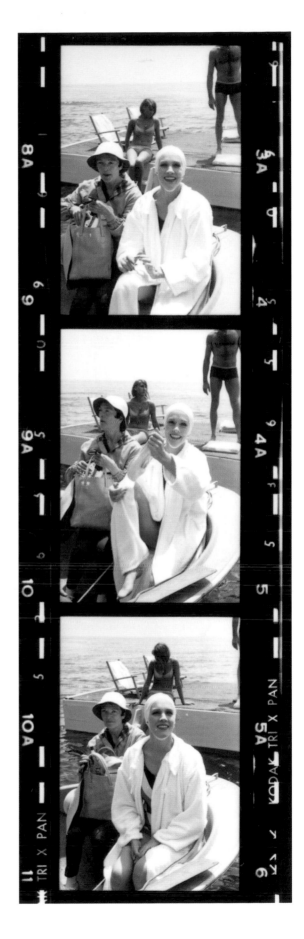

THE THOMAS CROWN AFFAIR
1968

Director: Norman Jewison
Photographer: Unknown

———

In 1968, Faye Dunaway and Steve McQueen were two of the
most bankable, most attractive stars in Hollywood, and Norman
Jewison's cat-and-mouse romance featured both actors modeling
fashions that were just as high ticket and of the moment as the
players themselves. These contact sheets show Dunaway trying
on just a few of her character's 31 costume changes, all of them
designed by Theodora Van Runkle, who had helped to turn the
actress into a fashion plate with her work on *Bonnie and Clyde*.
The look involving the large white hat, from Dunaway's entrance
into the film, became particularly iconic. It was Dunaway's favorite
scene in the movie, and she gave part of the credit to her headwear:
"I walk seemingly for miles in close-up, with dark glasses and
a big hat and a slight smile," she wrote. "You don't know who this
woman is or what she's up to."[61] Just as memorable is the chiffon
dress shown opposite, which Dunaway donned in the film's famous
chess match scene, a highly charged, extenuated tête-à-tête that
builds to what Jewison intended to be "the longest kiss in screen
history." The director added, "I thought this one physical thing
should tell everything about that aspect of their relationship,
so that I wouldn't have to deal with it anymore."[62]

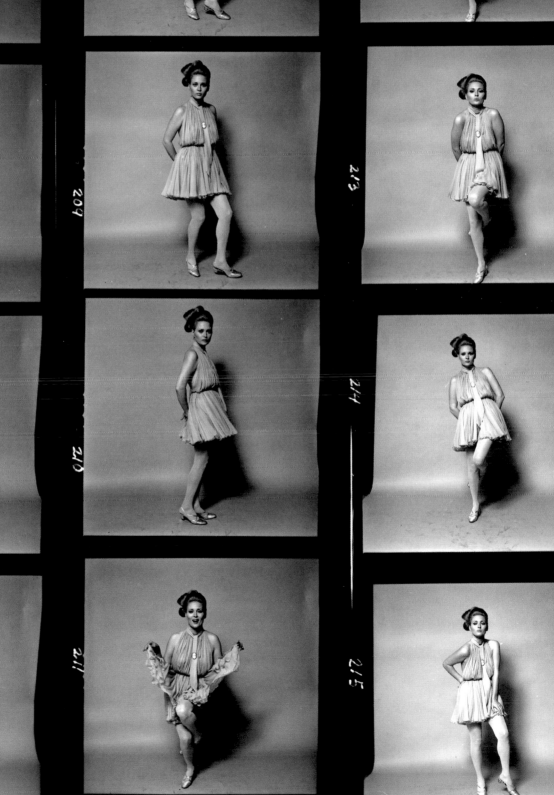
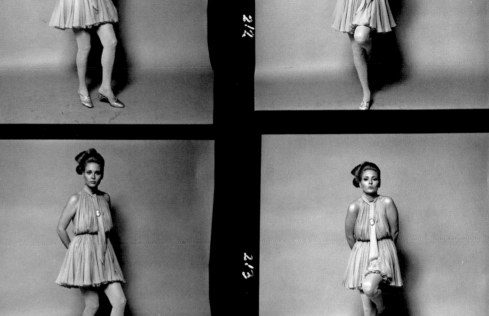

67·184·18

JOHN AND MARY
1969

Director: Peter Yates
Photographer: Terry O'Neill

———

The post-sexual-revolution romantic drama *John and Mary* was a collaboration by a trio of artists at the peak of their stardom: Dustin Hoffman and Mia Farrow had just headlined *Midnight Cowboy* and *Rosemary's Baby*, and director Yates's previous picture had been the Steve McQueen hit *Bullitt*. These kings of the zeitgeist came together to make a film that was unconventional—it tracked, in non-linear style, 24 hours in the life of its title characters, during which an argument about Jean-Luc Godard's *Weekend* in a singles bar leads to a one-night stand, and then true love—while also striving to capture the changing sexual mores of its time. But the swinging singles' scene was not exactly old hat to its lead actress. Farrow had played intimate scenes on screen, in the soap opera *Peyton Place*, before ever going to bed with a man in real life. Her introduction to sex had come through her first husband, Frank Sinatra, and while she was shooting *John and Mary*, Farrow was developing the romance that would result in her second marriage. "What I recall most about the making of that film was that during it a relationship was forming, via telephone, with André Previn," Farrow wrote. She flew to Ireland to be with Previn "the minute *John and Mary* was completed,"[63] and within months, she was married and pregnant with twins.

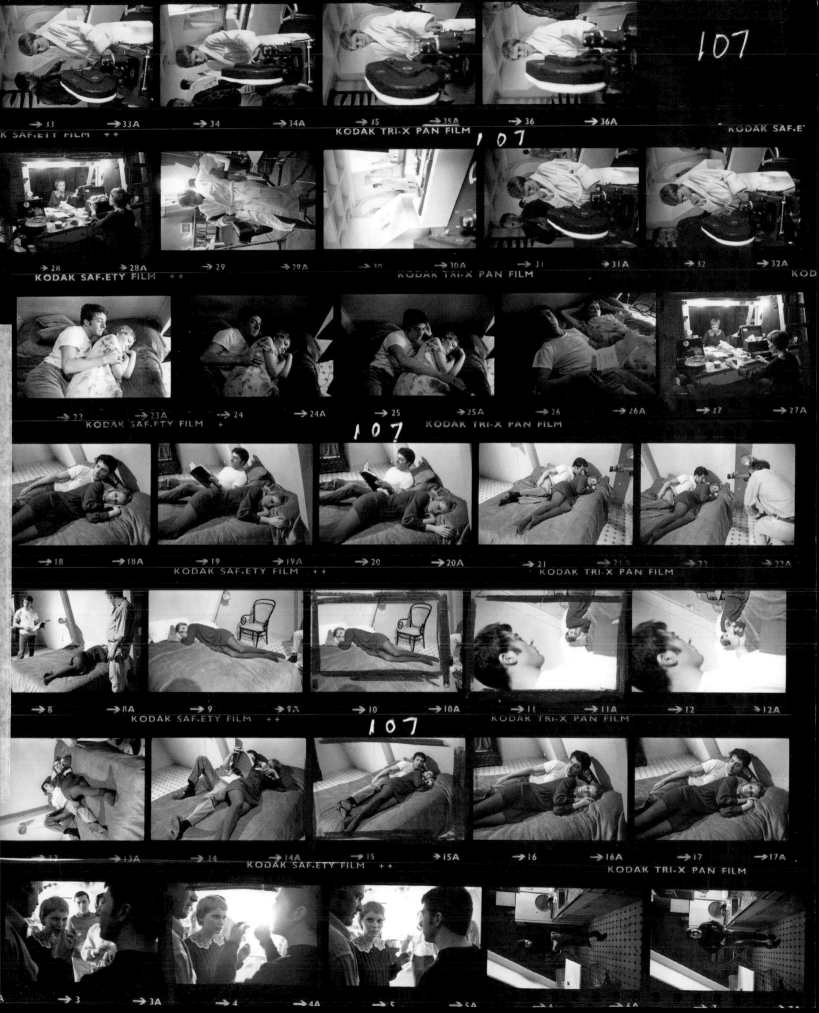

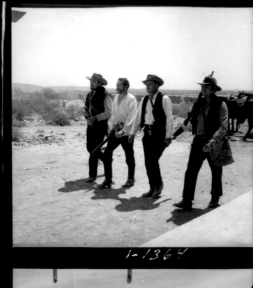

1-1364

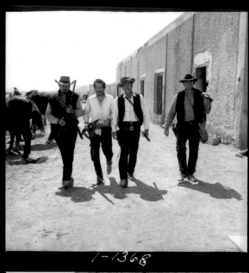

1-1368

1-136_

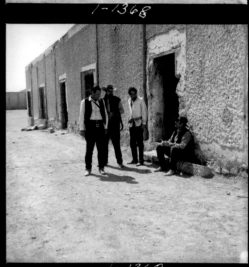

1-1369

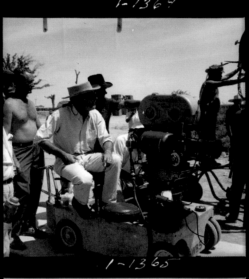

1-1365

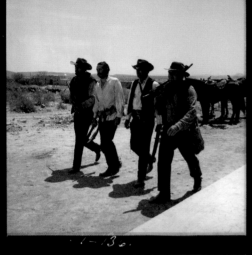

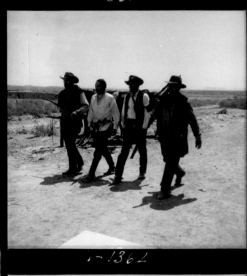

1-1362

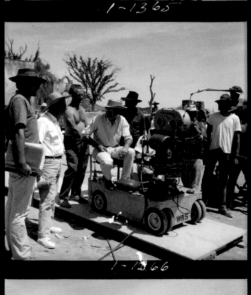

1-1366

1-1370

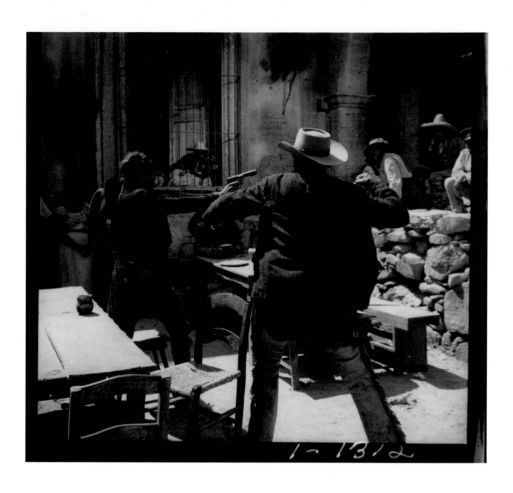

THE WILD BUNCH
1969

Director: Sam Peckinpah
Photographer: Unknown

—

Peckinpah's bloody vigilante epic, starring Ernest Borgnine, Robert Ryan, and William Holden, was set in the waning days of the wild west, but the director meant to make an implicit statement on the war in Vietnam, and the violent imagery being beamed from the battlefields into American living rooms every night. Perhaps because of these parallels to real, contemporary life, the film ignited fierce debate on its initial release, with some critics condemning its ultra-violent imagery, and others praising Peckinpah's use of vivid technique to impress on the viewer an argument that critic Roger Ebert described as "paradoxically, a statement against violence, and a reaction to it." The film was so extreme that even the performers themselves weren't always sure how they felt about it. "When we were actually shooting, we were all repulsed at times," admitted Borgnine. "There were nights when we'd finish shooting and I'd say, 'My God, my God!' But I was always back the next morning, because I sincerely believed we were achieving something."[64]

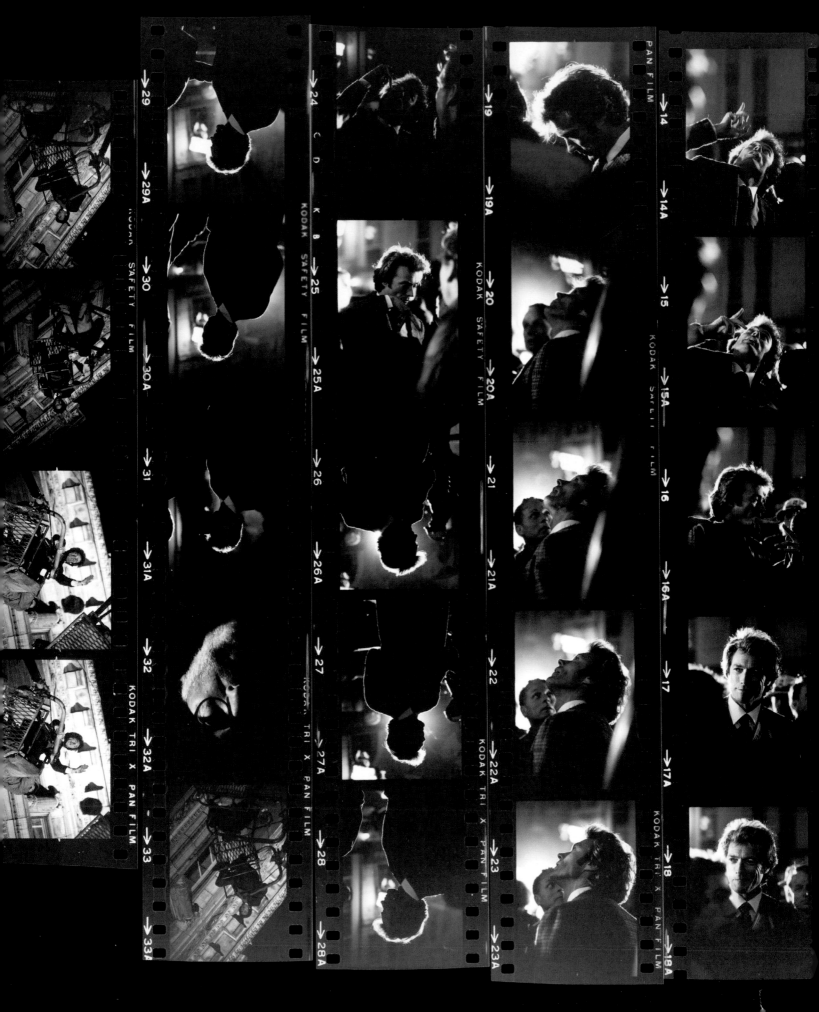

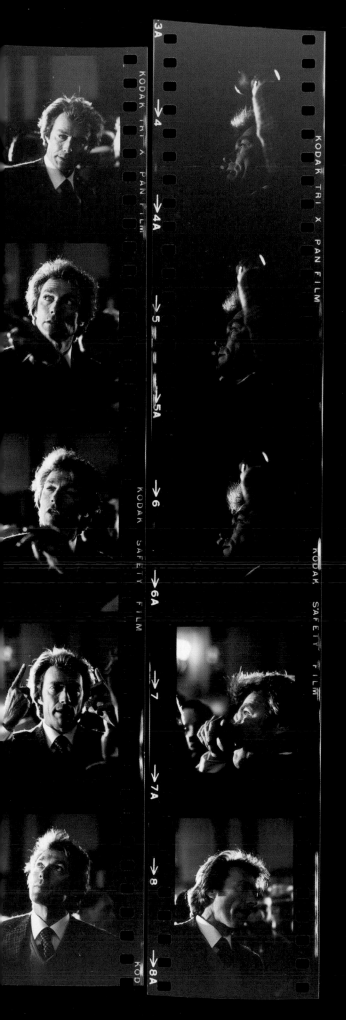

DIRTY HARRY
1971

Director: Don Siegel
Photographer: Bill Eppridge

———

The character of Harry Callahan is now considered a hallmark of Clint Eastwood's acting career, one he'd reprise in four sequels in the 17 years after the first film hit it big at the box office. But Eastwood was only offered the script after a number of other actors—including Robert Mitchum, Burt Lancaster, Frank Sinatra, and John Wayne—turned down the part. For his part, Eastwood took the role on two conditions: that the location be moved to San Francisco, a city still reeling from the Zodiac murders that the story paralleled, and that his frequent collaborator Siegel be hired to direct. Eastwood and Siegel had a close enough working relationship that one night, when Siegel was felled by the flu, Eastwood—who had just finished directing his first feature, *Play Misty for Me*—stepped in to direct a scene in that Harry rides a crane to talk to a suicidal man threatening to jump from an apartment window. This contact sheet appears to document that night, and Eastwood's double act, both appearing on camera in the crane, and discussing the shot from safe on the ground.

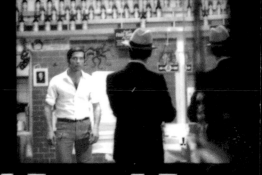

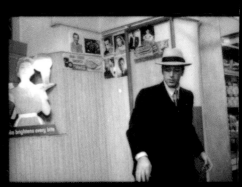

THE GODFATHER
1972

Director: Francis Ford Coppola
Photographer: Unknown

Francis Ford Coppola fought hard to cast Al Pacino—then
a New York theater actor who had starred in just one feature
film, *The Panic in Needle Park*—in the crucial role of Michael
Corleone in his adaptation of *The Godfather*. Peter Bart, of
The Godfather studio Paramount, had chosen Italian-American
Coppola to direct the film in the name of authenticity; he and
Paramount chair Robert Evans wanted to "smell the spaghetti."[65]
But Evans, who dismissed Pacino as a "runt," pushed for a more
conventionally handsome actor, like Robert Redford or Warren
Beatty, or even James Caan. Evans eventually relented, on the
condition that Coppola cast Caan as Michael's brother Sonny.
The film would catapult Pacino to the top of the acting A-list,
but though his performance is the heart of *The Godfather*, Pacino
had to settle for a Best Supporting Actor nomination come Oscar
time. Marlon Brando, whose performance as the Corleone family
don was heavily aided by makeup and prosthetics (seen overleaf),
would be nominated for Best Actor in Pacino's place—and win.
The perceived slight meant enough to Pacino that he boycotted
the Oscar ceremony. On the night, Brando was a no-show too,
but for different reasons: in his place, Brando sent Apache
civil rights activist Sacheen Littlefeather. When Brando was
announced as the winner on Oscar night, Littlefeather took
to the stage and refused to accept the prize on Brando's behalf,
citing "the treatment of American Indians today by the film
industry" as the actor's impetus. Roger Moore, who had presented
the award, took the statuette home with him; it was eventually
collected by the Academy and given to Charlie Chaplin to

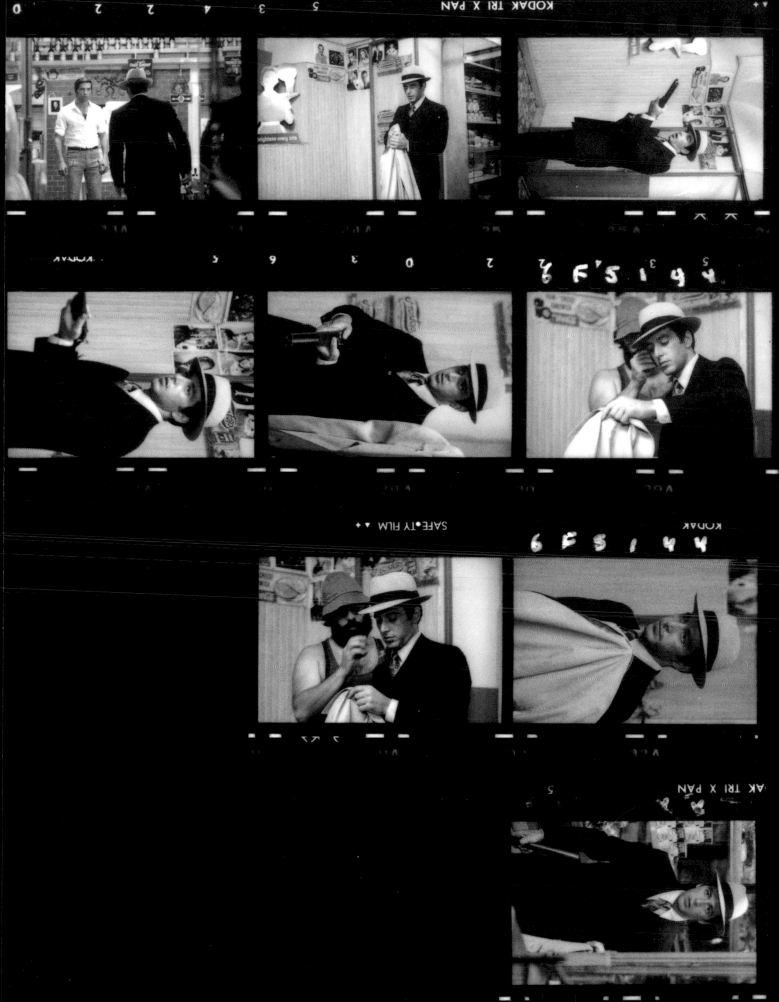

The look of Marlon Brando's aged Vito Corleone was the opposite of a flashy movie gangster. Urban legend holds that Brando stuffed his mouth with cotton balls for the screen test, but for filming the actual movie, Brando relied on the tools and frequent administrations of makeup maestro Dick Smith, who created a dental implant to create jowls. Smith is such a legend in his own right that he's sometimes referred to as "The Godfather of Makeup."

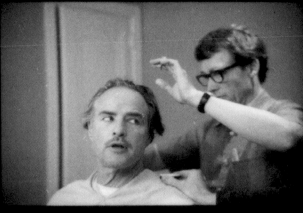

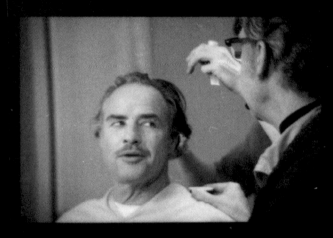

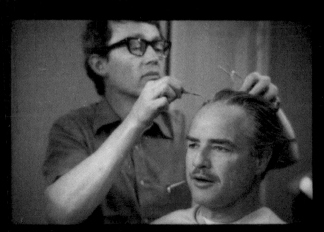

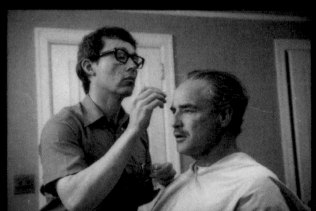

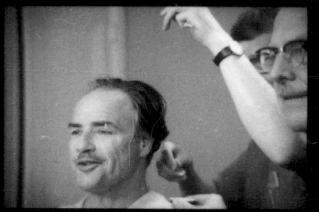
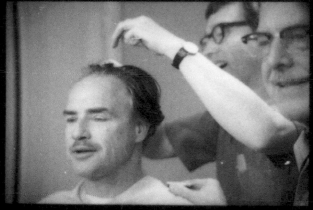

CHINATOWN
1974

Director: Roman Polanski
Photographer: Steve Schapiro

———

These images taken on the set of one of the most devastating American movies
of the 1970s—Polanski's first Hollywood-set production since the Manson Family's
murder of his wife, Sharon Tate, in 1969—have a levity to them that would seem
to be discordant with both the content of the movie and the reported vibe on set,
where Polanski clashed with writer Robert Towne, cinematographer Stanley Cortez
(who was fired after ten days), actress Faye Dunaway, and star Jack Nicholson.
Polanski and Nicholson were friends, and the latter was usually a consummate
professional, but one day the director felt his basketball-fanatic star was more
interested in a televised Lakers game than the day's shooting schedule. Frustrated by
Nicholson's level of distraction, Polanski barged into the star's trailer and smashed
the television set, causing the actor to storm off the studio lot. Later that day,
Nicholson and Polanski somehow ended up stopped next to one another at a
traffic light. "Suddenly struck by the comedy of the situation, I grinned at him,"
Polanski later remembered. "He grinned back, and we both started laughing."[66]

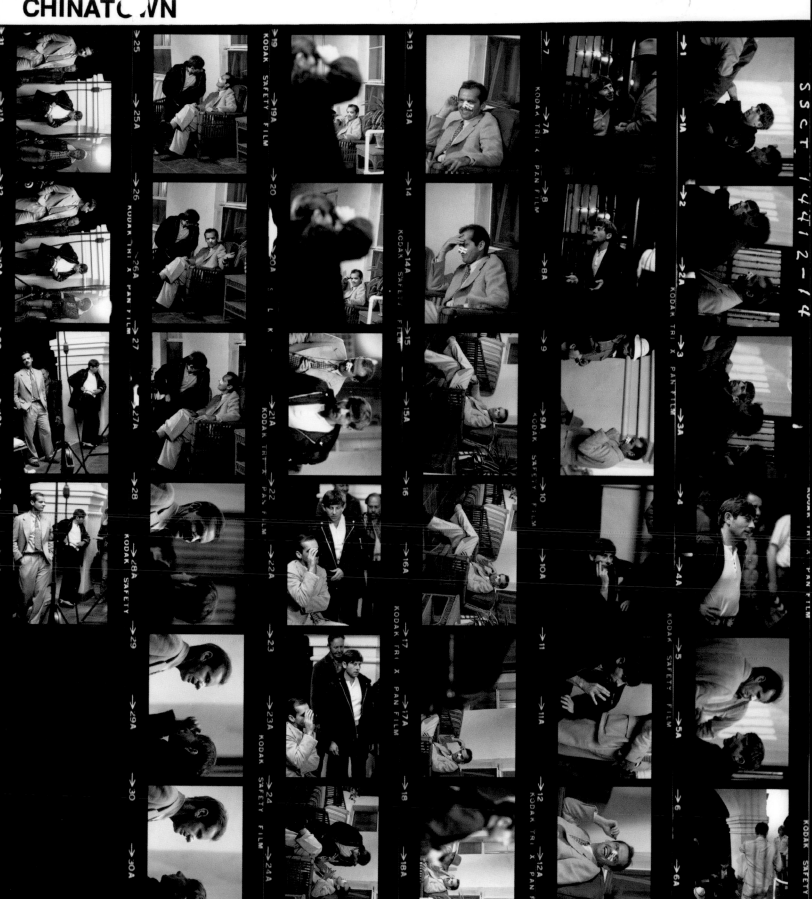

LOVE AND DEATH
1975

Director: Woody Allen
Photographer: Ernst Haas

In hindsight, *Love and Death* seems like a pivotal work in Woody Allen's long and continually vital filmography. A wide-ranging satire of Russian literature woven through with homages to Allen's personal favorite comedians and filmmakers (including Ingmar Bergman and The Marx Brothers), the film serves as a bridge between Allen's so-called "early, funny" period, and more artistically sophisticated, apparently more personal films like *Annie Hall* (1977) and *Stardust Memories* (1980). But for Allen himself, the *Love and Death* shoot is most memorable for being extraordinarily unpleasant. "When good weather was needed, it rained," he later said. "When rain was needed, it was sunny. The cameraman was Belgian, his crew French. The underlings were Hungarian, the extras were Russian. I speak only English—and not really that well. Each shot was chaos. By the time my directions were translated, what should have been a battle scene ended up as a dance marathon."[67] Here photographer Haas captures Allen the director in what looks like anxious conversation with his crew, and Allen the actor playing a scene in which his bumbling coward character seeks refuge from battle in a canon—a respite the filmmaker himself probably needed.

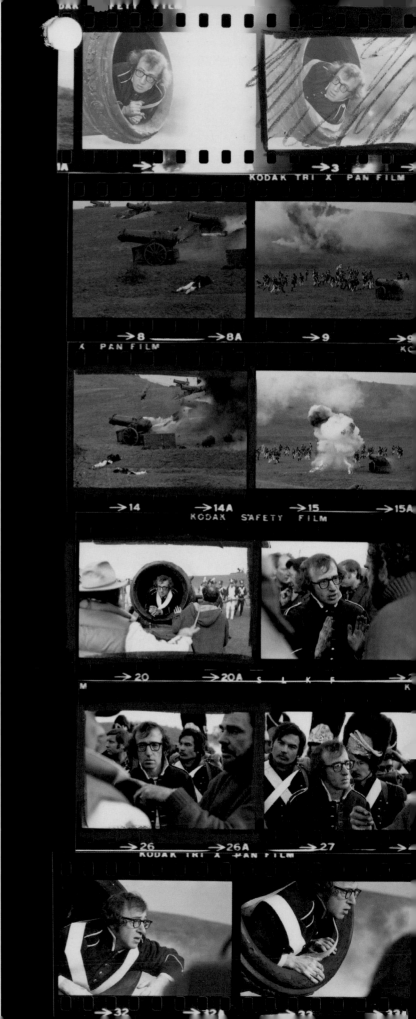

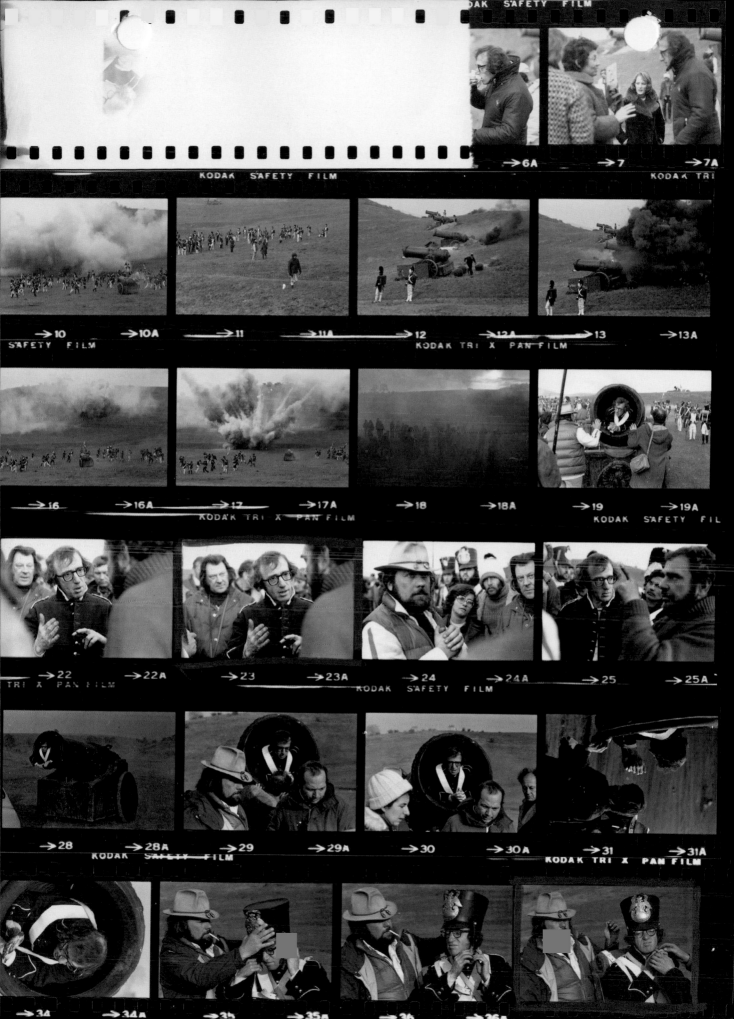

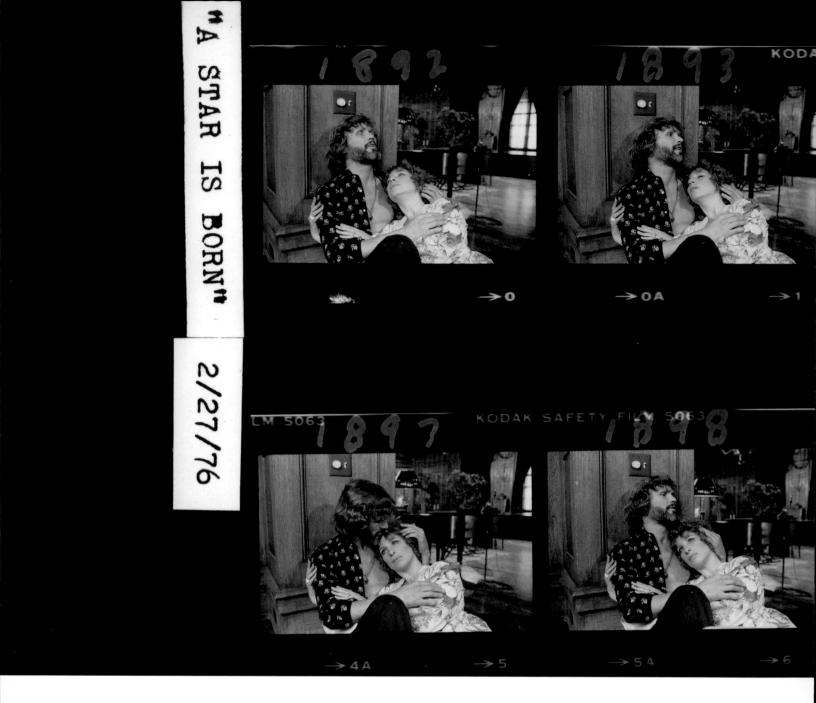

A STAR IS BORN
1976

Director: Frank Pierson
Photographer: Unknown

—

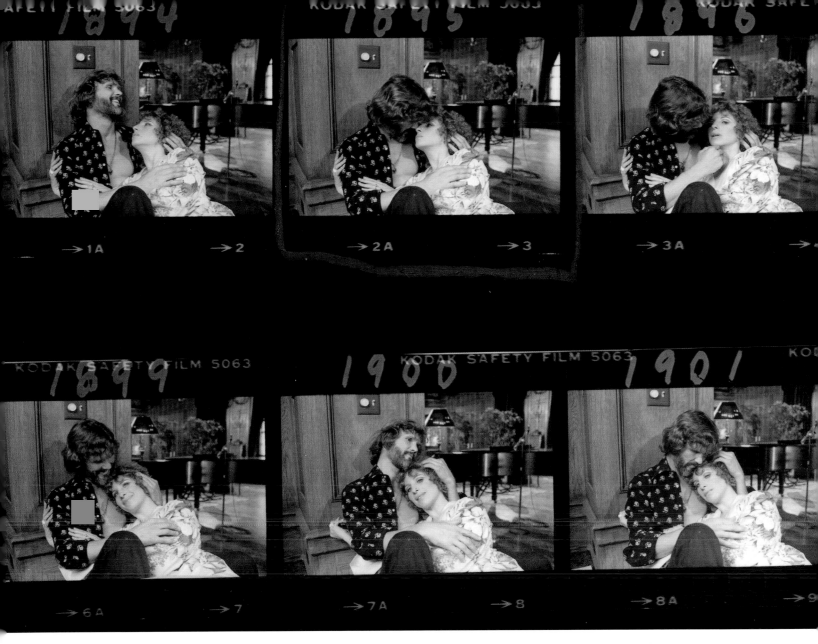

In 1954, Judy Garland and her then-husband Sid Luft produced a remake of a 1937 bit of Hollywood self-mythology called *A Star Is Born*, in the hopes of reviving the troubled Garland's career through a musical spectacular tailored to her talents and autobiography. More than two decades later, Barbra Streisand and her then-boyfriend Jon Peters tried the same trick, making their own version of *A Star Is Born* co-starring Kris Kristofferson. The major difference was that Streisand was at the top of her career, and had nowhere to go but down—which she did, at least emotionally, when the director assigned to the movie, Frank Pierson, published an exposé in *New West* magazine detailing his problems dealing with Streisand, including what he sketches as her diva-like demands, ego-driven delusions, and directorial interference. Streisand felt bruised by Pierson's

revelations—among other things, she called the article "so immoral, so unethical, so unprofessional, so undignified, with no integrity, totally dishonest"[68]—but the film wasn't exactly hurt: it stood as the biggest box office hit of Streisand's career until *Meet the Fockers* (2004). Pierson was not the first nor the last Streisand collaborator to describe her as being fiercely protective of her image; in fact, the single shot selected in marker on this contact sheet is the only frame in which the left side of Streisand's face (which, according to Pierson's article, she felt was her "good" side) squarely faces the camera. That shot closely resembles the "about-to-kiss" image used for the film's poster, although in the final layout, Streisand's distinctive profile would compete with Kristofferson's bare chest for the viewer's attention.

CARRIE
1976

Director: Brian De Palma
Photographer: Marv Newton

—

Brian De Palma has said that the prom prank that touches off the climax in *Carrie*—in which Sissy Spacek, as the titular outcast-turned-prom queen, is doused with a bucket of pig blood—was easy enough to shoot; art director Jack Fisk simply climbed a ladder and tipped the bucket full of Karo syrup and dye over the actress, who happened to be Fisk's wife. It wasn't so easy for her. "At first the 'blood' felt like a warm blanket, but it quickly got sticky and disgusting," Spacek remembers.[69] "I had to wear that stuff for days." Nepotism had played no role in Spacek's casting; in fact, De Palma had tried to discourage Spacek from even screen testing. "I was convinced that Brian only thought of me as Jack Fisk's wife," Spacek remembers, "...and I was going to prove him wrong."[70] She stayed up all night before the test reading the novel, and then showed up on set wearing an ill-fitting hand-me-down dress, with Vaseline smeared in her hair. "I looked like a total dork, and that was the point."[71] And it worked. "Jack told me that as soon as I came on screen, they knew they had finally met Carrie."[72]

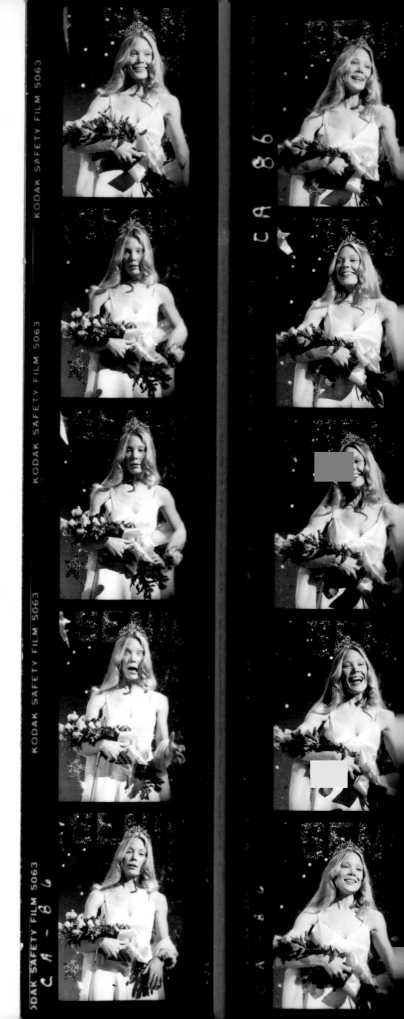

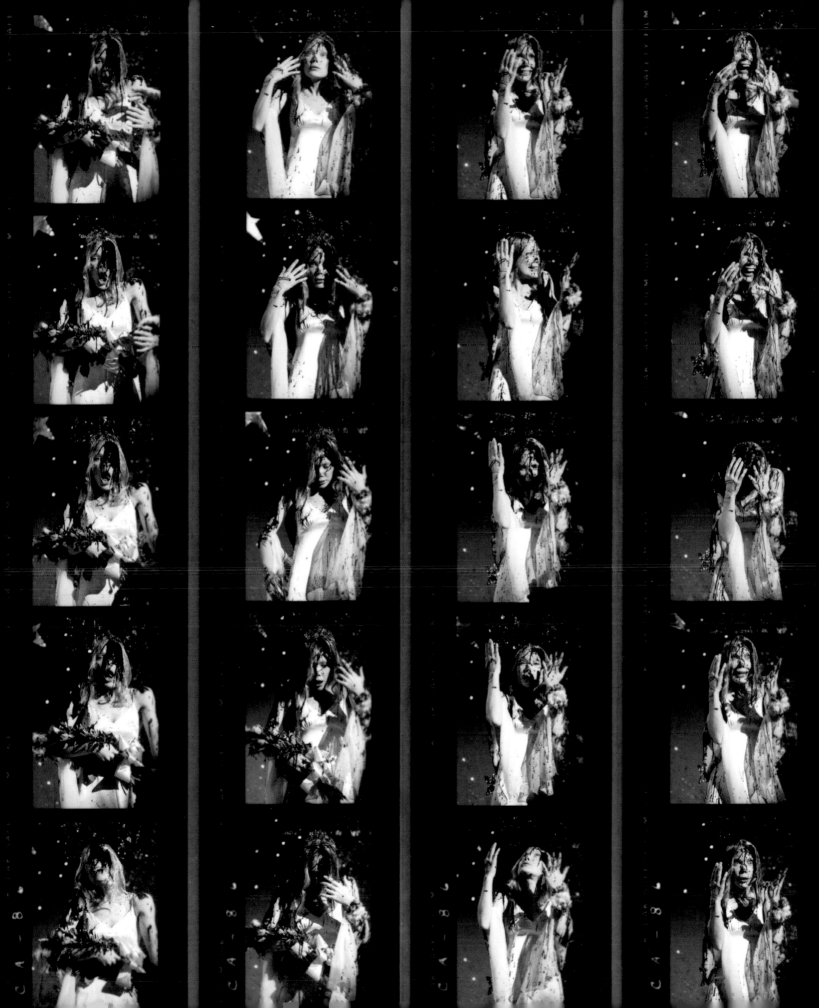

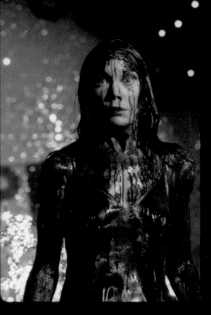
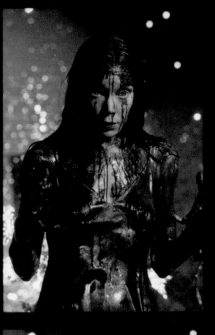
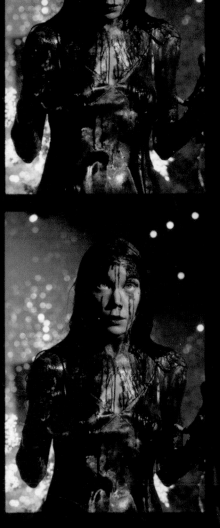
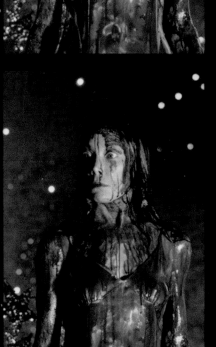
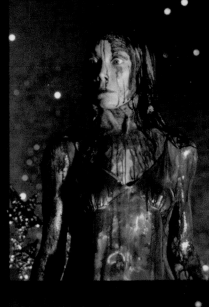
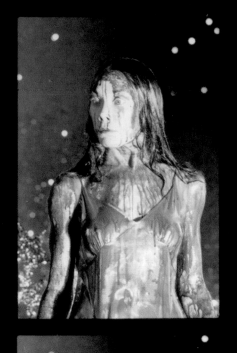
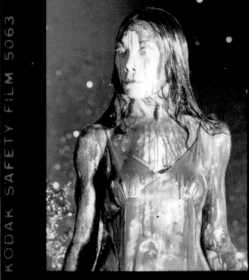
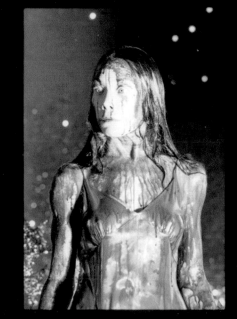

KODAK SAFETY FILM 5063

CA 133

KODAK SAFETY FILM 5063

KODAK SAFETY FILM 5063

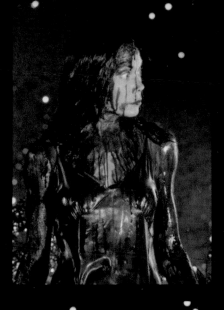
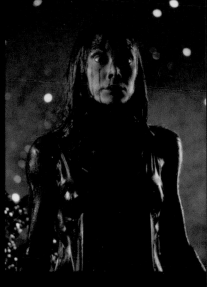

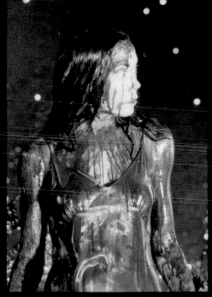

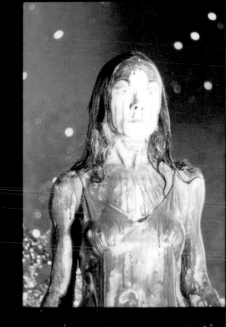
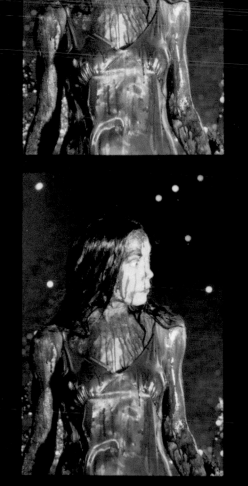

KODAK SAFETY FILM 5063

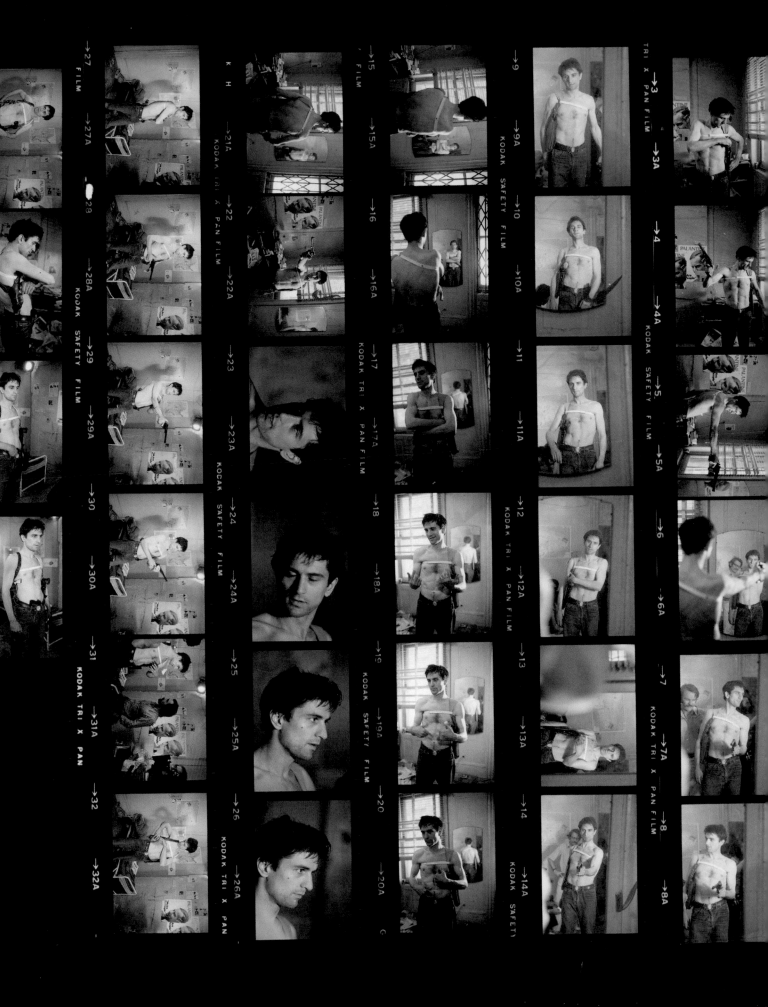

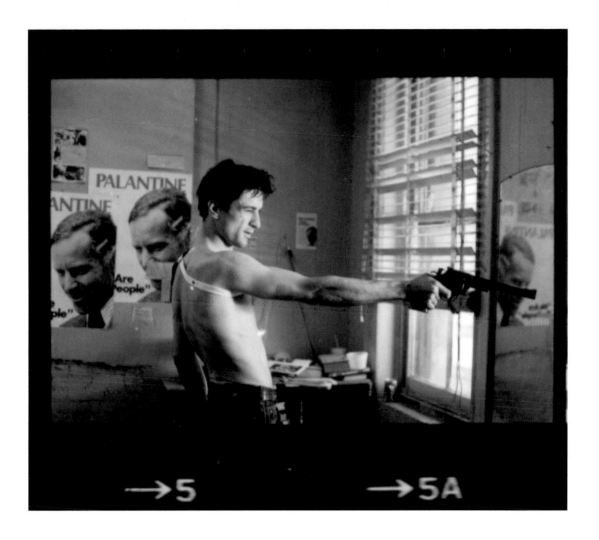

TAXI DRIVER
1976

Director: Martin Scorsese
Photographer: Steve Schapiro

—

Travis Bickle's "you talkin' to me?" monologue in front of the mirror in *Taxi Driver* has become the most iconic moment of Martin Scorsese's film, and perhaps of Robert De Niro's entire career. But there's some debate as to how that phrase actually made it into the movie. The lines weren't in Paul Schrader's original script, which merely gave the direction, "Travis speaks to himself in the mirror." De Niro improvised the speech. "Bobby asked me what he would say and I said, well, he's a little kid playing with guns and acting tough,"[73] remembered Schrader. The screenwriter said De Niro was imitating an underground New York comedian, but according to saxophonist Clarence Clemons, who worked with De Niro on his next film, *New York, New York*, "you talkin' to me" was inspired by Bruce Springsteen, who De Niro heard repeating the phrase to fans who were shouting his name at a concert. Scorsese remembers the scene coming together as a three-hour improvisation. "I was sitting at [De Niro's] feet with my headphones on. Because the noises from the street were drowning his voice, I asked him to repeat it: 'Again! Again!' Gradually he found a rhythm."[74]

A BRIDGE TOO FAR
1977

Director: Richard Attenborough
Photographer: Terry O'Neill

———

Robert Redford had initially turned down the role of Major Julian Cook in this World War II ensemble piece detailing the failed Operation Market Garden. After starring in and producing *All the President's Men*, he had planned to take some time away from acting to focus on Sundance, the resort he was building in Utah, and his political activism. But with producer Joseph E. Levine's other option, Steve McQueen, playing hardball on his fee, Redford's agent was able to land his client an offer of $2 million in salary for four weeks of work, plus bonuses if the shoot went overtime—cash Redford needed. It was an offer Redford couldn't refuse, but the European shoot was no cakewalk. The continent, according to Redford, "was saturated with *All the President's Men*, and by association I was being connected with the downfall of Richard Nixon. I'd rarely had to use personal security guards, but the violations were freaky."[75] Those security guards soon discovered there was a kidnap plot against the movie star. "The security guy literally threw me in the back of a car and took off for the border like he was competing at Le Mans," Redford remembered later. "I thought it was melodrama and, to be honest, I believed none of it. I was wrong." An independent investigation proved "that those people were real, and their order to get me was real. I read the reports, I saw the evidence, and it horrified me."[76]

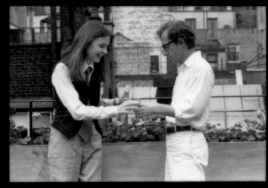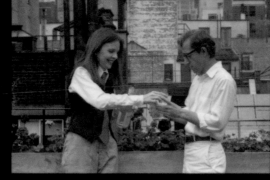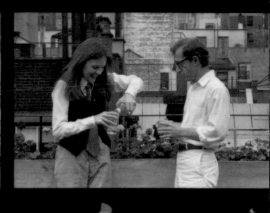

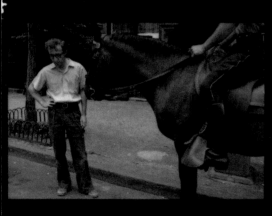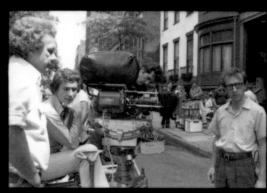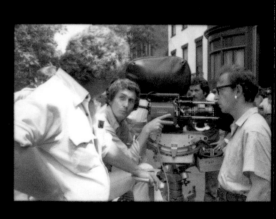
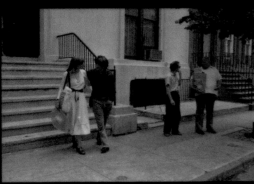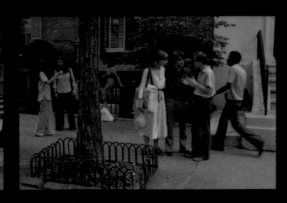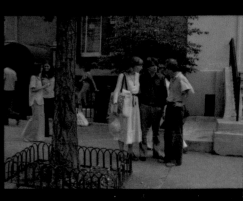

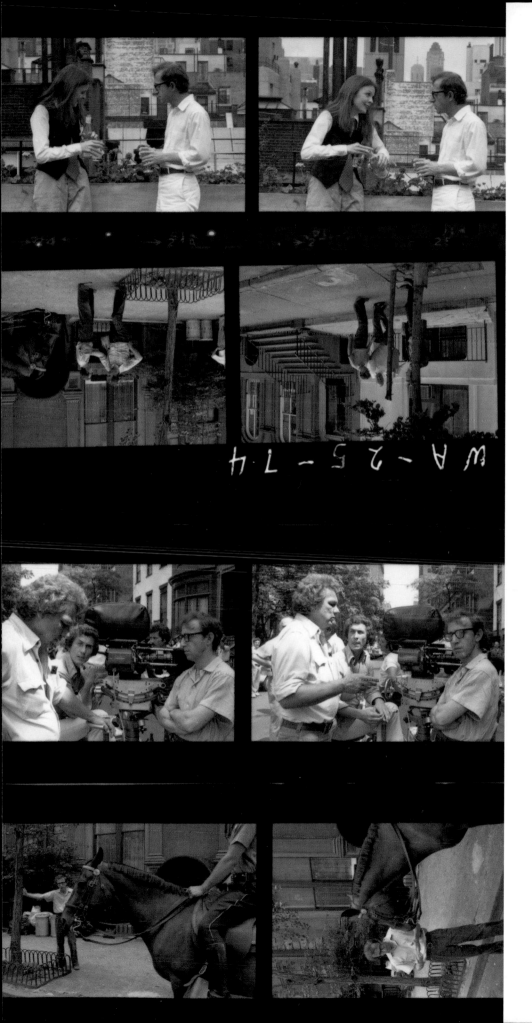

ANNIE HALL
1977

Director: Woody Allen
Photographer: Brian Hamill

—

This sheet contains iconic images of Diane Keaton dressed in the "menswear" look that became a late-1970s fashion sensation after the release of Woody Allen's Best Picture Oscar-winning feature. Allen, who wrote the script with his ex-girlfriend Keaton in mind, has often downplayed the autobiographical nature of the film, but he freely acknowledges that Annie's fashion sense was the same as Diane's. "[Keaton] came in, and the costume lady on the picture, Ruth Morley, said, 'Tell her not to wear that. She can't wear that. It's so crazy.' And I said, 'Leave her. She's a genius. Let's just leave her alone, let her wear what she wants.'"[77] Allen extended the "leave it be" approach to his unit still photographer. Hamill, who had already taken photos on the sets of films such as *A Woman under the Influence* and *The Conversation*, met Allen at the legendary Elaine's restaurant in New York, and was soon hired to shoot stills on the set of *Annie Hall*. He went on to photograph every Allen production after, up until *Melinda and Melinda* in 2004. "I've never asked him why he hired me—all I know is that he gave me the job and never gave me any ground rules or instructions," Hamill mused in 1995. A still photographer, Hamill has said, has two key jobs: to "figure out what the dramatic point of each scene is, and get a picture of that key moment"; and to get those shots "without disturbing anybody's concentration."[78]

Famous for his phobias, Allen braved live
lobsters for this scene constituting one of Alvy
and Annie's most bizarrely romantic memories.
Allen also threaded several references to lobster
(a food forbidden by Jewish dietary law)
throughout the film. In 2009, Allen published
a short story in the *New Yorker*, in which a man
swindled by Bernie Madoff is reincarnated as
a lobster—and gets his revenge.

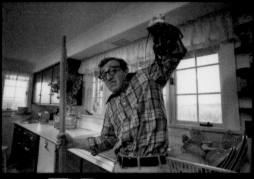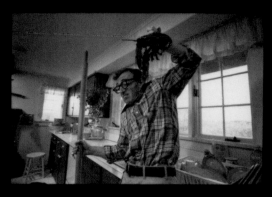

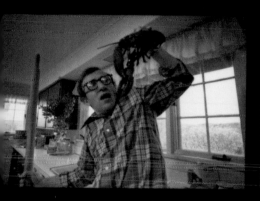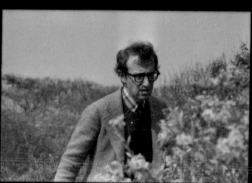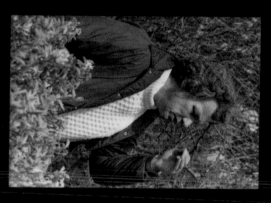

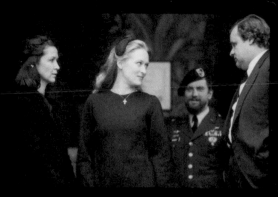
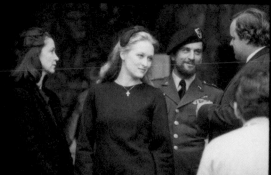
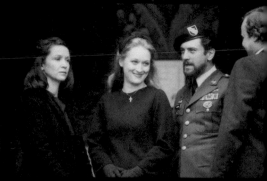

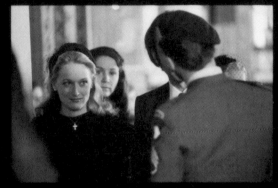
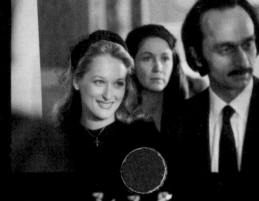

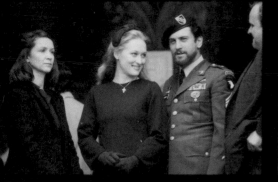
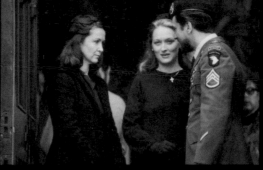
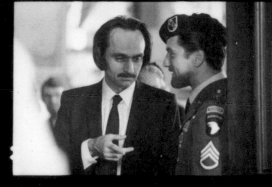

→ 27A **3174** → 28 →28A **3175** → 29 → 29A **3176** → 30

ETY FILM 5063 KODAK SAFETY FILM 5063 KODAK SAFETY FILM

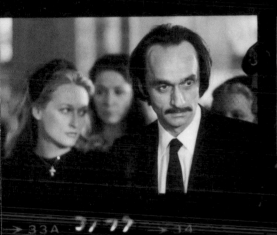
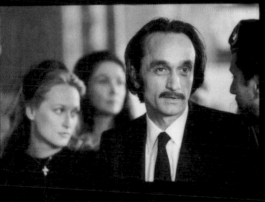
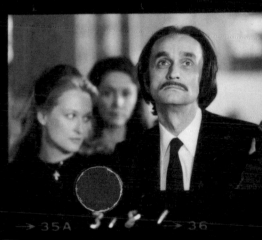

→ 33A **3177** → 34 → 34A **3180** → 35 → 35A **3181** → 36

THE DEER HUNTER
1978

Director: Michael Cimino
Photographer: Wynn Hammer

———

Meryl Streep made her film debut in *Julia* (1977), but her first significant role—and first Oscar nomination—came with Cimino's Best Picture-winning epic tracing the impact of the Vietnam War on a handful of friends from a small mining town. Here we see her playing Linda, the sheltered and demure young woman who becomes the object of affection of both Robert De Niro's stoic Michael and Christopher Walken's Nick. Also pictured is John Cazale, with whom Streep was romantically involved off-screen. *The Deer Hunter* was the last of the five films Cazale would star in—including *The Godfather, The Godfather Part II, Dog Day Afternoon*, and *The Conversation*—all of which were nominated for Best Picture. At the time of shooting, he was suffering from bone cancer; he'd die in March 1978, before *The Deer Hunter* was released. In their short time together, Cazale influenced Streep's acting process immensely. As she'd marvel long after Cazale's death, "His compassion for the people he was portraying, and the responsibility he felt to a fictional character, as though it were a real soul—that made him go that deep into his characters, and do beautiful, beautiful work."[79]

APOCALYPSE NOW
1979

Director: Francis Ford Coppola
Photographer: Unknown

———

Coppola's Vietnam epic is widely regarded as one of the greatest, most ambitious films of its era—and also acknowledged to be the product of one of the most troubled film shoots of all time. These contact sheets from an unknown photographer, as chaotic as the shoot itself, are tribute to how much on-set photography had evolved over the previous decades. The notion of a staged "behind-the-scenes" shot, or recreation of scenes from the film, couldn't apply to a production this far out of the realm of studio system control—a shoot that proceeded largely off-script, at the whim of the weather and between roadblocks caused by various drug problems and illnesses of cast and crew, as well as the demands of the Philippine government. It's also a sign of the new world order that for all of the stars on set—Martin Sheen and Robert Duvall are pictured; the cast also included Dennis Hopper, Marlon Brando, and a young Harrison Ford—the photographer paid most attention to Coppola, the larger-than-life (even after having lost 100 pounds due to the stress of the shoot) presence in nominal control of this mad venture.

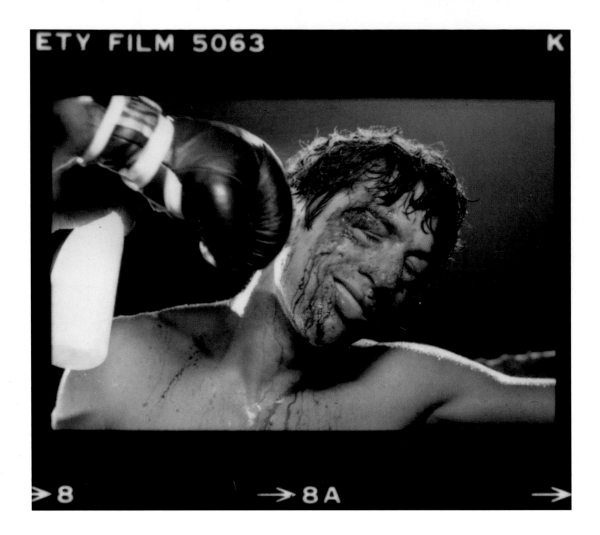

RAGING BULL
1980

Director: Martin Scorsese
Photographer: Christine Loss

Traditional notions of, and divisions between, star and director were complicated
in the making of Scorsese's landmark biopic of boxer Jake LaMotta, a fact attested
to by these contact sheets taken by longtime Hollywood still photographer Christine
Loss. Scorsese, seen overleaf, was one of the dozen or so young American directors
who had come to prominence in the 1970s and enjoyed the kind of celebrity once
reserved for camera-ready stars with heavily constructed personas. Meanwhile,
Robert De Niro was extraordinarily active behind-the-scenes: he brought the
material to an initially reluctant Scorsese, and later worked with the director
to revise and redevelop the film's screenplay. The Method-trained De Niro also
resisted some of the typical trappings of stardom, including posing for publicity
photos. As Loss recalled in 1989, the actor "never wanted to see a still camera
pointed at him. It just made him very distracted. So my strategy was to stay out of
his eye-line and still manage to get great shots—even the enhanced poster shot."[80]
Though vexed by the process, De Niro was happy with the results, and he invited
Loss to shoot on the set of his next film, *True Confessions*.

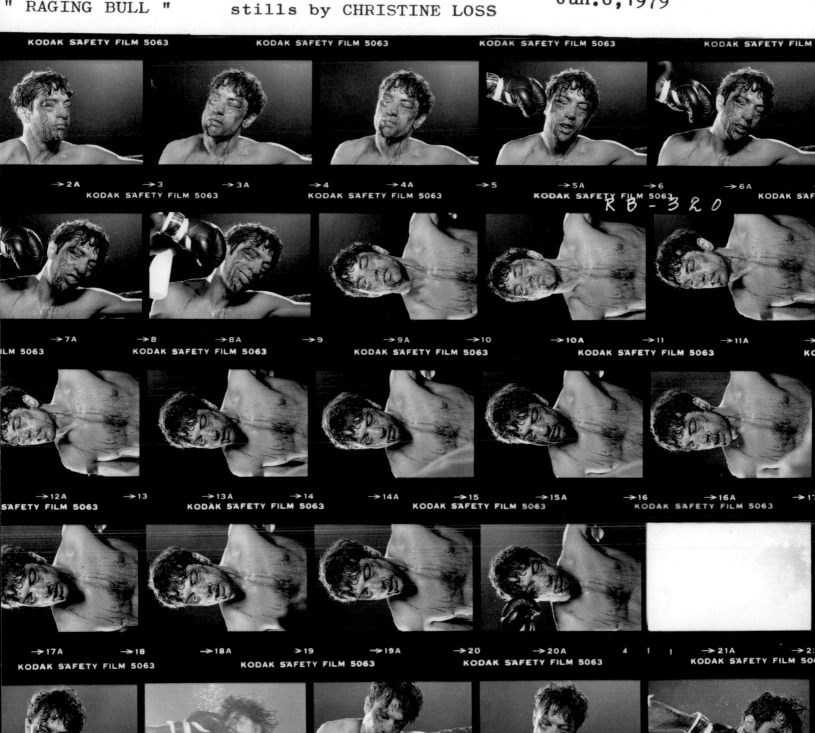

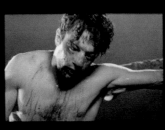
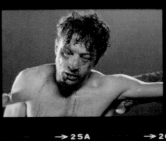
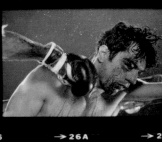

RB-320

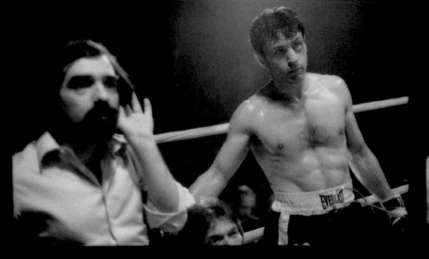

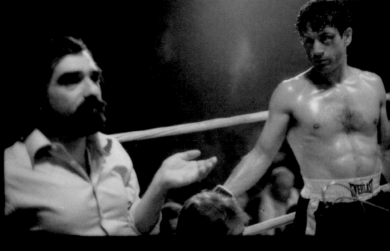

→ 8A → 9

FILM 5063

KODAK SAFETY FILM 5063

→ 9A → 10

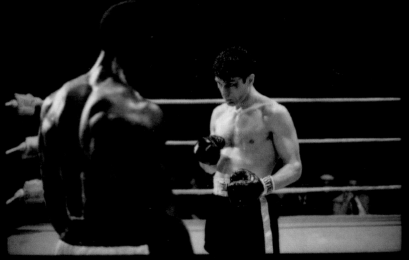

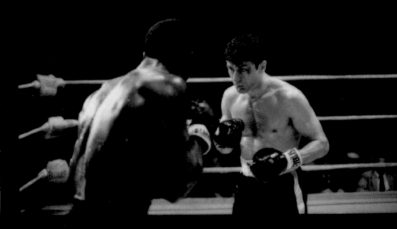

→ 13A → 14

ODAK SAFETY FILM 5063

→ 14A → 15

KODAK SAFETY FILM

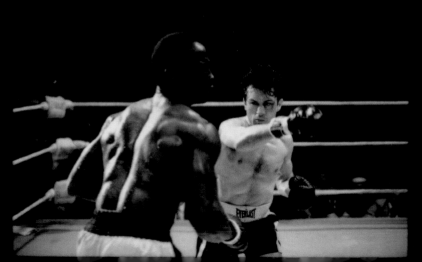

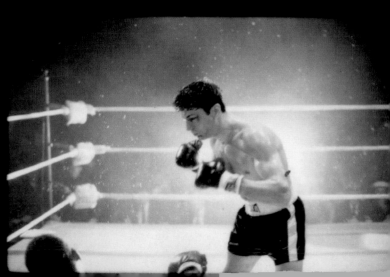

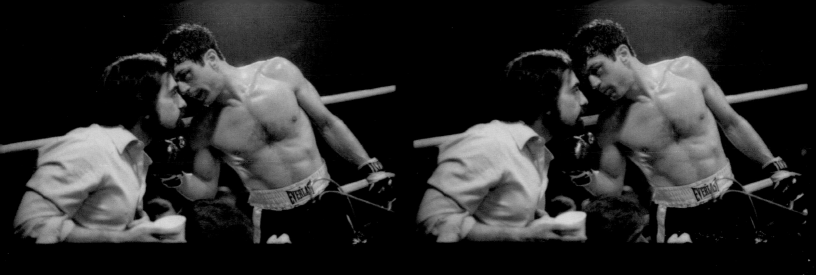

→10A →11 →11A →12

KODAK SAFETY FILM 5063 KODAK SAFE

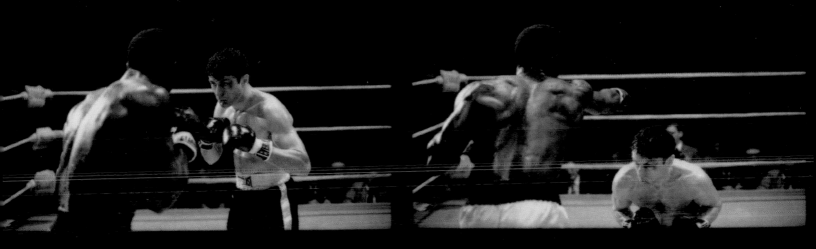

→15A →16 →16A →17

63 KODAK SAFETY FILM 5063 K

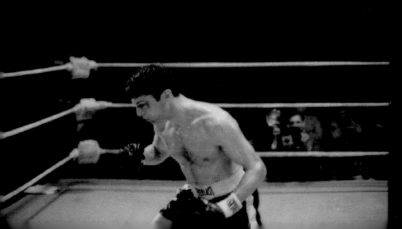
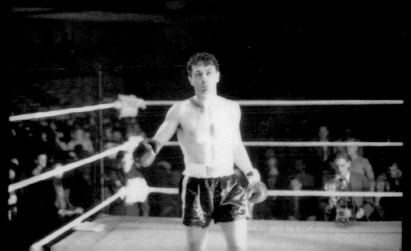

**BRANDON LEE ON THE
SET OF *THE CROW***
1994
Director: Alex Proyas
Photographer: Robert Zuckerman

THE LAST DAYS
OF CELLULOID
1981–1997

By the early 1980s, the New Hollywood era, with all its bold aesthetic and thematic gestures, had given way to the blockbuster era. The star power transferred away from directors, back to, well, stars. Genres that were previously reserved for "B" movies, such as horror and science fiction, became mainstream.

Photographic technology and its practical application had changed, too: now that almost all movies were produced in color, audiences demanded color promotional images, and the best way to shoot color stills was via transparency film. These negatives would be developed as individual slides, which would be distributed on sets and at publications in plastic sleeves called "20-ups," mimicking the ease and narrative quality of the contact sheet without requiring printing.

Not only were fewer contact sheets printed once color stills took over, but as these paper-based representations of largely unused negatives faded out of currency, the ones that did exist were more likely to end up in the trash. The computer revolution, which could have aided in the preservation of such images, in at least one case actually hastened their destruction. During the transition, Warner Brothers reportedly cleaned out an entire room full of photos and negatives, in order to make room for computers. Photographer Sid Avery, who co-founded

the Hollywood Photographer's Archive in an effort to preserve his work and that of his colleagues, was tipped off to a huge stash of images, mostly from the 1970s and 1980s, that had been found in a dumpster. Most of the images were unmarked, with no photographer credited, so Avery hit his Rolodex, calling his peers to ask if they could identify their own work within the bounty. Many of the images in this chapter come via mptvimages, the for-profit successor to the HPA, also founded by Avery, who died in 2002. (The Archive is now run by Sid's son and close collaborator, Ron Avery.)

Given the changes in technology and Hollywood's sometimes careless attitude regarding the preservation of its recent past, the contact sheets in this section—all except one produced from 35mm black-and-white negatives—are somewhat anomalous, even anachronistic. Whether captured for editorial or promotional purposes, they are the result of a specific decision to shoot on print film rather than color transparencies. The format, particularly in black and white, becomes a visual signifier of a lost era, and its use on sets like *Desperately Seeking Susan* and *Fatal Attraction* bestows an old-Hollywood air on stars like Madonna and Glenn Close that they might otherwise not have been associated with.

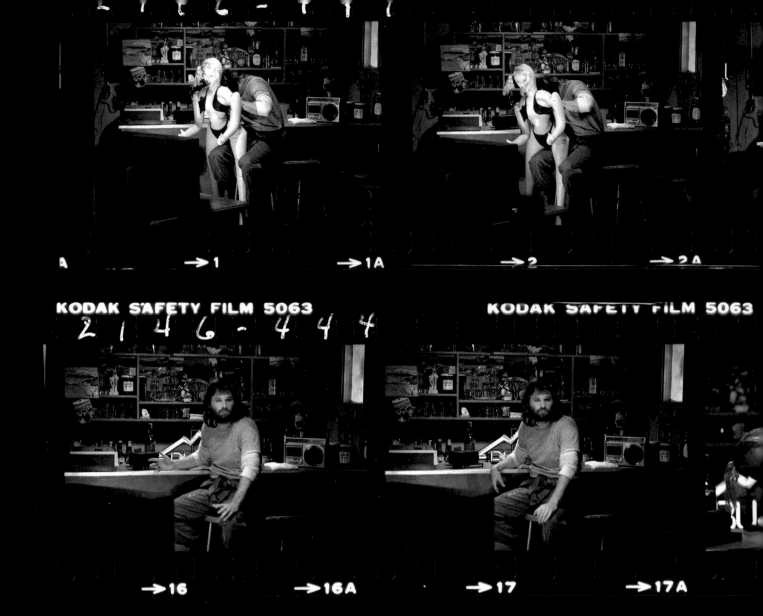

THE THING
1982

Director: John Carpenter
Photographer: Chris Helcermanas-Benge
—

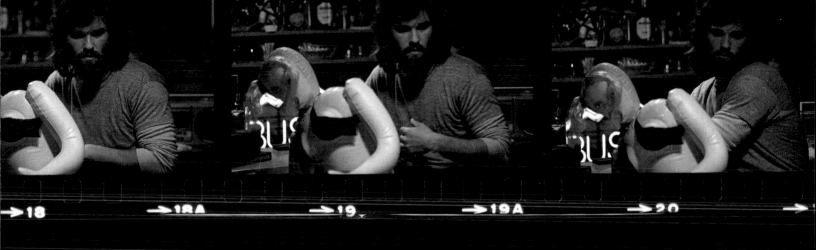

The only woman in the cast of John Carpenter's alien-in-Antarctica flick was Adrienne Barbeau, the director's wife, who played the voice of a computer. Otherwise, the blow-up doll pictured here with Kurt Russell was the only female presence on the set—and the doll's scene was eventually left on the cutting room floor. "It was the most interesting set I was on because the psychology of what happened on that movie was unique, it was something I've never seen," Russell said later of the all-male cast and crew. "Very little posturing goes on with men when there's no women to posture for and…it seriously begins to show itself in the movie."[81] Opening in the U.S. on the same day as *Blade Runner* and just two weeks after a much cuddlier alien movie, Steven Spielberg's *E.T.*, *The Thing* was hardly a hit, but over time it became a cult classic. "[*E.T.*'s] message was the exact opposite of *The Thing*," Carpenter would later say. "As Steven said at the time, 'I thought that the audience needed an uplifting cry.' And boy was he right…On the other hand, our film was just absolutely the end of the world and was centered on the loss of humanity."[82]

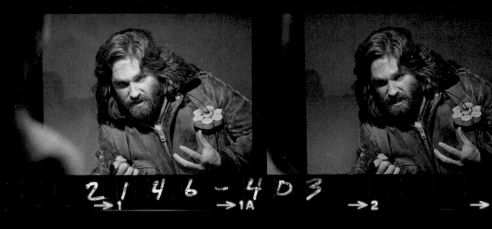

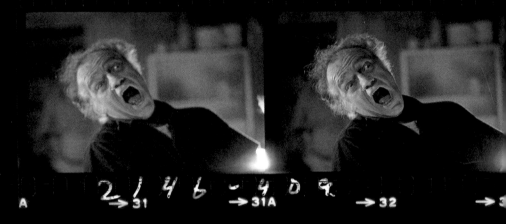

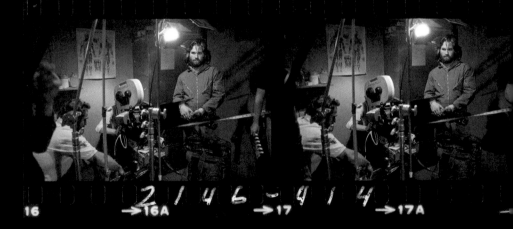

The Thing was the third of five films that Russell would make with Carpenter, seen at right directing his actor. The partnership was personally and creatively fruitful, even if the movies didn't always make much money. Russell likened their bond to family: "John's like that older brother that you know is smarter than you, but he lets you do the things you do well without making you feel he knows how to do them better."[83]

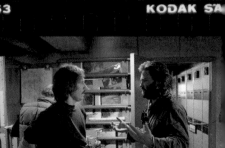

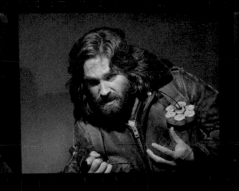

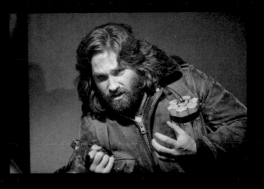

KODAK SAFETY FILM 5063

→3 →3A →4 →4A →5 →5A

KODAK SAFETY FILM 5063 KODAK SAFETY FILM 5063

→33 →33A →34 →34A →35 →35A

KODAK SAFETY FILM 5063 KODAK SAFETY FILM 5063 K

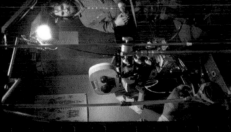

→18A →19 →19A →20 →20A 4 9

FILM 5063 KODAK SAFETY FILM 5063 KODAK SAFETY FILM 5

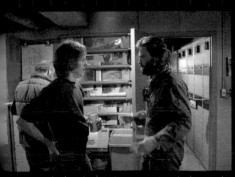

→23 →23A →24 →24A →25 →25A

SCARFACE
1983

Director: Brian De Palma
Photographer: Sidney Baldwin

Today, *Scarface* is thought to be one of the quintessential films of Al Pacino's career, a catchphrase-packed powerhouse ripe for both parody and loving emulation. At the time of its making and release, however, the film, which went way over budget, was criticized for its excess and extreme violence. Pacino, who had tried and failed to get Glenn Close cast in the moll role that eventually went to (and made a star out of) Michelle Pfeiffer, struggled on set with Brian De Palma, a visual stylist who didn't give the Method actor the attention he was used to. The film wasn't immediately profitable, and both critics and people in Hollywood hated it. Partially due to frustration over the way the movie was received, Pacino took a hiatus from film acting for most of the rest of the 1980s, preferring to focus on theater. Decades later, after *Scarface* had been fully reclaimed as a classic, the actor said he had always felt public opinion would turn around eventually. "You make a lot of pictures, and you realize some don't have it," he reflected in 2003. "I knew there was a pulse to this picture; I knew it was beating. And then I kept getting residuals from the movie, kept getting checks."[84]

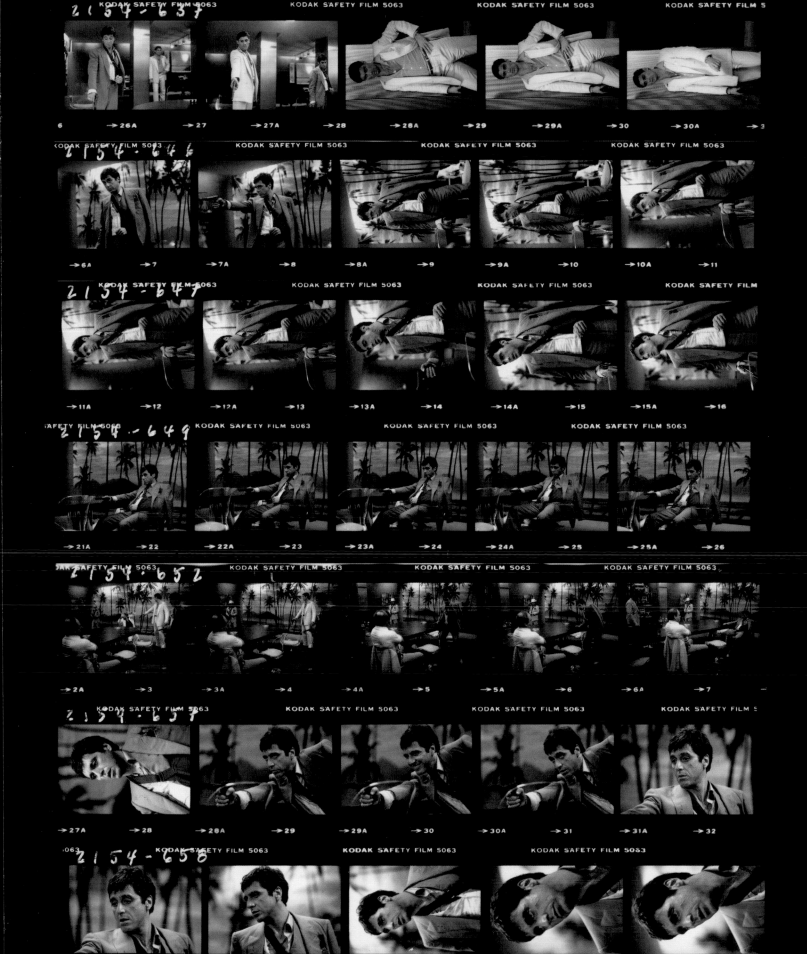

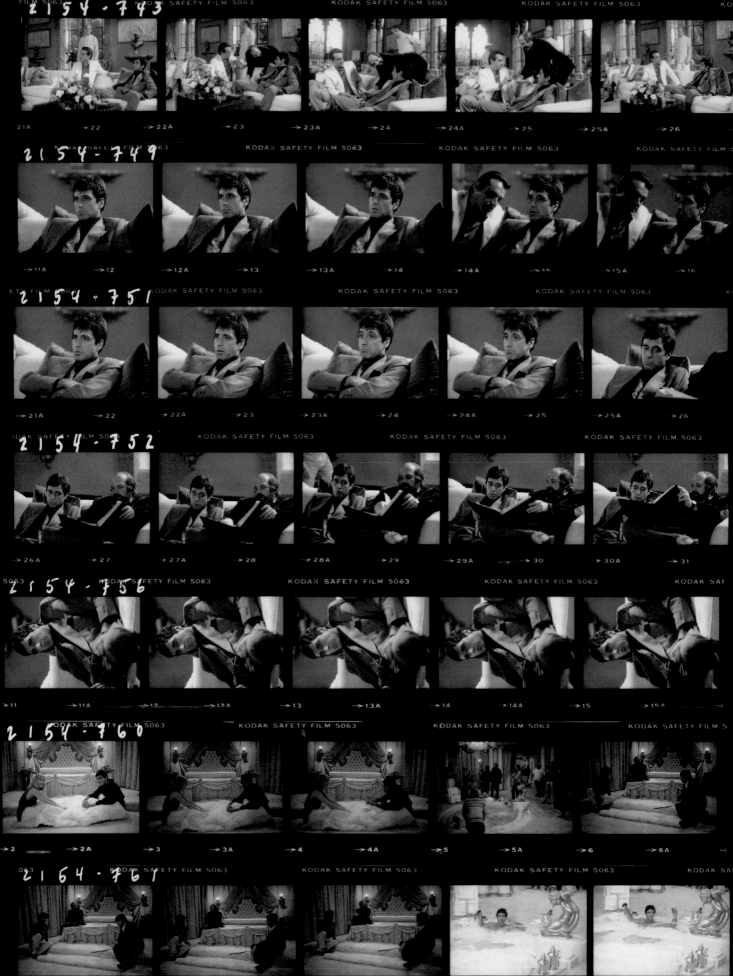

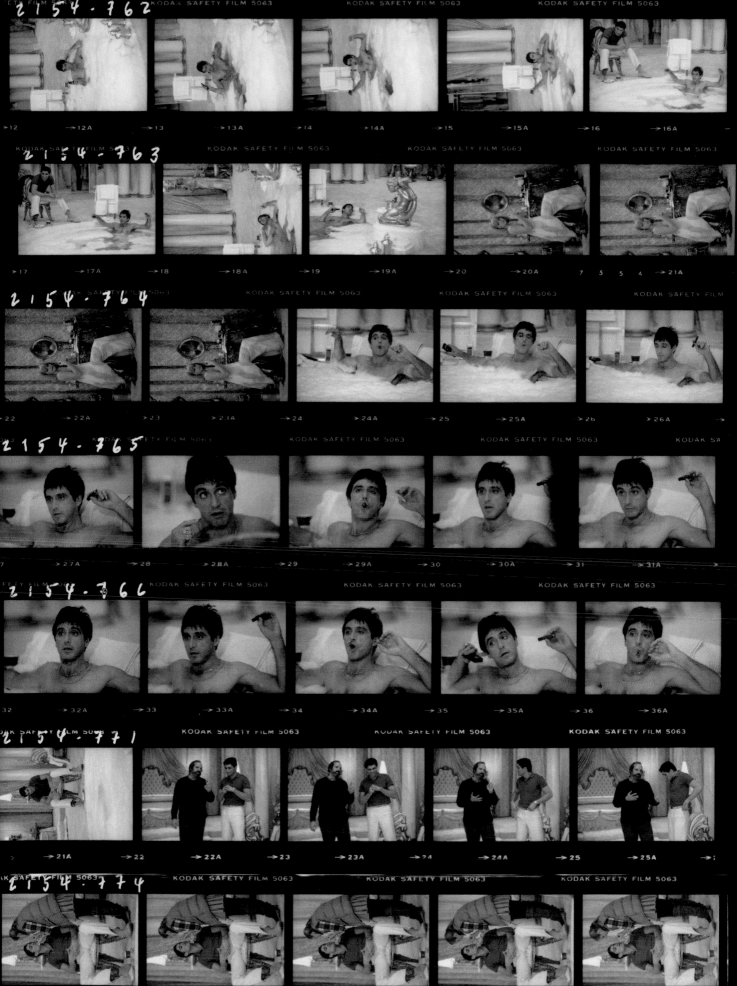

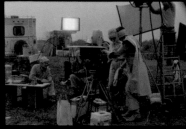

→1 →1A →2 →2A →3 →3A →4 →4A

→7 →7A →8 →8A →9 →9A →10 →10

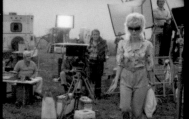
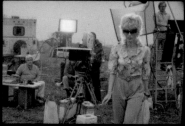

→13 →13A →14 →14A →15 →15A →16 →16A

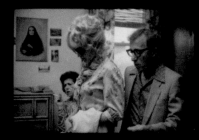

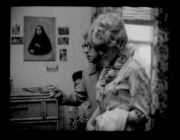
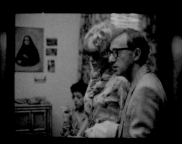

→19 →19A →20 →20A W 7 1 6 →21A →22 →22A

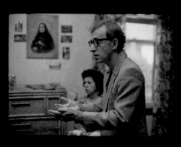
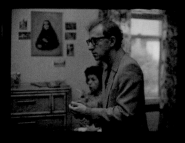
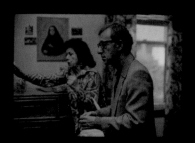
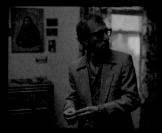

→25 →25A →26 →26A →27 →27A →28 →28A

BROADWAY DANNY ROSE
1984

Director: Woody Allen
Photographer: Brian Hamill

—

By 1984, Woody Allen and Mia Farrow had been a couple for four years, and she had appeared in two of Allen's films, *A Midsummer Night's Sex Comedy* and *Zelig*, in roles that played on Farrow's familiar, waif-like beauty. With their third collaboration, Farrow's partner gave the actress a whole new challenge, and a new image to match. A former gangster's mistress, Farrow's Tina rocked big dark glasses, even bigger, brassy hair, and form-fitting slacks over padding to simulate curves. She was glamorous (if slightly grotty) and tough in a way that Farrow had never appeared on-screen before. It was the one role, according to Farrow, that Allen wrote specifically for her. "[Allen] says I mentioned wanting to play a character we saw in a restaurant, and he may have written her into the film," Farrow remembered later. "It was fun assembling that person, the wig, the falsies, and the lavender clothes, even though it's a black-and-white movie, and another accent. That was the biggest stretch I'd ever made." For Farrow, Tina's large, dark glasses were essential to staying in character. "I've got these eyes that just give me away: a touch of Bambi or something," she admitted. "There's one scene where he has me take off my sunglasses, just for a second, and my whole character comes apart completely."[85] Interestingly, the one image marked for printing on this sheet of frames taken by frequent Allen set photographer Brian Hamill is of the actress ostensibly out-of-character and off-camera—or, rather, behind it, looking through the viewfinder of the motion picture camera as if to gauge how the next shot had been set up.

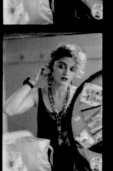
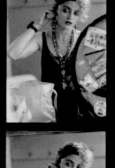
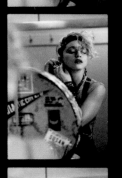

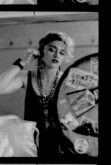

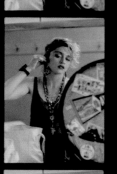

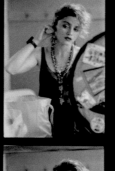
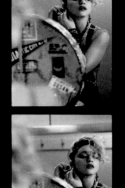

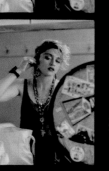

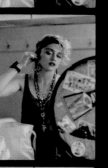
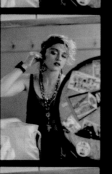
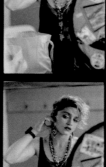

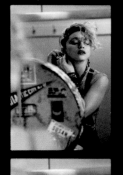
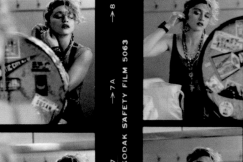

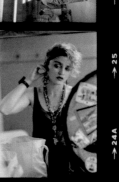
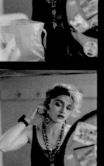

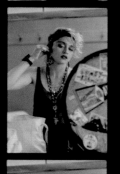
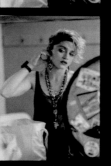
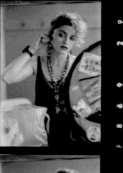
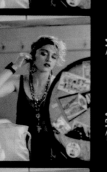
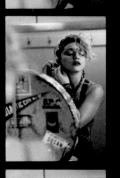

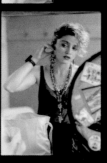
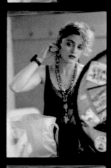
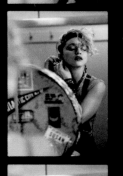
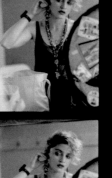

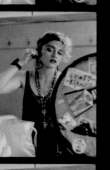
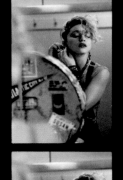

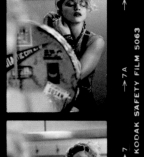

DESPERATELY SEEKING SUSAN
1985

Director: Susan Seidelman
Photographer: Andy Schwartz

———

Madonna wasn't "Madonna" yet when she was cast in her first mainstream movie. A fixture of the downtown New York scene of the 1980s and a neighbor of director Susan Seidelman, the future Material Girl auditioned for the role of Susan alongside Ellen Barkin, Jennifer Jason Leigh, and Melanie Griffith. The relative unknown won out because, as the director said in 2010, "[the film] needed to be grounded in some kind of authenticity. We didn't want actors putting on costumes and playing downtown."[86] As the film was shooting in 1984, Madonna was just experiencing her first flush of fame, with the video for "Lucky Star" entering into rotation on MTV. By the time the film was released, in September 1985, the *Like a Virgin* album had spawned five hit singles, making Madonna a global superstar. Contact sheets often give us a chance to see an established star, however momentarily, slipping off the facade of their stardom. These images of Madonna shooting her first film allow us to see a soon-to-be world-dominating megastar before that facade had fully been created. The photos shown overleaf were taken in the New York club Danceteria, where Madonna's career was launched. This shoot, recalls photographer Andy Schwartz, was the first time everyone heard her hit song, recorded for the movie, "Into the Groove."[87]

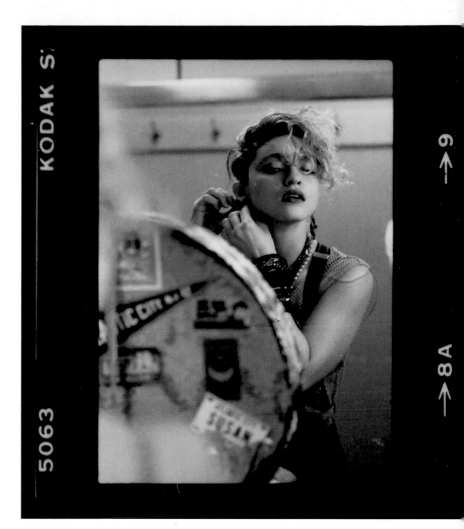

DS
74

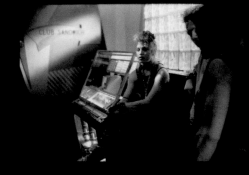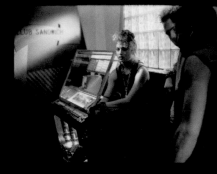

→ 3A　　→ 4　　→ 4A　　→ 5　　→ 5A　　→ 6

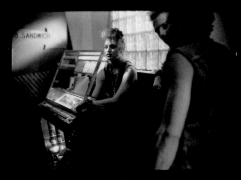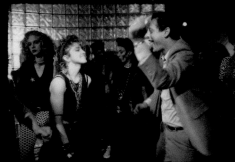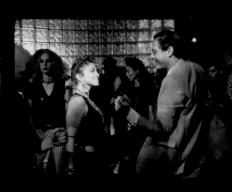

→ 9A　　→ 10　　→ 10A　　→ 11　　→ 11A　　→ 12

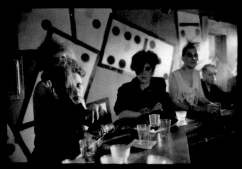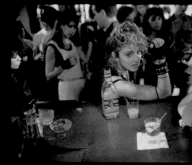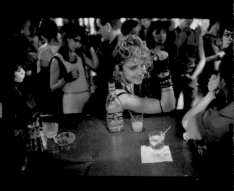

→ 15A　　→ 16　　→ 16A　　→ 17　　→ 17A　　→ 18

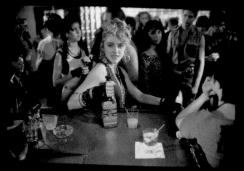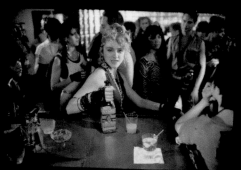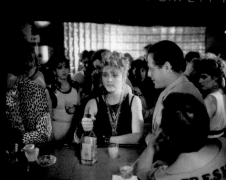

9　H 21A　　→ 22　　→ 22A　　→ 23　　→ 23A　　→ 24

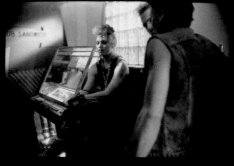
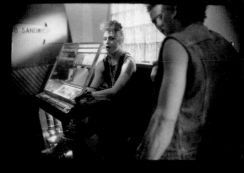
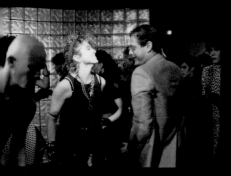
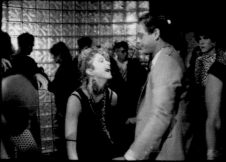
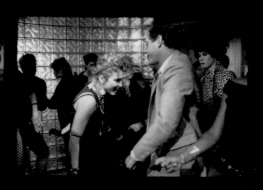
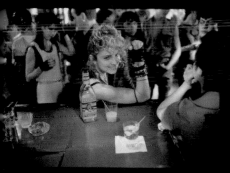
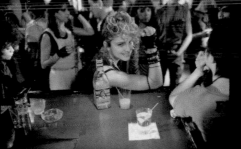
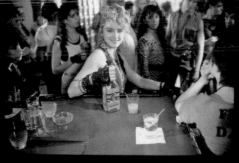
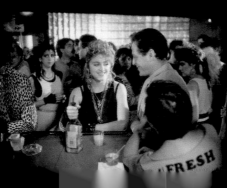

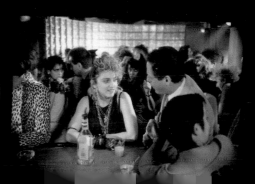

WEIRD SCIENCE
1985

Director: John Hughes
Photographer: Randy Tepper

—

Writer-director John Hughes redefined teen cinema in the 1980s with hits such as *Sixteen Candles* and *The Breakfast Club*, both of which featured Anthony Michael Hall as a nerdy high schooler pining for acceptance from the cool kids. When Hughes then cast Hall in the lead in the very of-its-era sci-fi-comedy *Weird Science*, the actor was still asked to play the nerd, but this time, it was a nerd who acquires the talent and technology to bring his dream woman (Kelly LeBrock) to life. Hall's stardom hit its peak with *Weird Science*. Afraid of being typecast as the brainy outcast, he turned down similar parts in Hughes's *Ferris Bueller's Day Off* and *Pretty in Pink*, but he struggled to become a leading man. Though it would take several decades, that elusive superstardom would eventually come not for Hall, but his *Weird Science* co-star, Robert Downey, Jr., seen here clowning around in the role of bully Ian. On the set of this film, Hall was a star, and Downey, the son of cult filmmaker Robert Downey, Sr., was virtually unknown. To hear Downey tell it, teen kingmaker Hughes claimed credit for "discovering" the future Iron Man. "For the *Weird Science* audition, John Hughes, who was supposed to be real hip at that moment, said, 'So you want to run the scene with the guy before you do it?' I said, 'No.' Went in. Read the scene. I rocked. And John Hughes is like, 'Hey—I found another one.'"[88]

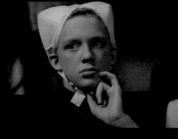
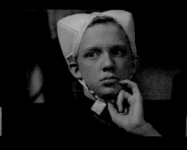

→22A →23 →23A →24 →24A →25

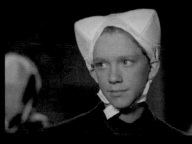

→2 →2A →3 →3A →4 →4A

→7A →8 →8A →9 →9A →10

27A← 27← 26A← 26← 25A← 25←

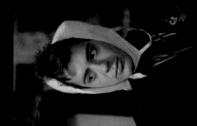
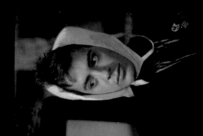

KODAK SAFETY FILM 5063

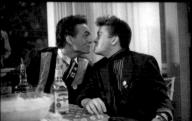
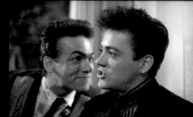
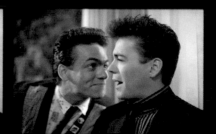

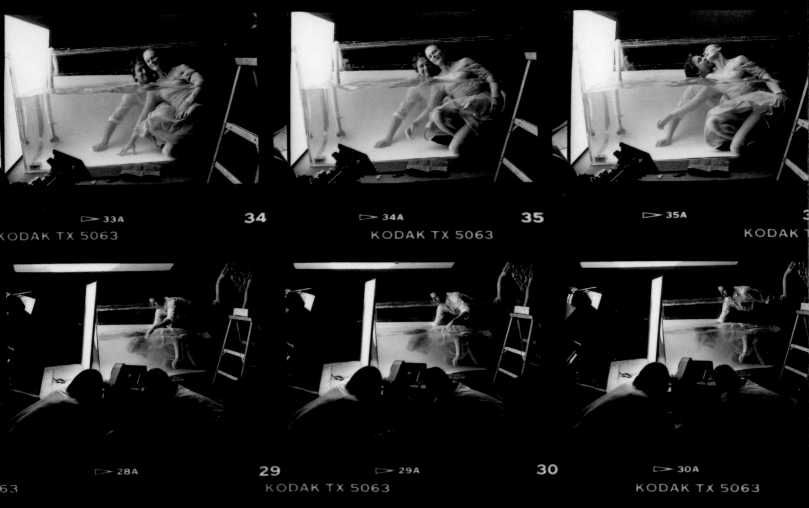

▷ 33A 34 ▷ 34A 35 ▷ 35A

KODAK TX 5063 KODAK TX 5063 KODAK T

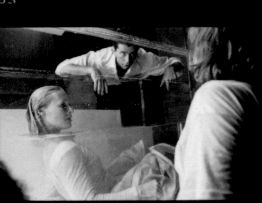
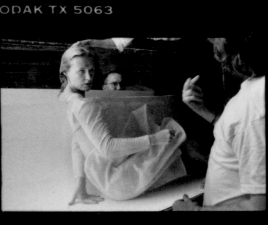
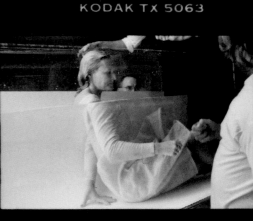

63 ▷ 28A 29 ▷ 29A 30 ▷ 30A

KODAK TX 5063 KODAK TX 5063

▷ 23A 24 ▷ 24A 25 ▷ 25A

KODAK TX 5063 0 1 3 2 0 4 1 1

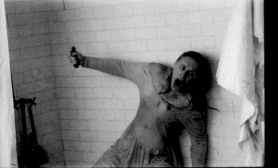
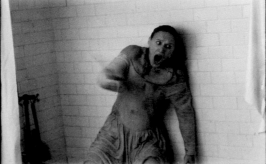
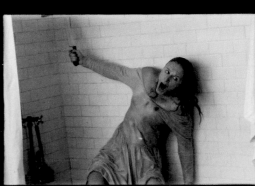

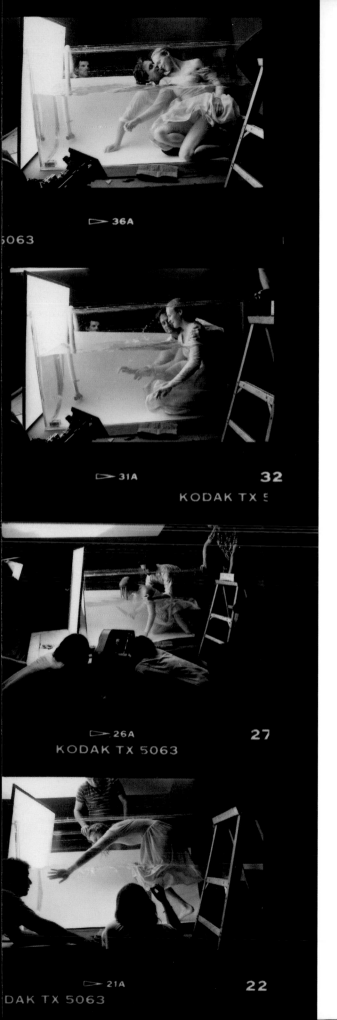

FATAL ATTRACTION
1987

Director: Adrian Lyne
Photographer: Andy Schwartz

—

Fatal Attraction was one of the biggest movies of 1987, a cultural phenomenon
that bled beyond the box office and became a flash point in debates about changing
values in terms of sex, domesticity, and gender equality. These debates often took
into account the well publicized fact that the end of the film as it was released—in
which the psychotic jilted lover played by Glenn Close is killed by Michael Douglas's
character's wife—was tacked onto the film after the original ending—in which
Close's Alex somewhat more sympathetically commits suicide—tested badly. Close
and Douglas had a generally strong working relationship (as evidenced by these
photos), but the actress was firmly against the new ending, which her co-star, as a
producer of the film, was trying to push through. Close had carefully researched
the character, even consulting with psychologists to determine what would be
realistic behavior in the context of the original script. "So to be brought back
six months later, I think it was, and told that you're going to totally change that
character, it was very hard,"[89] Close remembered later. "Looking back I think
I was right to feel the way I felt," Close said in 2011. "I also think they were
right to change the ending for what it did for the movie."[90]

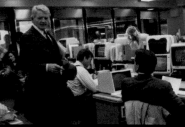

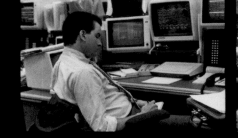

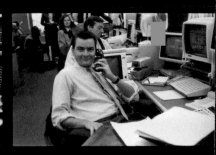

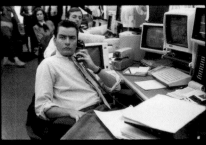

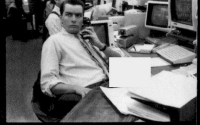

WALL STREET
1987
Director: Oliver Stone
Photographer: Andy Schwartz

Younger generations may know Charlie Sheen chiefly as the star of less-than-sophisticated sitcoms and lurid tabloid exploits, but in the mid-1980s—when he was the hottest young actor in Hollywood, the star of two consecutive Oscar-nominated films—Sheen's future seemed not just brighter, but more respectable. The son of actor Martin Sheen, Charlie picked up a passion for film acting while traveling to the sets of movies like *Apocalypse Now* with his dad. He got his first major starring role, in Oliver Stone's *Platoon*, at the age of 21. Stone bolstered his indictment of the financial sector by putting a premium on authenticity, from the design of the set seen here ("Everything there was real," Stone pointed out. "All the computers really worked"[91]), to the paces he put his young actor through. In addition to shadowing a real young broker (from whom Sheen borrowed his character's red suspenders) and taking a six-week crash course on the basics of trading, Sheen sunk $20,000 of his own money into a bad stock deal. "It was a pretty good hunk of cash," Sheen said. "I figured if I had something on the line, it would intensify my curiosity."[92]

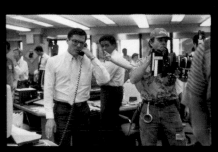

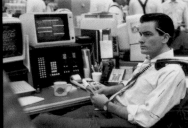

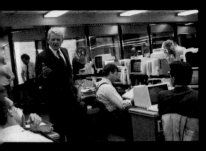
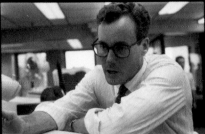
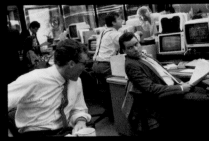

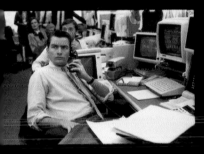

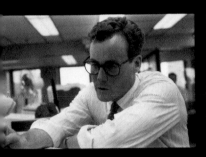
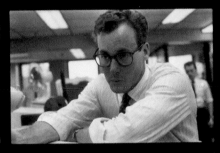
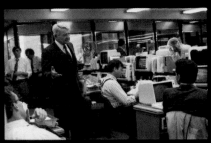

183

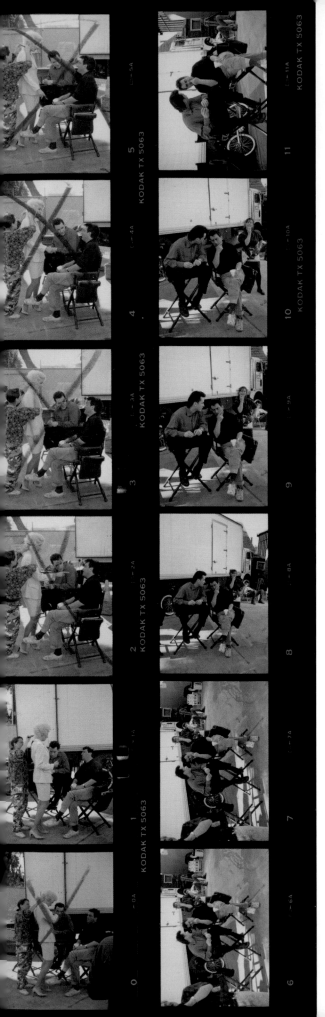

THE GRIFTERS
1990

Director: Stephen Frears
Photographer: Suzanne Hanover

———

The role of Lily, a small-time con artist trying to reconnect with the now-grown son (John Cusack) she had as a teenager, was a whole new look for Anjelica Huston. The daughter of legendary filmmaker John Huston, and granddaughter of actor Walter Huston, in 1985 Anjelica had become the first third-generation Oscar winner in history when she was named Best Supporting Actress for her work under her father's direction in *Prizzi's Honor*. To play the matriarch of a far less functional family in *The Grifters*, Huston spent time observing women in low-rent casinos, and traded out her trademark long raven locks for a Marilyn Monroe-reminiscent platinum wig. "Anjelica is such a lady you have to violate her in some way," Frears said. "I had to break that rather Italian image and vulgarize it."[93] Judging solely by the marks on this contact sheet—a whopping 22 exposures, all of them featuring Huston, are given the big red "X"—Huston's new image was difficult to photograph satisfactorily. Untouched are the frames showing Frears and Cusack, who was in the midst of taking on a new look of his own: just a year removed from the high-school heart-tugger *Say Anything...*, *The Grifters* completed Cusack's transition to fully-adult roles.

THE SILENCE
OF THE LAMBS
1991

Director: Jonathan Demme
Photographer: Ken Regan

———

A landmark in more ways than one, the phenomenal success of Jonathan Demme's adaptation of the Thomas Harris novel can be summed up in its two unbroken Oscar records: it was the first (and only) horror movie to win Best Picture, and it was the last film to win awards in all five major categories (Picture, Director, Actor, Actress, and Screenplay). The film stands as the arguable career peak for both star Jodie Foster, and Demme (on set with Foster at top)—a pairing that almost didn't happen, as Demme had intended to cast Michelle Pfeiffer until Foster flew herself to New York to make the case for why she deserved the role. "*Silence* changed a lot," Foster said in 2005. "The fact that a woman was at the head of the marquee, a woman playing a character that could have been written for a man, that her gender didn't really matter; the fact that a thriller action hero didn't have to be a woman with muscles, it could be a woman with a brain. I think it changed a lot."[94]

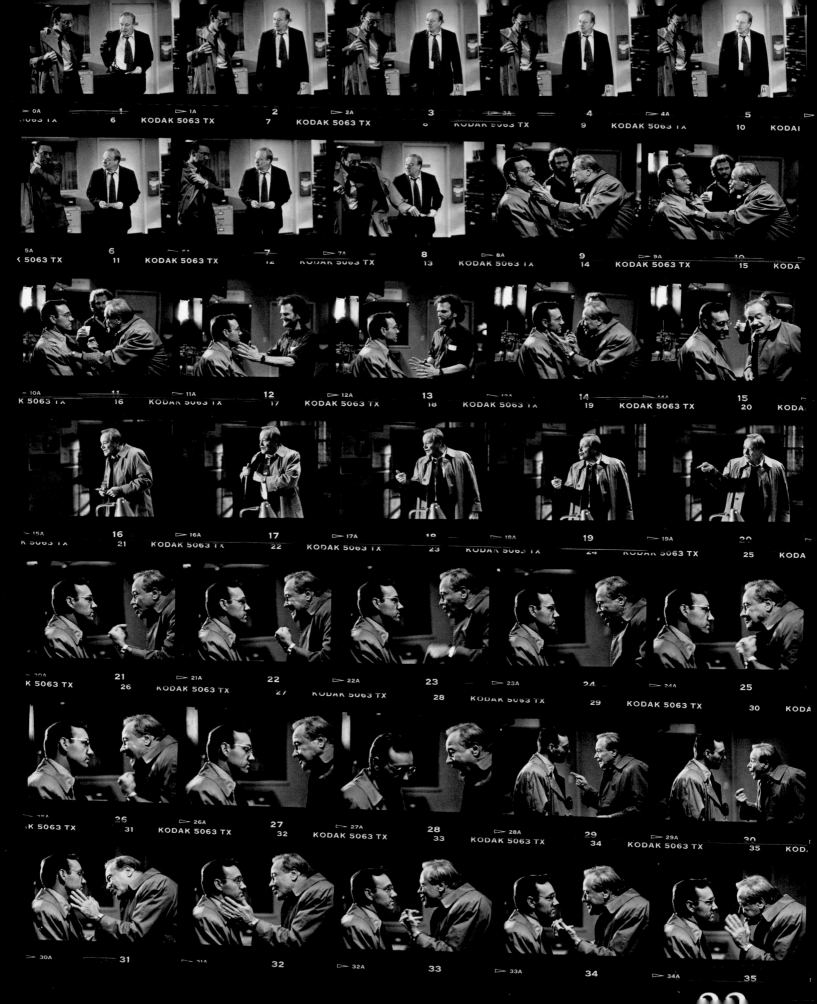

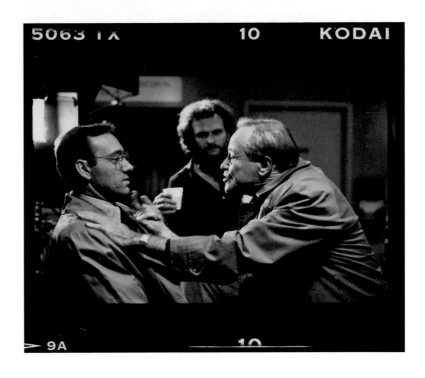

GLENGARRY GLEN ROSS
1992

Director: James Foley
Photographer: Andy Schwartz
———

It took over four years for producer Jerry Tokofsky to secure financing to make
a movie out of David Mamet's Pulitzer Prize-winning play, and by the end of the
two-month shoot, several members of its all-star, all-male cast were in tears over
the end of what had been a uniquely satisfying experience. Director James Foley
(seen above, directing Kevin Spacey and Jack Lemmon) ran the production more
like a play than the typical film, putting his ensemble (which veteran star Lemmon
described as "probably the best cast I ever worked with"[95]) through ample rehearsals.
"[We] all started to take on the characteristics of our parts during the filming,"
Spacey has said. "I was thinking that I had no right to be there, that I was a stooge,
that I was going to be found out at any moment..."[96] It was Spacey's first substantial
film role, one he landed thanks to co-star Al Pacino, who took Foley to see Spacey
in a performance of the play *Lost in Yonkers*. Once on set, Pacino helped push Spacey's
performance further through improvisation, yelling insults directed at "Kevin"
instead of calling Spacey by his character's name. "He forced me to react in a way
that made the scenes work beautifully," Spacey said later. "I didn't have to act."[97]

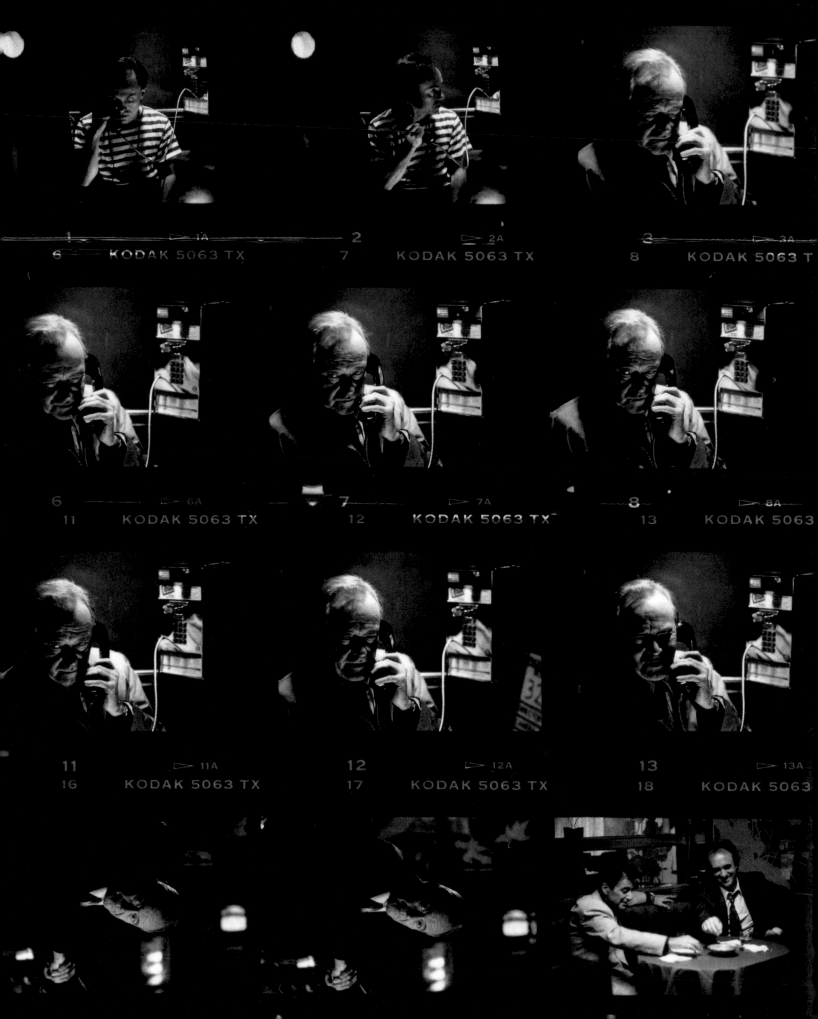

4 ▷ 4A
9 KODAK 5063 TX

5 ▷ 5A
10 KODAK 5063 TX

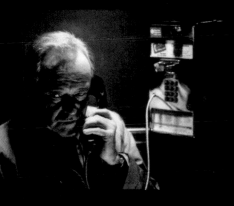
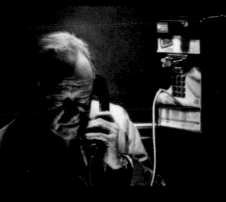

9 ▷ 9A
14 KODAK 5063 TX

10 ▷ 10A
15 KODAK 5063 TX

14 ▷ 14A
19 KODAK 5063 TX

15
20 KODAK 5063 TX

15 ▷ 15A

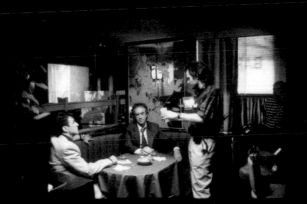

In these dramatically lit images of Lemmon's Shelley Levene at a pay-phone, the veteran actor's "stand-in," at top left, is none other than the man responsible for the lighting scheme, Spanish cinematographer Juan Ruiz-Anchía. Ruiz-Anchía worked with Foley to design the film's office location to imply hierarchy between the salesmen, while still allowing room for the camera to move around, and to avoid having to light Al Pacino (seen at bottom) on his "bad" side.

DAZED AND CONFUSED
1993

Director: Richard Linklater
Photographer: Gabor Szitanyi

Linklater's ode to 1970s high school slackers features a number of future stars—Ben Affleck, Parker Posey, Renée Zellweger—but perhaps no one made more of his limited screen time than Matthew McConaughey. The actor landed this, his first film role, after chatting up the film's casting director in a Texas bar. 24-year-old McConaughey understood his character, Dave Wooderson, the older guy who continues to hang out with high school girls because, as he puts it, "I get older, but they stay the same age." "That was the piece for Wooderson that I was like, 'That's not a line, that's his *being*,'" McConaughey said later. "That's his philosophy."[98] The actor was able to inject some of his own philosophy, too. His father had died a few days into the shoot, and after attending the funeral, McConaughey found himself back on set, musing over the meaning of life and death:
"I can still have a relationship with my dad, but I've got to keep him alive. He's got to just keep livin'."[99] McConaughey carried that thought into an ad-libbed bit of advice, from Wooderson to his teenage friends—"The older you do get, the more rules they're gonna try to get you to follow. You just gotta keep livin' man, l-i-v-i-n'"—which Linklater left in as the peg of one of the final scenes of the movie.

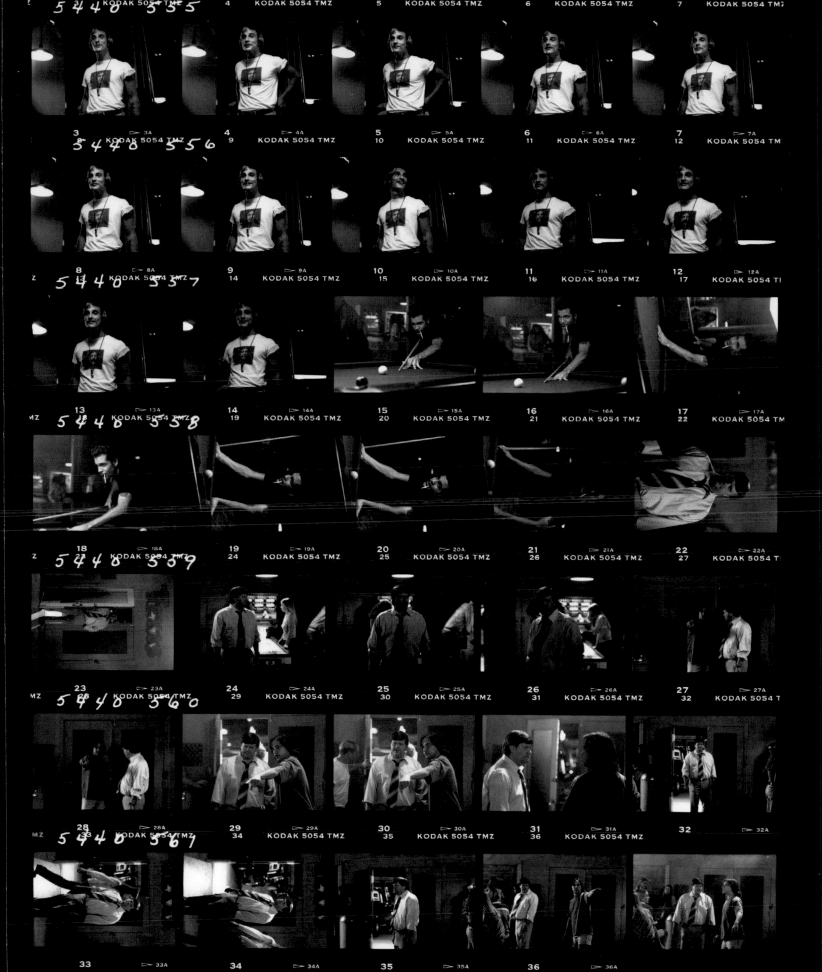

THE CROW
1994

Director: Alex Proyas
Photographer: Robert G. Zuckerman

It should have been a routine stunt. Actor Michael Massee fired a gun at *The Crow*'s star, Brandon Lee, from about 15 feet away, detonating a prop explosive in a paper bag Lee held in his hands. Lee fell to the ground, as directed. But once director Proyas called "Cut," Lee didn't get up: somehow, a live bullet fragment had made its way into the gun, that bullet became lodged in Lee's spine, and after hours of surgery at a local hospital, the actor died. The son of martial arts megastar Bruce Lee—whose own sudden death at the age of 32 has long been the subject of conspiracy theories—Brandon Lee was supposed to be launching a promising acting career with this role as a murdered rocker who comes back from the grave to avenge his death, when he met his own untimely demise. In the wake of the accident (which an investigation determined to have been caused by negligence on the part of the film crew, although no criminal charges were filed), Proyas, in consultation with producers, Lee's mother, and his fiancée, decided to finish the film without Lee, using a double and digital effects to cover the few scenes the actor had left to shoot. *The Crow* was a hit, inspiring multiple low-budget sequels and a lasting cult following, ensuring that Lee's memory lives on in spite of the senseless tragedy that ended his life.

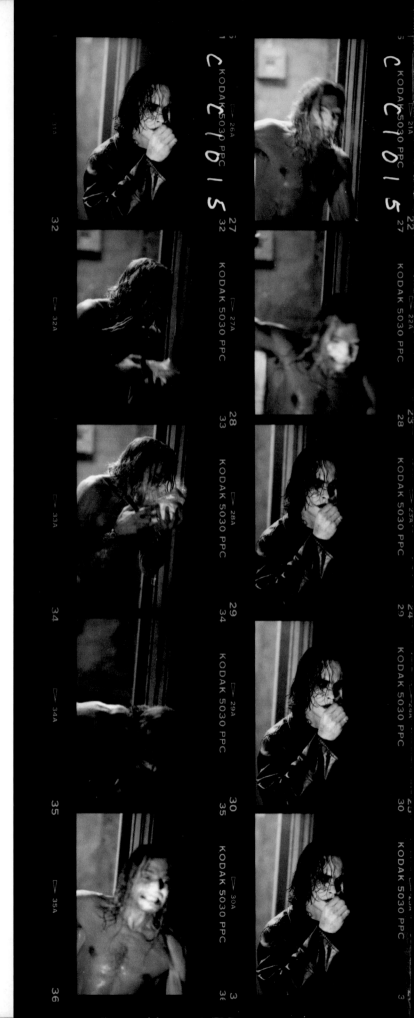

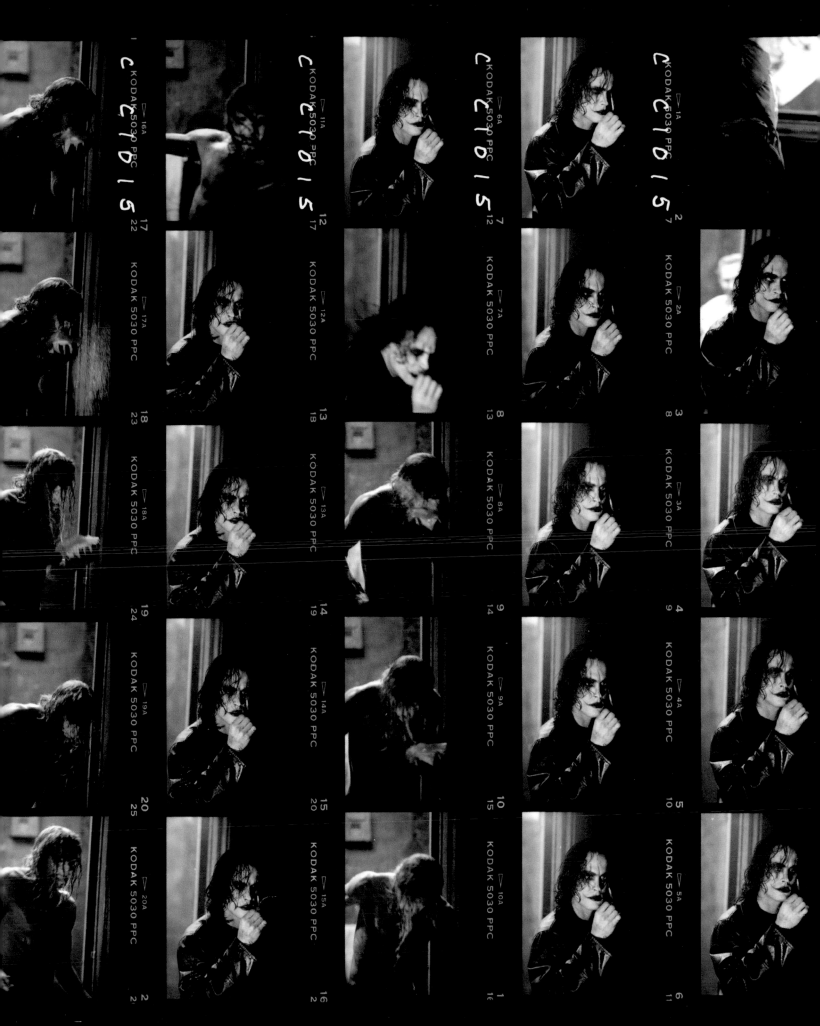

C C I O 6 7

2　KODAK 5030 PPC　　3　KODAK 5030 PPC

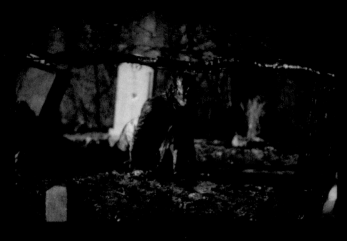

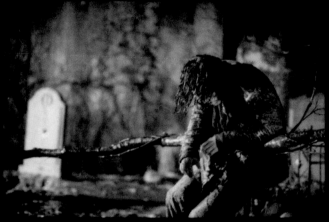

2　▷ 2A　　3　▷ 3A
7　KODAK 5030 PPC　　8　KODAK 5030 PPC

C C I O 6 7

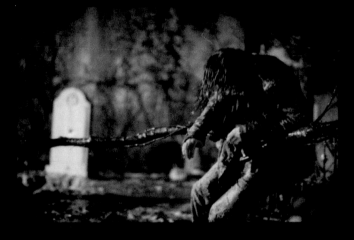

7　▷ 7A　　8　▷ 8A
12　KODAK 5030 PPC　　13　KODAK 5030 PPC

C C I O 6 7

12　▷ 12A　　13　▷ 13A
17　KODAK 5030 PPC　　18　KODAK 5030 PPC

C C I O 6 7

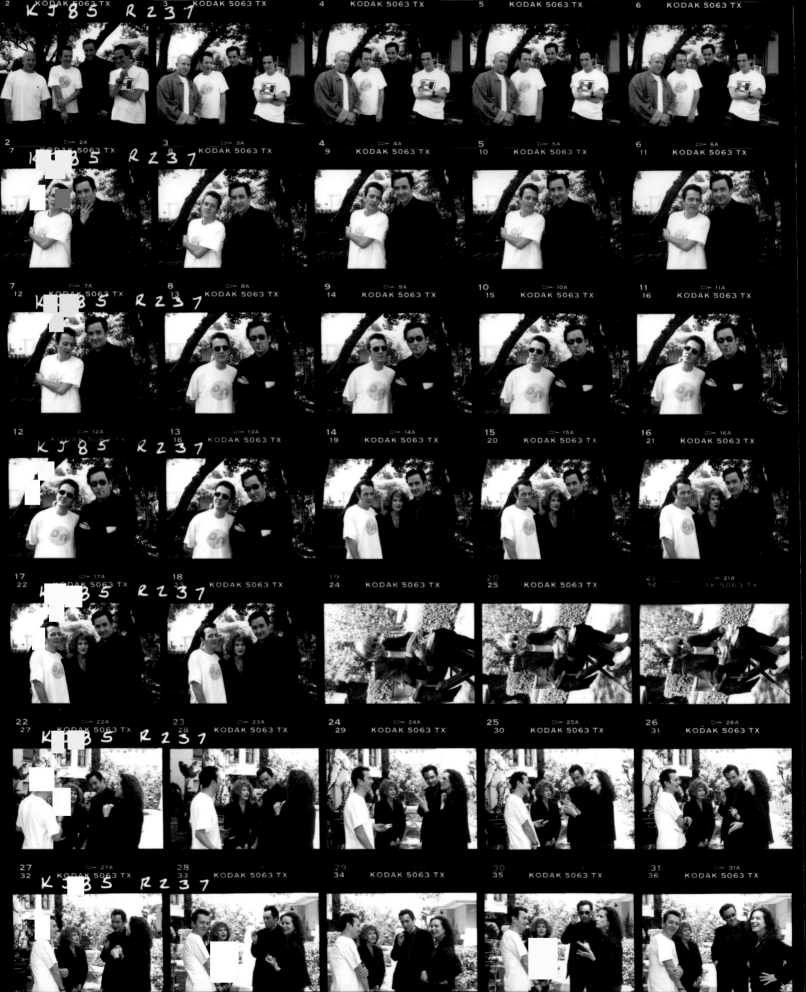

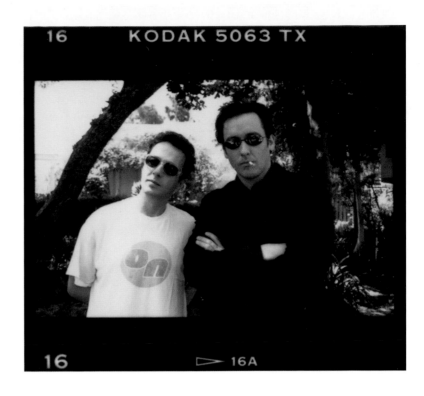

GROSSE POINTE BLANK
1997

Director: George Armitage
Photographer: Suzanne Hanover

—

While writing their sardonic, professional hit man/high school reunion action comedy *Grosse Pointe Blank*, John Cusack and Steve Pink (seen on the far left of the group in the top strip of this sheet) listened to a lot of "very heavy"[100] songs from British punk band The Clash. Cusack, who was also starring in and co-producing the movie, happened to be friends with former Clash frontman Joe Strummer (posing here, on Cusack's right). Cusack and Strummer met when they were cast together in Alex Cox's *Straight to Hell* (a film that Cusack ultimately backed out of rather than shave his head), and the star called his pal and asked him to work on *Grosse Pointe Blank*'s soundtrack. The rocker ended up moving to Los Angeles for three months, although in the end, the studio decided to only use two of the new songs he recorded. These portraits were taken during a break from shooting at the Ambassador Hotel—"one of Los Angeles's great locations!"[101] remembers Suzanne Hanover, a veteran Hollywood still photographer of comedies, who is now the president of the non-profit honorary association The Society of Motion Picture Still Photographers. The Ambassador, the site of the assassination of Robert F. Kennedy, served as a location for films as diverse as *Pretty Woman, Fear and Loathing in Las Vegas*, and *Forrest Gump* before being demolished in 2005; as one wing was being torn down, Emilio Estevez was shooting his Kennedy assassination biopic *Bobby* in another.

CODA: CONTACT SHEETS
IN THE DIGITAL ERA

———

As technology changed in the 1980s and 1990s, the practice of printing multiple negatives tapered off, and eventually digital shooting, editing, and printing became standard. Even before the advent of digital cameras, the near-extinction of the printed contact sheet was accelerated by the increasing availability of film scanners. Negatives could be scanned in batches, and loaded onto disks, CDs, and eventually websites and memory cards for review and distribution, thus saving significant time and money in printing costs. By the 21st century, when digital cameras really began to take over the still business, the photochemically-printed contact sheet was long on the wane. But the past haunts the present: computer programs such as Lightroom, which is an industry standard for organizing and editing images, aim to replicate the ease and narrative aspect of the printed proof sheet, albeit with a much greater degree of malleability. Still, because digital images are so cheaply and easily taken—and deleted—these modern versions of the contact sheets lack the sense of narrative and process that makes the celluloid-sourced proof print so special and exciting.

There has also been a fundamental shift, in this century, in regards to the kinds of photos of movie stars and other celebrities that the public wants to see. Staged photo shoots still have their place—and, in fact, in the world of fashion magazines Hollywood actresses have all but replaced models as cover stars —but they represent a rarified corner of the business. Today's equivalent of fan and photo magazines are tabloids and blogs, full of images taken on the red carpet and on-the-fly by paparazzi. In some sense, the appetite for these photos—some taken in collaboration with stars, but more often than not designed to catch a celebrity unaware and unprepared—is the logical conclusion of the "candids" trend that emerged with smaller cameras and film formats over 50 years ago. But a grainy, off-kilter snap of a starlet stumbling out of a nightclub is quite different, stylistically and philosophically, from a glimpse of James Dean with his guard down on the set of *Giant*, or even a shot of the Rat Pack fooling around. As Ron Avery puts it, back in his father's day, "We always went to a lot of trouble to show people in the best way."[95] The bulk of today's celebrity images, shot from a distance on ultra-long lenses and transmitted wirelessly moments after they're taken, are defined by speed: the quantity-over-quality clip at which they're captured, and the incredibly fast rate at which they're disseminated, consumed, and disposed of. In that sense, modern celebrity photography is as ephemeral as modern celebrity.

FOOTNOTES

INTRODUCTION

1. Alois M. Müller, "Prototypes and After Images" in *Film Stills: Emotions Made in Hollywood*, edited by Müller and Annemarie Hürlimann (Zurich: Museum für Gesaltung Zürich, 1993), 20
2. Author interview with McBroom, August 2013

CHAPTER 1

3. Peter Stackpole, *Peter Stackpole: Life in Hollywood, 1936–1952* (Livingston: Clark City Press, 1992), 16

A Place in the Sun
4. Steve Erickson, *Zeroville* (New York: Europa Editions, 2007), 1
5. Quoted in "Taylor and Clift: Photos From the Set of 'A Place in the Sun'" *LIFE* http://life.time.com/culture/liz-taylor-montgomery-clift-rare-photos-a-place-in-the-sun-1950/#ixzz2eieSZW5M

The African Queen
6. Quoted in Ann Sperberg, *Bogart* (New York: William Morrow, 1997), 444
7. Lauren Bacall, *By Myself* (New York: Ballantine Books, 1978), 251

Limelight
8. Charlie Chaplin, *My Autobiography* (New York: Penguin Classics, 1964), 455

From Here to Eternity
9. James Kaplan, *Frank: The Voice* (New York: Doubleday, 2010), 585

Julius Caesar
10. Quoted in Peter Manso *Brando* (New York: Hyperion, 1994),322
11. Quoted in Kenneth L. Geist, *Pictures Will Talk: The Life and Films of Joseph L. Mankiewicz* (New York: Charles Scribner's Sons, 1978), 225
12. Quoted in Peter Manso, *Brando: The Biography* (New York: Hyperion, 1994), 330

13. Marlon Brando, *Brando: Songs My Mother Taught Me* (New York: Random House, 1994), 174

A Star Is Born
14. Ronald Haver, *A Star is Born: The Making of the 1954 Movie and its 1983 Restoration* (New York: Alfred A. Knopf, 1988), 276
15. Ibid, 277

Rear Window
16. Darren Franich, "'The Girl' and the Director: A guide to the Hitchcock Blondes" *EntertainmentWeekly.com*, October 20, 2012

Kiss Me Deadly
17. Quoted in *Robert Aldrich: Interviews*, edited by Eugene L. Miller, Jr. and Edwin T. Arnold (Jackson: University Press of Mississippi, 2004), 130

Summertime
18. Michael Korda, *Charmed Lives* (New York: Random House, 1979), 388–389
19. Ibid, 390

The Man with the Golden Arm
20. Rebecca Keegan, "Kim Novak says she's bipolar, regrets leaving Hollywood" *Los Angeles Times*, April 13, 2012

Bus Stop
21. Debra Levine, "Don Murray held Marilyn Monroe close in 'Bus Stop'" artsmeme.com, September 6, 2010
22. Bosley Crowther, "Movie Review: Bus Stop (1956)" *New York Times*, September 1, 1956

Funny Face
23. Quoted in David Joseph Marcou, *The Cockney Eye* (La Crosse: La Crosse History Unbound, 2013), 41

Raintree County
24. Quoted in Patricia Bosworth, *Monty* (San Diego: Harcourt Brace Jovanovich, 1978), 298
25. Owen Williams, "Matt Bomer to Play Montgomery Clift" *EMPIRE*, September 19, 2013

The Pride and the Passion
26. Sam Kashner, "Sophia's Choices" *Vanity Fair*, March 2012
27. Quoted in Deirdre Donahue, *Sophia Style* (New York: Friedman-Fairfax, 2001), 69

Some Like It Hot
28. Quoted in Neal Hitchens and Randall Riese, *The Unabridged Marilyn* (Chicago: Congdon & Weed Inc., 1987), 2
29. Jane Russel and Georges Belmont, "The Reluctant Sex Symbol" *Irish Examiner*, July 30, 2011
30. Petronella Wyatt, "Tony Curtis on Marilyn Monroe: It was like kissing Hitler!" *Daily Mail Online*, April 18, 2008
31. Tony Curtis, *The Making of Some Like it Hot: My Memories of Marilyn Monroe and the Classic Movie* (New York: John Wiley and Sons, 2009), 121

Psycho
32. Quoted in François Truffaut, *Hitchcock* (London: Simon & Schuster, 1983), 265–266

The Apartment
33. Quoted in Cameron Crowe, *Conversations With Wilder* (New York: Alfred A. Knopf, 1999), 137
34. Ibid, 136
35. Charlotte Chandler, *Nobody's Perfect: A Personal Biography of Billy Wilder* (London: Simon & Schuster, 2002), 228

Breakfast at Tiffany's
36. Excerpted in Sam Wasson, *Fifth Avenue 5 A.M.* (New York: HarperCollins, 2010), 180

West Side Story
37. Transcription of comments Wise made at American Film Institute Seminar, October 1980, quoted at http://www.afi.com/wise/films/west_side_story/wss.html

To Kill a Mockingbird
38. Allison Hoffman and Joel Rubin, "Peck Memorial Honors Beloved Actor and Man" *Los Angeles Times*, June 17, 2003

The Birds
39. All Hedren quotes from John Hiscock, "Tippi Hedren interview: 'Hitchcock put me in a mental prison'" *Telegraph*, December 24, 2012

Mary Poppins
40. Helena de Bertodano, "Dick Van Dyke: 'I'd go to work with terrible hangovers. Which if you're dancing is hard.'" *Telegraph*, January 7, 2013
41. Todd Leopard, "Dick Van Dyke tells Mary Poppins stories" *CNN.com*, January 27, 2009
42. Andrea Mandell, "Julie Andrews Reveals Secrets Behind Mary Poppins" *USA Today*, December 17, 2013

My Fair Lady
43. Cecil Beaton, "Audrey Hepburn" *Vogue*, November 1, 1954
44. Emmanuel Levy, "My Fair Lady: The Conflict between Cukor and Beaton" *emmanuellevy.com* July 21, 2006
45. Cecil Beaton, *Beaton in the Sixties* (London: Phoenix, 2003), 16

Night of the Iguana
46. John Huston, *An Open Book* (Cambridge, MA: Da Capo Press, 1994), 310

Doctor Zhivago
47. Quoted in Tim Ewbank and Stafford Hildred, *Julie Christie: The Biography* (London: Andre Deutsch, 2008), 113
48. Ibid, 121
49. Ibid

Fahrenheit 451
50. Quoted in James Monaco, *The New Wave* (Oxford: Oxford University Press, 1976), 60
51. Jill Stewart, "LA People 2009: The Writer—Ray Bradbury" *LA Weekly*, April 22, 2009

Gambit
52. Email interview with Ray

One Million Years B.C.
53. Eric Spitznagel, "Interview with Raquel Welch" *Men's Health*, March 8, 2012

CHAPTER 2

Bonnie and Clyde
54. David Newman, "What's it Really All About? Pictures at an Execution" in *Arthur Penn's Bonnie and Clyde*, edited by Lester D. Friedman (Cambridge: Cambridge University Press, 2000), 38

The Graduate
55. Kimberly Nordyke, "'Dallas' Star Linda Gray: It's My Leg on 'The Graduate' Poster" *Hollywood Reporter*, January 30, 2013

Once Upon a Time in the West
56. Email interview with Ray

Star!
57. Quoted in Richard Stirling, *Julie Andrews: An Intimate Biography*, (New York: St. Martin's Press, 2007), 201
58. Ibid
59. Ibid, 205
60. Ibid, 209

The Thomas Crown Affair
61. Faye Dunaway and Betsy Sharkey, *Looking For Gatsby: A Life* (London: Simon & Schuster, 1995), 171
62. Jeff Stafford, "The Thomas Crown Affair" *TCM.com* http://www.tcm.com/tcmdb/title/17804/The-Thomas-Crown-Affair/articles.html

John and Mary
63. Mia Farrow, *What Falls Away* (New York: Nan A. Talese, 1997), 155–156

The Wild Bunch
64. Ebert, Roger. "Sam Peckinpah: Dying Is Not Fun and Games" *Chicago Sun-Times*, June 29, 1969

The Godfather
65. Mark Seal, "The Godfather Wars" *Vanity Fair*, March 2009

Chinatown
66. Roman Polanski, *Roman* (New York: William Morrow, 1984), 353

Love and Death
67. Jeff Stafford, "Love and Death" *Turner Classic Movies* http://www.tcm.com/this-month/article/88479%7C0/Love-and-Death.html

A Star Is Born
68. James Kimbrell, *Barbra: An Actress Who Sings* (Wellesley: Branden Pub Co., 1989), 249

Carrie
69. Sissy Spacek, *My Extraordinary Life* (New York: Hyperion, 2012), 175
70. Ibid, 170
71. Ibid
72. Ibid, 171

Taxi Driver
73. Quoted in Kevin Jackson, *Schrader on Schrader and Other Writings* (London: Faber and Faber, 1990), 119
74. Michael Henry Wilson, *Scorsese on Scorsese* (Paris: Cahiers du Cinema, 2005), 53

A Bridge Too Far
75. Michael Feeney Callan, *Robert Redford: The Biography* (New York: Alfred A. Knopf, 2011), 253
76. Ibid

Annie Hall
77. Stig Bjorkman, *Woody Allen on Woody Allen* (London: Faber and Faber, 1994), 85
78. Kristine McKenna, "Pictures of a Picture Maker" *Los Angeles Times*, December 2, 1995

The Deer Hunter
79. Quoted in *I Knew It Was You: Rediscovering John Cazale*, directed by Richard Shepherd. HBO Documentary Films, 2009

Raging Bull
80. Quoted in Don Snowden, "Dreams and Scenes from Working Class Hollywood: For the Crews, It's Another Day at the Office" *Los Angeles Times*, July 2, 1989

CHAPTER 3

The Thing
81. Haleigh Foutch, "Kurt Russell Shares Behind-the-Scenes Stories at AFI's Night at the Movies Screening of THE THING" *Collider.com*, April 27, 2013
82. Quoted in Patrick Goldstein, "COVER STORY : Apocalypse 2013 : John Carpenter and Kurt Russell team up for another 'Escape,' this time from the island of L.A. (Yes, that's what happens when a 9.6 shaker hits.)" *Los Angeles Times*, February 4, 1996
83. Ibid

Scarface
84. Quoted in Bernard Weinraub, "A Foul Mouth With a Following; 20 Years Later, Pacino's 'Scarface' Resonates With a Young Audience" *New York Times*, September 23, 2003

Broadway Danny Rose
85. Sheila Johnston, "What Mia Farrow did next" *Independent*, April 7, 1994

Desperately Seeking Susan
86. Quoted in Dave Itzkoff, "Once More Into the Groove: 'Desperately Seeking Susan' Turns 25", *New York Times*, September 22, 2010
87. Email interview with Schwartz, August 2013

Weird Science
88. Quoted in Lynn Hirschberg, "Robert Downey Jr.'s Weird Science of Acting" *Rolling Stone*, May 19, 1988

Fatal Attraction
89. "Glenn Close and Michael Douglas' *Fatal Attraction*" *The Oprah Winfrey Oscar Special* ABC-TV, March 3, 2010
90. Quoted in Jess Cagle, "Reunion: *Fatal Attraction*" *Entertainment Weekly*, October 7, 2011

Wall Street
91. Chris Hall, "From directing Charlie Sheen in Wall Street to hanging out with Fidel Castro: Oliver Stone on his life and career in photographs" *Daily Mail*, April 27, 2013
92. "How Charlie Sheen Turned Into a Wall Street Player" *AMC*, April 27, 2008

The Grifters
93. Quoted in Betsy Sharkey, "Anjelica Huston Seeks The Soul of a Con Artist" *New York Times*, December 2, 1990

The Silence of the Lambs
94. "The Total Film Interview: Jodie Foster" *Total Film*, December 1, 2005

Glengarry Glen Ross
95. Quoted from *Charlie Rose*, October 1, 1993
96. Alex Simon, "Kevin Spacey: Hollywood's Chameleon" *Venice Magazine*, September 1997
97. Michael Fleming, "Playboy Interview: Kevin Spacey" *Playboy*, October 1999

Dazed and Confused
98. Quoted from radio interview, "Matthew McConaughey, Getting Serious Again" *Fresh Air*, April 23, 2013
99. "Matthew McConaughey" *Texas Monthly* http://www.texasmonthly.com/topics/matthew-mcconaughey

Grosse Pointe Blank
100. Chris Salewicz, *Redemption Song: The Ballad of Joe Strummer* (London: Faber and Faber, 2006), 512
101. Phone interview with Hanover, January 2014

CODA

102. Phone interview with Avery, August 2013

CREDITS

p2: Photo by Bert Hardy/Picture Post/Hulton Archive/Getty Images

p4–5: © Bob Willoughby/mptvimages.com

p7: Courtesy mptvimages.com

INTRODUCTION

p8: Schuyler Crail/Warner Bros/The Kobal Collection

p11: Photo by Hulton Archive/Getty Images

CHAPTER 1

[Opener]: Photo by Ernst Haas/Getty Images

A Place in the Sun: Photo by Peter Stackpole/Time & Life Pictures/Getty Images

The African Queen: Photo by Eliot Elisofon/Time & Life Pictures/Getty Images

Limelight: Look Magazine Photographs Collection, Library of Congress, Prints & Photographs Division

From Here to Eternity: © Bob Willoughby/mptvimages.com

Julius Caesar: Photo by Peter Stackpole/Time & Life Pictures/Getty Images

A Star Is Born: © Bob Willoughby/mptvimages.com

Rear Window: Michael Ochs Archives/Getty Images

Sabrina: Archive Photos/Getty Images

White Christmas: Look Magazine Photographs Collection, Library of Congress, Prints & Photographs Division

Kiss Me Deadly: Courtesy mptvimages.com

Summertime: Courtesy mptvimages.com

The Man with the Golden Arm: © Bob Willoughby/mptvimages.com

Bus Stop: Archive Photos/Getty Images

Giant: © Sid Avery/mptvimages.com

Funny Face: Photo by Bert Hardy/Picture Post/Hulton Archive/Getty Images

Raintree County: BIPS/Getty Images

The Pride and the Passion: Photo by Ernst Haas/Getty Images

Witness for the Prosecution: United Artists/The Kobal Collection

Pillow Talk: Courtesy mptvimages.com

Some Like It Hot: United Artists/The Kobal Collection

Ocean's 11: © Sid Avery/mptvimages.com

Psycho: Courtesy mptvimages.com

The Apartment: Courtesy mptvimages.com

The Magnificent Seven: Courtesy mptvimages.com

Breakfast at Tiffany's: Paramount/The Kobal Collection/Howell Conant

The Hustler: Courtesy mptvimages.com

The Misfits: Photo by Ernst Haas/Getty Images

West Side Story: Courtesy mptvimages.com

To Kill a Mockingbird: © 1978 to 2014 The Leo Fuchs Archives

Cleopatra: Photo by Ernst Haas/Getty Images

From Russia With Love: Courtesy mptvimages.com

The Birds: Courtesy mptvimages.com

Mary Poppins: Photo by Earl Theisen/Getty Images

My Fair Lady: Courtesy of the Cecil Beaton Archive at Sotherby's

Night of the Iguana: Photo by Gjon Mili/Time & Life Pictures/Getty Images

Doctor Zhivago: Courtesy mptvimages.com

Fahrenheit 451: Photo by Paul Schutzer/Time & Life Pictures/Getty Images

Gambit: Photo by Bill Ray/Time & Life Pictures/Getty Images

One Million Years B.C.: Photo by Terry O'Neill/Getty Images

CHAPTER 2

[Opener]: Photo by Bill Ray/Time & Life Pictures/Getty Images

Bonnie and Clyde: Courtesy mptvimages.com

The Graduate: Courtesy mptvimages.com

Once Upon a Time in the West: Photo by Bill Ray/Time & Life Pictures/Getty Images

Star!: Photo by Terry O'Neill/Getty Images

The Thomas Crown Affair: Courtesy mptvimages.com

John and Mary: Photo by Terry O'Neill/Getty Images

The Wild Bunch: Courtesy mptvimages.com

Dirty Harry: Photo by Bill Eppridge/Time & Life Pictures/Getty Images

The Godfather: Courtesy mptvimages.com

Chinatown: © Steve Schapiro

Love and Death: Photo by Ernst Haas/Getty Images

A Star Is Born: Courtesy mptvimages.com

Carrie: © Marv Newton/mptvimages.com

Taxi Driver: © Steve Schapiro

A Bridge Too Far: Photo by Ernst Haas/Getty Images

Annie Hall: Photos by Brian Hamill/Woody Allen collection of Brian Hamill photography, Margaret Herrick Library, Academy of Motion Picture Arts and Sciences

The Deer Hunter: Photos by Wynn Hammer/Society of Motion Picture Still Photographers collection, Margaret Herrick Library, Academy of Motion Picture Arts and Sciences

Apocalypse Now: Courtesy mptvimages.com

Raging Bull: Christine Loss

CHAPTER 3

—

[Opener]: © Robert G. Zuckerman

The Thing: Chris Helcermanas-Benge

Scarface: Sidney Baldwin

Broadway Danny Rose: Photos by Brian Hamill/Woody Allen collection of Brian Hamill photography, Margaret Herrick Library, Academy of Motion Picture Arts and Sciences

Desperately Seeking Susan: Andrew Schwartz

Weird Science: Randy Tepper

Fatal Attraction: Andrew Schwartz

Wall Street: Andrew Schwartz

The Grifters: Suzanne Hanover

The Silence of the Lambs: © Ken Regan/Camera 5

Glengarry Glen Ross: Andrew Schwartz

Dazed and Confused: Gabor Szitanyi

The Crow: © Robert G. Zuckerman

Grosse Pointe Blank: Suzanne Hanover/Society of Motion Picture Still Photographers collection, Margaret Herrick Library, Academy of Motion Picture Arts and Sciences

CODA

—

p200: Anne-Christine Poujoulat/AFP/Getty Images

All images appear © their respective copyright holders. Every effort has been made to credit and trace photographers, however the publisher would like to apologize for any unintentional omissions.

ACKNOWLEDGMENTS

KARINA LONGWORTH

The text for this book was researched at my favorite place in Los Angeles, the Margaret Herrick Library. As I have been on so many previous projects, and surely will be again in the future, I am indebted to the whole of the Herrick's staff for their guidance and expertise. In helping to locate imagery and information and aiding in the navigation of the library's various systems and regulations, Faye Thompson was particularly supportive, resourceful, and tenacious.

A number of photographers graciously answered questions about their own images, and also the history and craft of Hollywood still photography, including Ron Avery, Suzanne Hanover, Bruce McBroom, Bill Ray, and Andy Schwartz.

For inviting me to work on the book, and for supporting the process, I am grateful to Katie Greenwood, Natalia Price-Cabrera, Zara Larcombe, Rachel Silverlight, and everyone at the Ilex Press.

Finally, I must thank Rian Johnson for his love and encouragement, and for setting the bar of curiosity and creativity in our household so high as to inspire me to raise my own game every day.

KATIE GREENWOOD

Thanks go to Andy Howick at mptvimages.com, and everyone who made this book possible: Amba Horton and Caroline Theakstone at Getty Images, Joelle Sedlmeyer at Life, Matt Severson and Faye Thompson at the Margaret Herrick Library, Kia Campbell at the Library of Congress, Dave Kent and Darren Thomas at The Kobal Collection, Albert Palacios at the Harry Ransom Center, and Joanna Ling at Sotherby's.

For supporting the project and providing contacts and permission, I am indebted to Suzanne Hanover, Andy Schwartz, Brian Hamill, Steve Schapiro, Christine Loss, Robert G. Zuckerman, Sidney Baldwin, Alex Fuchs, Gabor Szitanyi, Ken and Suzanne Regan, Chris Helcermanas-Benge, and Randy Tepper.

Karina Longworth—thank you for your wonderful words. Matt Wood at Made Noise—thank you for designing such a beautiful book.